T0083705

Anselm Kiefer

In conversation with Klaus Dermutz

THE
SEAGULL
LIBRARY OF
GERMAN
LITERATURE

Anselm Kiefer

In conversation with Klaus Dermutz

TRANSLATED BY TESS LEWIS

LONDON NEW YORK CALCUTTA

This publication has been supported by a grant from
the Goethe-Institut India

Seagull Books, 2022

Originally published as Anselm Kiefer, *Die Kunst knapp nicht unter,*
Anselm Kiefer im gesprach mit Klaus Dermutz © Suhrkamp Verlag
Berlin, 2010

First published in English translation by Seagull Books, 2019

English translation © Tess Lewis, 2019

Published as part of the Seagull Library of German Literature, 2022

ISBN 978 1 80309 038 2

British Library Cataloguing-in-Publication Data
A catalogue record for this book is available from the British Library

Typeset by Seagull Books, Calcutta, India
Printed and bound by Hyam Enterprises, Calcutta, India

CONTENTS

Foreword *xi*

Paint in Order to Understand,
Understand in Order to Paint 3

Boredom in Childhood—
That's What is Most Valuable Later 16

An Opening onto Vastness:
Onto the Steppe and the Firmament 59

Fire on Branches, Wings and Stones 92

Snow over Barjac 134

I Make Matter Secretive Again by Exposing It 141

Remnants Fascinated Me from Very Early On 176

Oedipus Is Transformed from a Figure
of Guilt into a Figure of Light 221

I Call on Nature for Assistance 230

Art Just Barely Survives 279

Biography *313*

A Note on Sources *317*

References Cited in the German Original *318*

Acknowledgements *319*

Dedicated to
Bettina and Paul Julian

Thanks to Thomas Teo

'For we are like tree trunks in the snow.'

Franz Kafka, *The Trees*

FOREWORD

The conversations collected in this volume explore the philosophical and theological foundations of Anselm Kiefer's art, which is inspired in myriad ways by Isaac Luria's mysticism and cosmogony and by the poetry of Ingeborg Bachmann and Paul Celan. These conversations touch on the elements earth, water, air and fire, on stories from the Old and New Testaments as well as on the void central to Buddhist thought. In Japanese philosophy, *Ku*, emptiness, is the fifth element. The void is also a central element in Kiefer's art, the emptiness of world and earth. These conversations trace the return of all that is past, delve into German and European history and discuss Kiefer's intensive engagement with the Shoah—especially through his 'response' to Celan's poems.

The conversations began in the spring of 2003 in Vienna and continued over the following years in Barjac until late 2008 and, after Kiefer's move to Paris, in the French metropolis. They can be read individually but also in chronological order. To a certain extent, the starting point determined the course they would take. After an evening rehearsal of Klaus Michael Grüber's staging of Sophocles' *Oedipus at Colonus* (2003) in the Vienna Burgtheater, I spoke to Kiefer in May 2003 about his

interpretation of the play, about the stage design and costumes. A half year later, I travelled to the final rehearsal of Grüber's staging of *Elektra* (2003) in the Teatro di San Carlo in Naples, for which Kiefer had again designed the set and costumes. Questions about theatricality underlay the beginning of this book project and thread their way through all the conversations.

Kiefer's *oeuvre* is informed by an 'aesthetic of the remnant' and within this compass are embedded reflections on humanity's place in the cosmos and on artistic production. The artist, for Kiefer, is 'constantly foundering. He never achieves what he wants. He can only skirt the crater, and, when he gets too close, he falls in like Empedocles.'

After an intensive examination of gnosis and Jewish mysticism, Kiefer turned to the subject of Mariology and to works he had begun more than thirty years earlier for the exhibition *Maria durch ein Dornwald ging* [*Mary Walks Amid the Thorn, 2008*]. In his paintings and installations, Kiefer fathoms transformative energy. A simultaneous volcanic exploding of eroded strata of the earth and ossified relationships and translocation and transformation of matter runs through all his creative work. These topics were particularly marked in the paintings and works included in the *Palmsonntag* [*Palm Sunday, 2006*] exhibition.

Kiefer's universe harbours many worlds and labyrinths that could not be addressed in these conversations. The conversations were held in the hope of articulating several of his creative work's fundamental themes. They were conducted in the belief that this immeasurably rich *oeuvre* can only be viewed from multiple perspectives. Thus, they explore Kiefer's artistic and cultural stances, his work and his world view. Kiefer's credo is contained in a paradox: 'I make matter secretive again by exposing it.'

Klaus Dermutz
Berlin, Spring 2010

CONVERSATIONS

2003–2009

PAINT IN ORDER TO UNDERSTAND, UNDERSTAND IN ORDER TO PAINT

Mr Kiefer, you were born on 8 March 1945. What images do you see when you picture your childhood?

The war was still going in March '45. Bombs fell on Donaueschingen, a railway junction, where I grew up. The French were advancing. I was born in the basement of the hospital. My parents stuck wax in my ears, like Odysseus did to his companions, so I wouldn't hear the bombs. The bombs were the sirens of my childhood.

You vomited up the cow's milk that your parents fed you as an infant. Your parents were worried you would die of malnourishment.

No child can digest cow's milk. I came within a hair's breadth of dying. Aside from the fact that I almost starved as an infant, everything went along normally. The rubble was always in sight. The house next to us was completely bombed out. I never experienced this rubble as something negative. It's a state of transition, of reversal, of change. I built houses with the stones scavenged in the big cities by the so-called rubble

women—who are today an almost mythological concept. The rubble was always a starting point for the construction of something new.

Polish painter and theatre director Tadeusz Kantor spoke of 'clichés of the future' when he saw a bombed bridge in Warsaw in 1947.

Rubble is the future. Because everything that is will pass. There's a wonderful chapter in Isaiah with the verse: 'Over your cities grass will grow.' This saying alone always fascinated me, even when I was a child. The poetry of it, the fact that you see both at once. Isaiah is a prophet who sees things in simultaneity—he sees the city and the different layers covering it, the grass, and then another city, the grass, and then another city, and so on.

Was your first name chosen more by your mother or your father?

By both of them, I believe. At the time, classical painters like Anselm Feuerbach were highly regarded. The name a child is given is rather important because it determines his life to some extent—either in opposition or emulation. I became very engaged with the Feuerbach family later, with the philosopher Ludwig Feuerbach. It was a family that played a prominent role in Germany for two generations. There was the painter, an art historian, an archaeologist and the philosopher Ludwig

Feuerbach, almost forgotten today but very important for Marx and Engels. Ludwig Feuerbach was very successful then. In Germany he was a star. Feuerbach was a revolutionary. Another Feuerbach was an influential lawyer.

You studied law initially.

I thought I didn't need the art academy. It was a kind of genius complex. I studied law because I was very interested in language and because of my awareness that our coexistence is predicated on legal norms, that is, on equality before the law. I've studied a great many political and legal philosophers, Hobbes, Montesquieu. I was very interested in the philosophy of law. But I never wanted to be a lawyer. I completed all the credits. I studied seriously, I didn't just audit.

Does your name also make you think of Anselm of Canterbury? The medieval theologian who wrote Cur deus homo, W*hy God became a Man.*

In the Catholic tradition, Anselm of Canterbury is the renowned scholastic. Why did God create man? Why didn't God just let it go? That's a good question (*laughs*).

How would you answer that?

I have no idea why God created man. That's the fundamental question in all religions, especially in Judaism.

Why is there anything? God was consummate, after all. In Christian theology and mythology, this question was always treated very apologetically. The theodicy, the justification of God in Christian theology, always seemed very insipid to me. In Jewish mysticism, this question was a spur to particular theoretical considerations that always inspired me deeply.

According to Christian theology, evil came into the world through man's freedom. Man can also decide against God's love.

But God created man. Man is a being who is profoundly evil, who can be profoundly evil. We still see it today. We are constantly horrified anew. Culture can continue, civilization can continue, the abyss of man's faulty polarity remains.

'Deus absconditus' is written on one of your paintings in Barjac. In the mysticism of the cabbalist Isaac Luria, evil enters the world because of God's withdrawal from it. The breaking of the vessels occurs through a cosmic catastrophe.

That depends, either through a cosmic catastrophe or because the receptacles—human beings—are too weak. Not all the vessels break, just certain ones. That's how so-called evil is explained. Of course, it's a completely different process than in Christian philosophy, much more interesting. I've been occupied with Isaac Luria's

tzimtzum for twenty years. It's a very abstract process, an intellectually very exciting and intensive process: the idea of a withdrawal from which something originates.

What leads to the breaking of the vessels for you?

First comes God's withdrawal. God withdraws into himself and thus leaves room for the world. Then comes the rupture. This does not occur simultaneously, it's a development. It didn't have to be this way, with the vessels breaking. It was only necessary because a reason for the world's dysfunction had to be found. Jewish mythology should never be read unambiguously. If there had been no grace that brought about the breaking of the vessels, nothing at all would have existed. At once a joy and a destruction. Not unequivocal.

You're very interested in circular rather than eschatological movement, in the endless ascending and descending.

In Merkabah mysticism, there are stairs leading up and down, there's Jacob's dream, too. It's a very interesting circular movement. For me, there's no eschatology.

What, then, would be the meaning of human life?

There is none for me. I endure life by creating order in a small sphere. Order is not the right term—by creating coherence with my artistic work. Otherwise I would not be alive.

You find the idea that each plant is connected to a star a comforting one.

I probably did say that I found it a comforting thought. The notion that each plant has a counterpart in a star comes from Robert Fludd. I was so taken with that dictum that I pursued it and studied Robert Fludd. There's something contemporarily modern in that proposition—the connection between the macrocosm and the microcosm, towards which Einstein always strived. The formula for both worlds has not been found yet. Yet Robert Fludd did discover it in a poetic way.

Do you think that each person is also connected to a particular star?

Most definitely. That can be understood literally. A star is not just a star but often an entire galaxy, yet it's difficult to be involved with a galaxy. Naturally, it's a marvellous phantasmagoria. It works in a subconscious way: choosing a star and being conscious that you are connected to a star. It endows earthly existence with a completely other dimension. It relativizes everything.

In your stage set for Klaus Michael Grüber's production of Oedipus at Colonus *in 2003, you tied Oedipus' fate to a star chart.*

The constellation is the epitome of Greek mythology. Through the entire performance, Bruno Ganz had to

find his way by the stars. Instead of a map, a star chart helped Oedipus.

Ash fell during the whole show.

Ash is a wonderful medium. It's the ultimate medium. After ashes, no further deformation is possible. When the bits of ash fall, they're like atomic particles that capture light. Ash fell constantly, a slight trickle that was always illuminated. You couldn't tell if the sparks of light were being gathered, were rising or falling. It's a Gnostic idea that sparks of light are caught in the earth and must be freed at the end of the world.

Ash could also be at the beginning.

An ending is always a beginning. At the start of our collaboration, Grüber and I envisaged the following perspective: Oedipus is a sadhu, an Indian itinerant monk who is clothed only with ashes. The ashes not only cover up but also give off light. Oedipus is transformed from an outcast criminal into a figure of light. He has gone through fire. He is ash. In the end, he is utterly burnt out, from humiliations and recriminations. Oedipus is cast out everywhere he goes. He is transformed into a saviour, a figure of light. The robe I designed for Oedipus is so stiff and rigid that it doesn't even need him. Oedipus founders, his light remains. Oedipus took guilt upon himself that did not originate in him but in

the design of the world. He completely rises above the personal. It's no longer about Oedipus the man—he becomes an idea.

Oedipus at Colonus was staged in an almost empty space. In Japanese philosophy, Ku, *emptiness, is the fifth element. The void is very important in your creative work.*

I've written a lot about empty space, about the empty space of childhood. By that I don't mean that there were no distractions like the radio and movies, and so on, I mean seeing without a conceptual framework, perception without intention. You can see an analogy to the beginning of the world, where everything is still immaterial, still-immanent energy that has not yet manifested itself. That's how concepts, images, crystallization points form as one develops, as if in a fluid that has been poured out and continues to spread. And these crystallization points, these coagulations will forever maintain a relation to this initial empty space. The past and the future are interrelated in many and complex ways. The farther I move in one direction, into the past, the farther I advance in the other, into the future. An eternally expanding dichotomy.

You have a special relationship to Naples. In an interview with the Corriere della Sera, *you said that you feel at home in Naples. You first went there in 1990. You watched the fireworks on New Year's Eve.*

Incredible. In the Spanish quarter, the poorest section of the city, there are the most explosions. It was just like in the war. Glowing red clouds of smoke hung over the area. The fire trucks and the militia couldn't even get through, cars were set on fire in intersections. What was a ritual, a celebration in archaic cultures: once a year, you stage something tremendous. I looked down on this spectacle from up on a mountain.

You call Naples a palimpsest and have said that it's perhaps the most interesting city in the world.

I owe Naples a great deal and I enjoy being there. Naples is interesting because of its location right next to Vesuvius and the threat that entails: the end can come at any moment. And because of its type of architecture—up on a mountain. It's always interesting when a city spreads up a mountain. Genoa, too. I like that city very much as well. The planar expansion of a city is tilted vertically, which gives the city greater intensity. The tilting of a city from a horizontal to a vertical always brings drama—just as I used the plastic sheeting from my studio as walls for *Oedipus at Colonus.*

In the catalogue of your exhibition in the Museo Archeologico Nazionale in 2004, you name Goethe and Beuys as your forefathers.

That was a nice aperçu. I would never see Beuys as my forefather, he was more of a contemporary. Despite the

widespread claims, I was never stationed in Düsseldorf. I was always in the forest and went to Düsseldorf three times a year. I showed Beuys my paintings and talked about them with him. I learnt a great deal from Beuys. Aside from his political theory, which I found abstruse, he had a terrific professionalism which helped make my path much shorter.

The 1970s in Germany were dominated by the conflict with the Red Army Faction. In 1972, Beuys created the installa-tion Dürer, ich führe persönlich Baader + Meinhof durch die Dokumenta V *[Dürer, I will personally guide Baader + Meinhof through Documenta V].*

That was a Dada-gag (*laughs*). I demonstrated when Holder Meins died. However, I drew a clear line when things started with Hanns Martin Schleyer. Some of my fellow students celebrated when Schleyer died. This cold shutting down of all emotion was so brutal that it led me to distance myself.

George W. Bush is currently dividing the world into good and evil.

That's a catastrophe. I refuse to go to America at the moment even though I know many Americans who think differently than those who are calling the shots politically. It's too bad because it's there that I first became known. In America there is a simplification of

thought and open imperialism. I believe that kind of politics bodes very ill for the world. It's not only the president who thinks that way.

Bush was re-elected.

That's what's most shocking.

There's a picture on the White House homepage of Laura Bush in the Modern Art Museum of Fort Worth, standing in front of your Buch mit Flügeln [Book with Wings, 1992–1994].

That photograph is simply for recruiting a completely different and very thin tranche of voters. It's not so important. What is important is that the politics being practiced today are so vulgarly Manichean that we can only fear the very worst. In a world that has become as complicated as today's, which demands every possible consideration and combination in thought and the highest level of expertise, things are being conducted on the level of a cowboy-movie cliché. That is very, very bad. Osama bin Laden and Bush have wrangled each other to greater prominence. The suicide attacks were a fitting response to Bush. Plans to take over the world, to use the old phrase, were already in the desk drawer. The USA had wanted to march into Iraq for a long time. When you control Iraq as a geopolitical space where there's oil, you control everything.

Two weeks after the suicide attacks on the Twin Towers, plans for the war had begun.

That's clear. In France, there's a book that claims Bush ordered those attacks. I won't go that far—it's not even necessary. It's one fundamentalism playing off another.

What would be a way out?

A more important foreign policy role for Europe. There are still other mindsets here. If only Europe would really step forward! But there are also the new Europeans, the Poles and so on, who were hoping to get a few dollars for joining the effort.

Bush is now trying to convince Europe to join the US effort.

Of course, because they can't win in Iraq alone any more. They tanked. They went to war—against the advice of the military. Usually it's the military who are ready to march in.

I'd like to return to your namesake, Anselm of Canterbury. In his introductory prayer to his ontological argument for the existence of God, there is the following maxim: Understand in order to believe, believe in order to understand.

Paint in order to understand and understand in order to paint. With every new subject I take on, with every experience I work through, there is at first no discourse. Understanding comes only in the process of painting.

But then the point of view that is gained alters in turn the process of painting. This procedure, this circular reasoning, can be applied to the production of each painting.

Barjac, 22 February 2005

BOREDOM IN CHILDHOOD—
THAT'S WHAT IS MOST VALUABLE LATER

Mr Kiefer, we're speaking in your library in Barjac. How was it when you came here in the early 1990s?

Initially there was nothing here, not one tree—just tundra. Only a few old houses in a dilapidated state. Rain had poured into them. The structures, in part, had no floors or roofs. All the houses here were uninhabitable.

To make the area habitable, you first laid out stones on the ground to make a plan.

The plan came later. First I renovated the old house, rebuilt the roofs and so on. To build the new houses later, I drove through the place with a bulldozer—me in front like the tour guides in the Louvre, that is, me with a stick in front, followed by the bulldozer. The bulldozer first created streets. That's the finest moment, when you lay streets out on a plot of land that doesn't have any yet. I drew the layout on the cleared ground with spray cans. That's how I started with the houses, I didn't have a plan.

A form of creation?

Yes, simply drawing up a plan 1:1. Usually plans are drawn on a scale of 1:20 or 1:100. I drew the plan for the future houses directly on the ground.

Was the light here the reason you chose Barjac as a location for your work?

That's the old ideology, that the light is different in the south. I don't need a diffcrcnt light pcr se. Every kind of light—in the north or in the south—is interesting. Northern light is also interesting, it has a different colour.

There are light shafts excavated in the tunnel and labyrinth system of your extensive compound. Shards of glass lie on the floor of these light shafts.

That's actually the extinguishing of light, the cutting off of light. There are no more openings that remind one of light. In the tunnels themselves, there's no longer any light at all. These are places from which light has been excluded, into which it only comes in small doses. These tunnels are peregrinations, actually a peregrination through the seven heavenly palaces. Sometimes the path goes up into greenhouses, which are filled with light, an explosion of light, then back underground in the tunnel. The seven heavenly palaces are not just above but below as well. It goes just as far down as it does up. These peregrinations have different themes.

The way there's a gathering of various themes and ideas in the *Odyssey*. And so there are shards. It's a reference to the *Shevirat Ha-kelim* in Isaac Luria's mysticism. Or there are stars—then it's a shower of stars. The large chunks of lead that fell here are called meteors. Each time something like this occurs in the tunnels, there's a house above where the event occurred, of which traces can now be seen in the tunnel. For example: over the meteors, there's a building with a large shelf of lead books that have been pushed apart or partly destroyed by the falling chunks. They came from above and fell into the tunnel. Below, you can always find traces of what happened above. For the falling stars there are a large number of glass labels on which the name of the corresponding star is written.

The numbers written on the longish glass strips follow NASA's numbering system of the stars.

Today you can find everything on the Internet. Back then I had write to NASA directly. The long numbers indicate the thermal energy, the redshift, the temperature and the distance. All this information is included in the numbers, they're scientific nomenclatures.

Man's fate is placed in the opening of the macrocosm.

Man's history is connected to the cosmos, just as his sustenance comes from the cosmos. Some substances and minerals come from the cosmos, from meteorites

that collided with the earth. Our atoms are closely connected to or even mixed together with atoms of the sun, the earth and other planets.

I had that feeling especially with the paintings in which you are shown lying on the ground, naked, only human. A sunflower or a wavy line of tulips rises from your body, at the bottom of the painting, all the way to the top, where your body is shown again in another position.

It's a kind of circulatory system. When you think of a spiral, you also immediately think of DNA. The naked man, who's no longer wearing anything, who no longer has any characteristics, who's no longer a person, who's no longer playing any role, who is disintegrating into the earth and is a part of the reigning metabolism.

His eyes closed.

In that state, one is no longer looking out. Everything is internalized. There is only an interior that becomes exterior.

Looking at the painting, this poem of Paul Celan's came to mind: 'Gymnosperm, here your / prayer shawl: / exonerate yourself / into the shawled. // And give yourself to me / like winning / blue to winning / white.' [1]

1 Paul Celan, 'Gymnosperm' in *Snow Part* (Ian Fairley trans.) (Riverdale-on-Hudson, NY: Sheep Meadow Press, 2007), p. 170.

The gymnosperm is, of course, something completely analogous. The Jews' prayer shawl is a ritual. The Jews wear the shawl when they pray. It's also a role. Karl Marx would call it a character mask a person has developed. When sensitivities are allowed to emerge and are then disappointed, according to Marx, these masks are created. It's a hardening necessary for survival. That's how I understand Celan's poem: the gymnosperm on the one hand and on the other, the prayer shawl that gives man a role or a support through scars.

One could say that your work is a form of exoneration.

That said, exoneration is ambivalent. When you can formulate something, you can cast it off, you can objectify it and see what it is. A liberation on one hand. But language is something that conceals and reveals at the same time. Ingeborg Bachman, I think, once said: I carry my language around with me like a house. Language is a house that surrounds you, that protects you, that you carry with you, that offers support and protection.

In Barjac you gave your paintings their own houses.

The paintings need their own buildings to work. They require their own site of action. Only from this site can they have an effect in the world. When you hang the paintings somewhere or combine them with other paintings, they lose their power. It's also necessary to have a threshold before the painting.

One enters the painting's room?

Yes. In the Bible it says: Put off thy shoes from thy feet, for the place whereon thou standest is holy ground. That happens at the burning bush. The angel of Yahweh appears to Moses from a flame in the bush. Moses wants to find out why the bush is burning but is not being consumed by the fire. When Yahweh sees that Moses is approaching the burning bush, God calls to him from the bush: Draw not nigh hither; put off thy shoes from thy feet, for the place whereon thou standest is holy ground. There's also mention of a threshold in this verse.

When I saw the buildings with the open doors, I was reminded of a comment made by Tadeusz Kantor about the Veit Stoss altarpiece in Krakow. He said that this altar is a work of art you can shut. The art works of yours that can be seen in the individual pavilions can also be shut.

It's important to be able to shut paintings away when you want to: so that they can rest from time to time. Or so they can recover their secret. Or so they can change in seclusion because what is hidden often changes greatly. For example, the prophets withdrew from everyone and went into the desert. The journey into the desert can also be seen as the shutting of a door. You shut yourself off from all the others and go into the desert where there apparently is nothing. The desert is

extremely fruitful. You go into the desert to come to a new perspective.

And we witnessed new perspectives today as you were building a tower of Die Sieben Himmelspaläste [The Seven Heavenly Palaces, 2001–2008]. *On the top floors of some towers in Barjac you can see a door leading to heaven.*

An opening. A door you can't shut. A passage. These elements of the towers sometimes have doors, open doors. When you look through them, looking up at a slant, you see right into the heavens. It's even more dramatic because of the doorframe, because it's cut out. Through it, the sky comes closer to us, it comes right up to us through this opening.

In the 2008 Bücher [Books] *exhibition that Heiner Bastian showed in his Berlin gallery on the occasion of your receiving the Peace Prize of the German Book Trade, there was a painting titled* Am Anfang [At the Beginning, 1985]. *A book is attached in the centre and the expanse of a landscape or a sea extends behind it.*

That's the sea. The book and the sea have always offered me very meaningful contexts. The waves constantly rolling in. From a geological perspective, too: the sea grinds boulders into sand, transforms entire mountains to sand. When you walk along the beach and listen to the surf, it's a music that takes you very far into the past,

that brings us back to our origins, to our life in the ocean. We come from the ocean. We are ocean creatures. The protozoa all lived in the ocean, that's where life began. I believe that our longings, our deepest, most secret longings, which can have various objects, come from the ocean. Our longing comes from the original 37-degree ocean to which we long to return.

The Book of Genesis says the Spirit of God hovered over the waters.

There's that too, but even more than that: our memory is in our cells. There's very little in our heads. Memory in the cells—that leads to the happy, unconscious state of the single-cell organism returning to the ocean. Our blood is sea water, the red blood cells are an addition. The chemical composition of blood is like that of sea water.

The book in At the Beginning *is open. It could have been closed. You chose an open book.*

I suggested a page. I chose a page as an example.

An empty page?

It's not empty—it contains everything.

The Japanese photographer, Hiroshi Sugimoto, shot cinema screens, on which an entire movie was projected, in one exposure so that the screens are white when the photographs

are developed. These white screens contain, so to speak, all the images of the film. I thought of Sugimoto's theatre series when I saw the open book in At the Beginning.

With everything contained there?—Yes.

The ideal distance, too? Pascal proposes that there's a certain ideal distance between the viewer and a picture. In Berlin, I tried to establish the ideal distance from your painting. I had the impression that the ideal distance would be a slight overview.

Certainly, the perspective is a slight overview. Pascal speaks of an ideal distance from a picture. I'd reinterpret his proposition a little. My paintings are also interesting when you look at them up close, then they're abstract, you can no longer make out any objects. In any case, without objects I wouldn't paint any pictures. But what Pascal probably also means and what we were exploring earlier is the proper location for a picture. I can only specify the right distance from a painting once I've created a framework, given it housing or a threshold from which the painting can be seen from the proper distance. I wouldn't designate the distance in metres but as a remove from life, a remove from the world—there must be some distance there.

Which the viewer himself looks for?

Yes. For a start there is a material, an actual distance: when you open the door, you see the picture. That makes it easier to find the right distance for you from the picture. If nothing is predetermined, if the painting is hung on some tree, or in a supermarket or somewhere, the viewer won't find his own distance.

The distance specified by the building protects the painting.

The building determines an initial distance, but it doesn't have to be maintained. The viewer can move closer or back away. Initially, the structure says: something new is beginning now. And then there's the possibility of seeing something that has disengaged itself from life, which is no longer life. Because we're all searching for a vantage point outside of life. We don't always want to remain in the midst of life. We're equipped with the idea, we're plagued by the thought that we want something that is beyond life, that transcends life.

Where does this desire come from?

Maybe it's because we've been banished from the ocean. Since we left the ocean, we're condemned to hover above things, to find a vantage point above or beyond things.

To find an Archimedean point.

An Archimedean point is something else, but you could say: to find the point or a constellation or a structure that—separating us from life—connects us to everything. Life does not connect us to everything. It binds us to what is right in front of our noses—with what is proximate.

In the West-östlicher Diwan [West Eastern Divan] *pavilion and in the* Für Paul Celan [For Paul Celan] *pavilion, in* Das Geheimnis der Farne [The Secret of the Ferns] *building, the paintings are hung to the side.*

Even before I'd read Paul Celan's 'The Secret of the Ferns', I'd always been very drawn to ferns. They were plants that had a special, a magnetic attraction for me. I believe this attraction is connected to the fact that ferns, tree ferns, were the very first plants on earth. They go very far back and so have their own particular mythology. On St John's Eve, the seeds of the fern are gathered—if handled properly, they can make you invulnerable and invisible. The fern, generally speaking, unfurled a mythological production.

Ferns are also associated with night.

With 22 June, the solstice, and so on. The seeds have to be collected on that day or it won't work.

Entering the space, one's gaze falls on the opposite wall. You've. written For Paul Celan. Secret of the Ferns *on that*

white wall. Paintings unfold on the walls to the left and right.

Like herbaria, where I created pictures using the ferns, their structure and their colour. There are, I think, 20 paintings on the right and 20 on the left. You go through a corridor of ferns. The space, you might say, is a clearing in a fern forest.

In this clearing there's also a quote from Ingeborg Bachmann. On one painting the verse is written: 'Everyone who falls has wings'.

In the poem 'Das Spiel ist aus' [The Game is Over] there are the verses: 'On the golden bridge only the one who still knows / the karfunkelfaerie's word will win. / I must tell you, it melted away with the last traces / of snow in the garden. // From many stones our feet are so sore. / One will heal. Let's hop on it / until the fairy-tale king, with the key to his kingdom in his mouth, / comes to lead us away and we sing: // It's a lovely time when the date pit sprouts! / Everyone who falls has wings.'

And in Ingeborg Bachmann's acceptance speech on receiving the Radio Play Prize of the War Blind, 'Die Wahrheit ist dem Menschen zumutbar' [The Truth Is to Be Expected for Man, 1959], there's a similar reflection: 'Who, if not those among us who have suffered difficult fortunes, could

best attest to the fact that our strength is greater than our misfortune, that, even bereft of a great deal, one can rise again and live in disillusion and that means without illusion.' In this painting, you've created a connection between the works of Paul Celan and Ingeborg Bachmann.

I didn't create that connection, it was already there. The Bachmann and Celan correspondence was published last year. They're very intimate letters. The publisher, Suhrkamp Verlag, sent me a volume in June, 2008, before the publication date.

In the exhibition Mary Walks Amid the Thorn, *there was a painting titled* Pietà (2007). *In it we see you lying naked on the ground in a thicket of brambles. This work is then set off at a remove through a lead-framed glass case.*

Almost as if in a glass sarcophagus, like Snow White. The dwarves carry Snow White in a glass coffin, they trip and the bite of apple falls from her mouth and she wakes up.

What surprised me in this picture is that the viewer has a strong overhead view. It's a look down into a dark, thorn-filled chasm in which you are lying. The title, Pietà, *recalls Christ's descent from the cross.*

The thorns are an allusion to the crown of thorns but they also create space. They hold the viewer at a distance.

The thicket of brambles offers protection, too?

Certainly. I imported the thorns from Morocco. We don't have thorns like that here. The North Africans use ramparts of thorns to protect their crops from goats that eat everything except these thorns. The thorns also play on the song *Mary walks amid the thorn.* Every seven years, the thorn wood flowers again, according to the song. It's like the Flying Dutchman that reappears every seven years.

'Mary walked amid the thorn / that bore not a leaf for seven years!': *the* Palm Sunday *room has an inward connection with the blooming of the thorny wood. Looking at the pictures in this room, I had the impression that the tips of the twigs looked like a skeleton, like a human spine or a fish skeleton.*

The protruding spurs give the palm branches the structure of a skeleton, a backbone. The palm fronds are a symbol of kingship, of victory and celebration. I dipped them in plaster. They were encrusted, they became sculptures.

An analogy to this—as with the shower of stars—there's one palm tree that has fallen over.

That palm tree turns the meaning of the victory into its opposite, into a misfortune or a failure.

At the same time, there's a sense of breakthrough in your Palm Sunday *paintings, a breaking through a hardened, solidified material, especially in the openings of the red-tinted structure.*

Sometimes the red is as red as a volcano. The palm tree, as I've used it, is to be understood as completely contradictory. On the one hand it's a symbol for kingship and victory. On the other hand if you think of Christian mythology, it also alludes to the day before defeat, before the crucifixion, before Holy Week. Palm Sunday is the Sunday before Holy Week. Jesus entered Jerusalem as a king but, at the same time, the Crucifixion begins with his entrance into Jerusalem, in other words, the downfall.

And in the downfall, the ascension.

The ascension came later. But first, it's a downfall because Jesus says on the cross, 'My God, my God, why hast thou forsaken me?' At that point it's over.

On the cross Jesus also says: 'It is finished.' That's how Jesus' death is described in the Gospel of John.

Are they different gospels?

There are different versions. The Evangelists Matthew and Mark tell us that on the cross, Jesus cried out loudly, 'My God, my God, why hast thou forsaken me?' In the gospel of Luke, however, Jesus' last words are 'Father, into thy hands

I commend my spirit.' The Catholic theologian, Karl Rahner, once emphasized that for Christians, both stances are possible, so they can say both 'My God, my God, why hast thou forsaken me?' as well as 'It is finished.'

'Why hast thou forsaken me?' means that my expectations that God would come and extract me have not been realized. And 'It is finished' means that the prophecies of the Scriptures have been fulfilled. The prophecy was fulfilled exactly. That's not a contradiction. When you say, 'It is finished,' it doesn't mean that it must be a victory. A defeat can be completed as well. 'It is finished'—I've done everything I could do and it didn't work. So when the temple is destroyed, you could also say it is finished. Or couldn't you? Destruction is also a completion. Yahweh's threat that he would let the temple be destroyed, the women be raped and the city become wasteland is then also finished.

At Jesus' death, on his final cry, the curtain in the temple tears in two from top to bottom.

That's also a completion—not a contradiction. Rahner argued against a contradiction that could be assumed. It would have to be examined closely.

Whatever Jesus' death on the cross means in the different gospels, what occurs after he is laid in the grave is also central to your thinking. After Jesus' resurrection, the grave is empty. Empty space plays an important role in your work.

Especially the dialectic with empty space. I basically think that through my work, I fill a space that had been emptied out in my childhood, a space, that is, that was not only empty of external things. We didn't have the Internet or a television. There was only a radio. In that village deep in the provinces, there was no theatre either. Everything you see as a child falls as if onto a wax tablet, onto something blank. It falls on it and has an effect. It's initially something still unfilled. It's taken in as it is. There's no explanation, no context. It's simply a collection of initially meaningless things. What you experience is not important at first. It's just there. I see empty space dialectically. I'm always deeply fascinated by abandoned factories because so much is present in them. In Germany, I worked in an abandoned tile factory. I was extremely fascinated by the traces, by the mass of the space, which in and of itself was empty and deserted but still filled with traces of thousands of workers.

The concept of the expansion of time is connected to empty space.

To the extent that you experience everything completely differently as a child. With age, time speeds up because you work much more. As a child, you experience boredom very powerfully: boredom in childhood—that's what is most valuable later. In boredom, you are at the

foundation of existence. You don't experience yourself when you're not bored. Heidegger wrote an entire lecture on boredom. I remember how he presented his reflections in that lecture on the boredom he has experienced. He'd been invited into company that wasn't entirely unpleasant but also wasn't anything special, so a feeling of boredom set in. He wondered why he had accepted the invitation and that's when the consciousness of existence began. And today it's such that everything we do, all our busyness, our activity on the Internet, it all destroys empty space, it clogs everything. There's no boredom any more. We work less than before—there's the 35-hour work week—but, at the same time, there's an industry that's leapt into the breach, offering activity-filled vacations. Everything is done to make boredom and the experience of emptiness impossible.

Your work could be understood as a means of making possible for the viewer a consciousness of existence and, with it, the fundamental motion of the world.

I hope so (*laughs*). The experience of a painting lasts for a certain period when you look at the picture properly. Objectively speaking, nothing happens in that time. The painting does not change in that moment. In that time, in which nothing happens, the awareness arises of empty space that can be filled.

Is it also a theatrical form of fulfilment?

Yes, but you have to think about exactly what you understand by theatricality.

You once told me that your first experience connected to the theatre was the following: you were riding your bicycle through a forest and you saw a stage.

An open-air theatre.

Did it look like a small scale version of a Hollywood set in the forest?

A small Hollywood set that had just been dumped in the forest. It was an open-air theatre near Rastatt. Ötigheim was the name of the village. All the village residents performed there. They put on *Ben-Hur*, *The Maid of Orleans*, *Wilhelm Tell* and other plays. The main roles were always played by professional actors—Joan of Arc was played a professional actress but all the rest were people from the village. It was a village theatre, a lay theatre, but a real theatre—there was a stage and a painted backdrop. I found this theatre incredibly fascinating because there were two realities: the world as we know it, the normal world, and with it, the artificial world. It's wonderful when you see the two next to each other as a child, the artificial world implanted in the normal world.

These two worlds can be found here in Barjac, too, in your amphitheatre, as you call your theatre: natural hills and

slopes with concrete steps set in them, an amphitheatre built into nature.

That's probably a response to that lay theatre (*laughs*). The amphitheatre is a kind of lay theatre. I'm not an architect—I built it without plans. I just started in, placed the containers there, used them as casing and poured the concrete into the spaces in-between.

What is nice about the amphitheatre is that it's a theatre you can move through. You can walk through the individual levels of the stage.

And you have the underground connections, like in a real theatre. There are also entrances and exits.

Your amphitheatre was the model for the space in Klaus Michael Grüber's 2003 production of Elektra *by Richard Strauss in the Teatro di San Carlo in Naples. What stayed in my memory from your stage design in Naples—and which I found again here—are the straw and shards of clay pots. On the one hand your amphitheatre was the royal palace of Mycenae. At the same time, I had the impression that your stage set was like a ruin—Elektra was living in a ruin.*

For Elektra, it is a ruin, something destroyed, because her family life was destroyed by Aegisthus. He dethroned Agamemnon and married Clytemnestra. For Elektra, everything is over, life is now simply destructive, there's nothing left. She lives down there like a dog in the hut.

35

In a letter to Franz Wurm, Paul Celan uses the image of 'human shards' that 'clatter' together 'from the ashes right into the ashes.' Elektra is a human shard.

Shards and clattering have a specific meaning. There's the poem by Hölderlin, 'Half of Life', with the final line: '. . . in the wind / the weathervanes clatter.' The vanes that turn in the wind, they clatter. The vanes become crystalline, they drop and shatter into shards. Shards have always attracted me, they come from the *Shevirat Ha-kelim* in Isaac Luria's mythology. What, exactly, does Celan say?

In the letter he writes: 'There are still other entities, yet human shards just clatter around in them, from the ashes right into the ashes.'

The link between shards and ashes is also interesting because ash is an end-product. It is a provisional end-product of metamorphosis. The shards are still shaped parts. Admittedly they're all clattered together but they're still part of a shape. Something can only end up as shards once it has solidified, once it has become crystalline, once it's no longer alive—which we discussed earlier with regard to character masks. A scar can form as a result of a disappointed sensibility. A scar is a hardening.

You've also connected the clattering, the shattering to the painter's palette.

I often did earlier.

And in the amphitheatre there are broken palettes in two places, a larger one in the upper area and a smaller one below.

Their form is still recognizable but the context and the parameters of art are all mixed up. The unity, the unified view of art, its sense of values, you might say, has been shattered, has broken into pieces. There is no longer a binding codex. That's what Walter Benjamin meant by fragments. The great works of the last century—like Robert Musil's *The Man Without Qualities*—were left unfinished. They are themselves also shards.

After Walter Benjamin, fragments of the past have been blasted into the present and thus evoke the memory of a downfall or destruction.

Yes, but not as a whole—as intrusions.

There's another image associated with destruction: the dissolution of images on rolls of film that you see in the upper levels of the amphitheatre. The images cascade down from the rolls. They seem to be dipped into a developing bath but they become ever less recognizable. Is it a bleaching out of colour?

Yes.

There's a painting on the lowest level of the amphitheatre with the inscription 'Argonauts'. *Below a dress that is*

covered with golden lines, you see a point of impact, like a bombsite.

A detonation, something has been broken. Only shards are left.

Bomb craters have always fascinated you.

I played in bomb craters. They were partly filled with water, circular lakes. There were several bomb craters in the area where I grew up. As a child, you register these forms like all the others. I often think of those craters. It's as if something were being poured into the earth with a funnel. A funnel is an implement used to guide something into a certain shape, into a certain vessel. You can think of the earth as a vessel. You create a funnel to bottle up the spirit in the earth (*laughs*). Funnel is an interesting word in connection with the vessel. Bomb craters are especially appealing.

Did you ever bathe in a bomb crater?

No. Water was always collected from the bomb craters for the garden. The crater was a reservoir for the plants.

A reservoir for life?

That's right. During the First World War, the soldiers threw themselves into the craters when they were attacked because they were protected there. They

practically incorporated themselves into the earth to get out of the flight paths.

You told me that the rods sticking out of the bunkers were used to detonate the bombs before they hit.

Those rods are called reinforcing bars. Bunkers are very interesting architectonic structures of great and amazing beauty and that's because they're not about living. The bunkers are actual *art for art's sake* objects because the space left inside bears no relation to the concrete used to build the bunkers. I always found it interesting that you need so much concrete for such a small space. If the two of us needed a bunker, it would have to be as big as the entire library in order to protect us. Bunkers are for me the most beautiful *art for art's sake* architecture. Back then, they built bunkers that were shaped like projectile casings, pointed on top. So that projectiles would detonate outside the concrete shell, they just left the reinforcing bars sticking out. When they were under fire, the bombs exploded first and so the impact on the walls of the bunker was lessened.

Steel rods also protrude from the concrete panels of the Seven Heavenly Palaces.

You could also see them as antennae, like those on a snail: antennae to communicate with the outside world. The steel rods here are not so much thought of as a protection against shelling. I see them more as antennae, as a gallery of antennae.

They also made me think of hands stretching up to heaven.

Antennae are outstretched hands. You can see that with snails. They have these antennae. They use them to orient themselves.

To return to the shards, to the breaking of the vessels and to Elektra living in a ruin. In the Old Testament there is a woman who is closely connected with ruins—Lilith.

I came across Lilith for the first time twenty or thirty years ago. I had read some text or other, in which was written: Lilith, who lives in abandoned ruins. This sentence alone fascinated me so much that I did some research to find out who Lilith was. I studied the source texts. Lilith lives in abandoned ruins—that's fantastic. She lives in a place the prophets have decreed to be a non-place: your cities will be abandoned, they will be desolate, they will lie in ruins, grass will grow over them—that's where Lilith lives. She is, in fact, ahistorical, there shouldn't actually be any people left but Lilith is still there. Actually no people should be there, therefore Lilith is not a proper person.

I had the impression that your Seven Heavenly Palaces *were ghost houses, which the wind blows through, making the cement walls and the iron rods sound.*

What's very beautiful is scaffolding made of round pipes. When the wind blows, it makes the most beautiful music, it blows through these pipes. It's fantastic. A year ago, I invited musicians into the Louvre, the composer Jörg Widmann, for example. He has written music that reminds me of the music that blew through this pipe scaffolding. It's global: the wind comes, blows through the pipes and comes out the other side, and so it makes its way around the world.

The music of the spheres?

Music of the spheres that is summoned on the earth. Just as there's solar wind, you could say that there are sounds that circle the world.

We just spoke of Lilith. Your stage set for Klaus Michael Grüber's production of Sophocles' Oedipus at Colonus *shows another 'non-place'. Colonus is a 'non-place' associated with dust, ash, falling sand.*

Colonus was a place that was out of bounds. At the beginning, the villager says to Antigone: you should not be here, go away immediately. A 'non-place' that is also sacred ground.

Bruno Ganz, who played Oedipus, prostrated himself on the ground in order to stay there.

That's how I depicted that place: as a dusty place where the end of a great many people is present as dust, as ash. Dust was falling constantly. With the costumes, I naturally thought of a sadhu, an Indian holy man who sits, clad only in ashes, with a burning crown of dung on his head.

What was nice about your costumes was that Oedipus' face was hidden by a hood. Only in the course of the play did his face become visible: the innocent man become guilty is revealed.

At first, it was again just a person: a mask. You could say that afterwards his mask, the hardening, slowly dissolved, and the person appeared along with his story.

Looking at the cover of the programme, you get the impression that Oedipus imprints himself in this space like a footstep. He is himself like a footprint.

There are footprints in the ashes. Or as in fresh snow. There was a trace of Oedipus. At the same time, he had a constellation in hand.

In your stage design, there was a star chart with one constellation assigned to Theseus and another to Oedipus.

Is that in Sophocles' play?

Not as I remember it.

The chart leads Oedipus. He's blind, but he keeps looking at the chart.

Oedipus rests near the chart. He stretches out on the ground and rests his head on a mud brick.

Maybe the star chart was my invention, not bad, right? (*Laughs*)

On that chart were written the columns of the NASA numeric code for the stars. What I found very thought-provoking about your cover design is the way man disappears into matter: into dust, ash, sand. And at the same time, there were these massive concrete stairs and the steel rods sticking out of the steps.

Oedipus climbs the stairs because he's climbing into another sphere. At the moment of transformation, he happens to be on the stairs. In the end, Oedipus becomes the saint of this place.

At the top of the stairs, he takes off his hood.

Through the scar, he returns to his story and becomes a saviour. In this spot he turns from one who is guilty of incest to a saviour.

Who brings peace to the city of Athens.

Oedipus becomes the saviour. That is amazing.

In your acceptance speech for the Peace Prize of the German Book Trade, you spoke about France being the Promised Land in your childhood. Was Germany an exile for you?

France was the Promised Land from a childish perspective. I grew up on the Rhine; that was the border. And beyond the Rhine was the country I wasn't allowed to enter. It was a country onto which I could project everything. It was a Promised Land insofar as it was an unexpressed land, an empty land, and so a Promised Land.

If you think about it from a biblical perspective, before one enters the Promised Land, one is . . .

. . . in a state of diaspora. I've always felt myself to be part of a diaspora. Always in the wrong place, in the wrong family. I was never where I wanted to be. I never wanted to be in Barjac either.

So how did you end up living and working in Barjac for fourteen years?

It happened the way things always happen in life—it just did. You make a mistake. You move to a place and it's the wrong place, but that doesn't mean something good can't come of it. Barjac was the wrong place. The place I was born was also the wrong place. And the family I grew up in was also the wrong family.

In Japanese philosophy, there's the idea that blossoms come from chaos. Do you see your life that way?

Yes. Rudolf Steiner believed that you seek out your own parents. You find yourself up there in some kind of intermediate place and you seek out your parents.

I once discussed this assumption with a French girlfriend and her response was: Can anyone really be so tasteless?

Perhaps one has the bad taste to dream of something better. There's always a discrepancy between where one is and where one wants to be, between what one wishes for oneself and what really happens when your wishes are, so to speak, fulfilled.

Was the move from Barjac to Paris difficult for you?

No, not at all. On the contrary, it was a great pleasure. I now have a new studio: a large building outside Paris. Funnily enough, it's right on the motorway to Germany (*laughs*). I'm on the motorway and in front of me there's an airport, which is, of course, a marvellous constellation: motorway and airport. I'm now completely mobile.

Your engagement with National Socialism, your attic series, the paintings, the rooms that cite National Socialist architecture, were always associated with the question of central perspective. I have the sense that your years in Barjac brought another perspective into your work.

Perhaps that's because for me the landscape here, although it's very beautiful, is without perspective. I've

never painted a picture with the landscape of Barjac as subject. Not as subject—that's not accurate in any case, but I've never used the landscape of Barjac as material. I've always felt *elendi* here, that is 'in another land'. *Elendi* is Middle High German, *elendi* comes from being in another country.

According to Kantor, the artist's place is on a border. In his last production, Today is my Birthday (1991), *Kantor established his place on the border: behind him, his theatre, before him, life. Do you see it similarly, that the artist takes up a place on the border, a border, to be sure, that is always shifting, always becoming another border?*

As an artist you're on the border in all sorts of ways. You're always trying to push the boundaries of art. You try to do what's barely still art. That's a limit situation, but it's also on the border of the unknown. Because you want to do something that will surprise, not always the same thing. So you could also say: it's overstepping a border, or an attempt to see over a border or the wish to overleap a border. Or to walk along a border, once this way, once that way, always changing borders.

Your West Eastern Divan *pavilion is an example of how the border can be shifted.*

The expression *West Eastern Divan* comes from Goethe. He formulated it when he discovered the poets Rumi

and Hafiz. Goethe entered a completely different culture, a border crossing that nonetheless brought him back to his own.

Does this border crossing also have something to do with the Arab philosopher and theoretician Alhazen? His name is written on the opposite side of the entryway. Alhazen wrote the Book of Optics. *One of the* Seven Heavenly Palaces *towers is built of brick. The spaces between the bricks get bigger and bigger towards the top. Did your engagement with Pakistan, with the poems of Hafiz or with the theory advanced in Alhazen's* Book of Optics *bring a new point of view? According to Hans Belting, Alhazen's theory presents a completely different perspective than the central perspective developed in Renaissance Florence. Have you explored these questions in recent years and were they connected to Barjac?*

Not so much with Barjac but certainly with my readings in philosophy, poetry and astrophysics.

This interest comes more directly from scientific preoccupations?

Yes, from astronomical sciences, from reading the work of Stephen Hawking and others.

Pascal proposes that man exists in an intersection of the microcosm with the macrocosm.

Man is the membrane, the semipermeable membrane between the micro- and the macrocosm.

When one looks at the microcosm, according to Pascal, man appears in all his grandeur. When one looks at the macrocosm, one realizes how tiny man is, like a mote of dust or an atom.

Man is as great as the macrocosm. If you take a number, 10 to the 26 power, it's incredibly far, that's 26 zeros, you can do the same with 10 to the minus 26 power. You enter the realm of the small, of the absolutely small. The distance from 10 to the 26 power is just as far as the distance from 10 to the minus 26 power. In this relation, the macrocosm is the same size and distance as the microcosm. And the membrane is the transition from one cosmos to the other.

In his book, A Lover's Discourse, *Roland Barthes wrote: 'Language is a skin: I rub my language against another. It is as if I had words instead of fingers or fingers on the tips of my words.'*

The skin is a very important organ—like the ear. You hear with your skin. For example: you perceive music, the bass tones in disco and such, with your skin. You learn much more than with your ears alone.

According to Sigmund Freud, the Ego is ultimately led by bodily sensations, especially by those on the surface of the

human body. Freud sees the Ego as a 'surface entity.' In your self-portrait as nude, the skin is the site of the transition from one cosmos to another.

The skin is itself the form, just barely form in what will soon no longer be distinct. When you die, everything hardens, everything loses form and disintegrates into atoms. Before the corpse disintegrates into atoms, before rigor mortis sets in, everything is crystallized, so to speak. There's wonderful story by Wilhelm Busch about a son who goes out into the cold. It's terribly cold outside. His mother says, stay at home, it's cold, so very cold. The boy goes out, the birds fall from the wires, everything dies and so on. The boy stiffens, freezes to death. The father goes out and brings their son home as a sheet of ice. The father trips on the threshold, stumbles and the boy shatters into ice shards. The mother sweeps the ice up and stores it in a jar. The ice melts and the son is back. I think Wilhelm Busch is not bad: The father stumbles, the son shatters.

The story of splintering you just told also occurs in a tale by Hans Christian Andersen, in 'The Snow Queen'.

She shatters too?

A shard of the magic mirror pierces the little Kay's eye and another his heart. Paul Celan was inspired by Andersen's tale to write a poem. It has the same title as Andersen's tale, 'The Snow Queen'.

I don't know that poem.

In Tadeusz Kantor's Wielopole, Wielopole, *the dead priest lies on his deathbed. His feet are bare. The local photographer's widow goes up to him and takes hold of his feet. The experience of death is made tangible through the skin, through skin that has been overcome with rigor mortis, that has become cold, as dry as paper.*

Skin that longer exchanges anything.

When I went to see my father on his deathbed and touched his skin, it was warm. When I went to him after he had died and been laid in his coffin, I touched his cheek once more. It was ice cold—there was no longer any reaction.

I had the same experience with my grandfather who died in 1949. I was four years old. I went into the room where he lay dead. I came out of the room and said: He's made of wood. That's a strange experience. As a child you don't experience a shock. At four years old you don't yet know what death is. I only observed that he felt wooden when touched. As a child I also had a doll, it wasn't big, half of its body was carved from wood. The upper half was hard and the lower was made of rags, there the doll was stuffed. I was always interested in why the doll was hard to its waist and then became soft. That was a strange and comical experience. As a child, you don't analyse things, you just observe them. Up to

here it's wood and then it becomes soft. Only later do you think about it.

Tadeusz Kantor developed his Theatre of Death *out of his experience when the priest, his great-uncle, died. Kantor was six years old when his great-uncle died. You were also confronted with death at the age of seven when white chickens flew over your parent's garden fence.*

I killed the chickens. I don't remember if I was six or seven or eight years old.

You beat the chickens to death with a spade. It was an experience that made you feel miserable.

It was a horrible experience. It was the urge to kill these creatures, an urge children often have. And along with that there was legitimization because the chickens often flew over the fence and ate up the garden. So the killing was quasi-legitimate. Even while I was killing the chickens, I felt terrible. It was a horrible experience of grief that the chickens were dead, naturally, and an experience of self-revulsion, for having done something like that, an experience of the absurdity of it all. The chickens were particularly beautiful, small, young, white hens against the damp-dark earth. It was a great shock.

That you extinguished life?

Yes, that one can be so brutal. It was a very immediate experience. When I heard speeches by Hitler and

Goebbels, I had a similarly immediate experience. Those speeches were also a very direct experience, a horrifying existential experience.

That got beneath your skin.

Very much beneath my skin because they were records that had been distributed by the Americans to enlighten the Germans (*laughs*). I listened to these records and was so fascinated by Hitler, by his will and at the same time his repulsiveness, his ridiculousness, everything together. I would say it was an experience like the one with the chickens, of the same intensity.

At what age?

It was later, I was maybe 21, 22 years old. It must have been in 1967.

When did you hear of the Holocaust?

It was in '67, '68, '69 that I began informing myself about the Holocaust. I read books and did everything possible to learn what happened. It wasn't so easy then, because only those many programmes were first shown on television in the 1970s. In the media, it was not so clearly discussed. Of course there were books, you could read about it.

And the trials that were reported on in the German press, in newspapers and on the radio?

The trials were not such a presence at the time. The Nürnberg trials were long past. The trials had been broken off.

In the 1960s, in the German Federal Republic there was an opening up. People started to confront the Nazi past.

More in the 1970s—programmes about the extermination camps were broadcast on television starting in 1974. You mean trials in which politicians who had been Nazis were exposed? Kislinger and Filbinger were later.

You once said you didn't want to become a Holocaust specialist.

I didn't want to be pigeonholed with this topic. I received many offers to build Holocaust memorials. But I didn't want to. I don't mean that I thought enough had been said, but I didn't want to become a Holocaust specialist.

To represent the absurdity of Nazi ideology, you created the Heroische Sinnbilder [Heroic Symbols, 1969] *to show what kind of false pathos and ridiculous grandeur were spread through the Nazi regime's propaganda.*

Those heroes, those figureheads, like Mussolini, too: when you see them in films and especially if the sound is muted, they look like joke characters. Chaplin was a

fantastic imitator, his movie *The Great Dictator* is fantastic, that kind of pathos bordering the ludicrous. That's why those dictators are so stricken when they're ridiculed. You're sent straight to prison for cracking a joke—for that very reason, because you're so close to the heart of it. Kantor was particularly good at hitting the pathos that can flip at any moment. When I think of those cardinals dancing and there's a Jew fiddling in front of them—which play is that in?

In the 1988 production I Shall Never Return, *Kantor's theatre, as we read in your 2003 text* Noch ist Polen nicht verloren [Poland is not yet lost], *offered you the 'most wonderful moments of my life': 'Poland is a work of art—Tadeusz Kantor the artist. Kantor, the loser. Art just barely survives. Kantor was always about to fail,* 'Qu'ils crèvent les artistes' [Let the artists die]. *Failure means: reaching the highest level . . . He set Cracow out in the world, in Brooklyn, Paris . . . and much farther afield until the end of the night, in the ice-cold firmament as Berenice did her hair . . . There's nothing comparable. You'd have wanted to linger with every moment of the production. It took such liberties, you stopped asking why some things are and why many more things are not, you no longer asked what it meant because the nonsense was so wonderful. People wanted to put him on the same line as Dada. But he went much further. Long after the urinal was returned to the public lavatories, Kantor remained as a spirit hovering over the waters.'*

I believe Kantor's theatre is absolutely the greatest. It goes up to the edge, right to the edge of the completely ridiculous. His theatre is an uncanny tightrope walk. At any moment you can step into the void. It's what I call tragicomical: representing the absurdity and meaninglessness of the world. Kantor is, for me, the greatest example of tragicomedy. Even more so than Pina Bausch and whatever else there is in the theatre.

Kantor's theatre is the best encounter with theatre for me, too. I've never seen such marvellous productions since.

There are many artists who have been inspired by Kantor, that's clear, but never more so than by Kantor.

Near the end of his life, Kantor wrote that you only have truth, holiness and greatness when you are willing to expose your life shamelessly.

That's the shamelessness of Bataille, if you'd like. Kantor's shows were also obscene in a certain way. When I think of the cleaning woman who mops the floor in *Wielopole, Wielopole*—there's a Bataillian obscenity in that scene.

Did you know Kantor's actors personally?

Every time Kantor was directing in Paris, I travelled there from my studio. After the play, I'd spend the entire night with the actors.

We talked about happiness this morning. You said that all progress and all accumulated knowledge are no help or are only very little help in finding happiness. You also asked how it helps us to know that the earth is a sphere and not a disc.

I sometimes wonder what it would be like if the earth were a disc. How would I feel then? I don't think much would be different. We know a few things about black holes, about the theory of relativity, about quantum physics and astrophysics. We know a few things, but actually we know nothing. What was there before the big bang? Now there's a theory that there were many big bangs: after the universe expands, it collapses again into an enormous black hole, then there is another big bang, and so on. There are so many theories and the theories only describe a lack of knowledge—they describe nothing but our ignorance. I sometimes have the feeling that progress runs alongside us, that it has nothing to do with us. It runs alongside us and we're very interested in it. I read reports about discoveries in astrophysics, I like reading them very much, I read it all, I consume it, but I have the feeling that, at the core, it has nothing to do with me. In fact, it's entertainment.

Reading about the latest discoveries in astrophysics does affect your painting.

But the new discoveries only tell me that I know nothing. All of science, all progress in science, in technology

tells me only how defective I am and that I don't know how inhuman I actually am, how inhuman man is.

And what does that have to do with you at the core?

I can't access my core. I can't access the law that fundamentally holds the world together. It's a vacuum. It's nothing.

And beauty?

Beauty is the bugbear that is trotted out in front of me. That's why I keep running ahead.

Chekhov once used the following image to answer the question of what the meaning of life is: it's as if one put a carrot on the end of a pole and, while riding, held it in front of the horse's nose. Would you see it that way?

Absolutely.

Death, for you, is like a big bang?

In the moment of certain death, when you know that you are dying, your entire life runs before you like a film, from childhood to the present—it all passes. What took days, passes in a few seconds. That is a strong concentration, a concentration of time as preceding the big bang. Death is thus like a big bang. The transition to the disintegration of the atoms. It's as concentrated as in a black hole. Your entire life is so compressed into

one second that it disperses in an explosion, it expands. The atoms then go everywhere.

You're preparing for the moment of death with yoga?

Through meditation, you can reflect on that moment, you could also say you can prepare for transitioning into atoms once again. You can simply let time collapse. Time is flexible after all. You can perhaps already enter into death.

In what sense?

Because everything is meaningless, there's no sense to that either. We don't talk about meaning, we talk about what we do, even though there's no meaning (*laughs*). During a long meditation, I had the powerful experience of lying on many large poles, like marionette poles from underneath, of lying between heaven and earth and slowly sinking towards the ground.

This experience is expressed in the paintings in which you're depicted lying on your back: in which there's a rising and falling, in which you are sitting or lying half-way up a tree like a shaman?

Yes, exactly. Now we really are at the end (*laughs*).

Barjac, 11 November 2008

AN OPENING ONTO VASTNESS:
ONTO THE STEPPE AND THE FIRMAMENT

Mr Kiefer, you were recently in Abu Dhabi and there you saw how a new island is created.

At the moment you only see water and sand. Sand is dredged up from the bottom of the ocean with ships, pumped onto land with water and with hydraulic pumps, it's brought to the island. Sand is the material for the island. I don't know how many million cubic metres of sand are brought in to create the island. When I visited Abu Dhabi, I was fascinated by the Faustian activity there—it reminded me of the last part of *Faust*, of *Faust II*, when Faust is at his end and he hears the sound of a hammer and a shovel. Faust claiming land from the ocean. He says: 'I hear the clink of spades, how happily! / It's my men busy at their digging, / The land and water reconciling / By fixing for the waves their boundary, / Confining in strict bonds the flooding tide. [. . .] Use every means / To round up more and more construction gangs. / Encourage them with smiles, drive them with curses, / Pay them, impress them, promise them prizes. / Daily let me have a full report /

How far along with the ditch the men have got.' And Mephistopheles answers very cynically: 'From the reports I receive, / It's no ditch, it's a grave.'[1] It's a grave for Faust. This Faustian project, reclaiming land, made a deep impression on me. In the Bible, when anything particularly impressive is depicted, for example: when the apostles are instructed to proselytize throughout the world, it says: 'I will fill every valley and level every mountain.' Geology is taken as an image or an analogy to portray an activity beyond human powers, a plan that exceeds man's means.

Belief, as Jesus teaches his disciples, can move mountains. In the Gospel of Matthew it says: 'For verily I say unto you, if ye have faith as a grain of mustard seed, ye shall say unto this mountain, Remove hence to yonder place, and it shall remove; and nothing shall be impossible unto you.'

There's also the ancient Chinese legend *Yugong Moves Mountains*, which Mao reinterpreted for his political purposes. The legend tells of a man and his sons who must move mountains. Another old man tells him that it's impossible, but Yugong begins to chip away at the mountain and carry basket loads away to another spot. The commentary states merely that at some point the

1 *Faust, Part Two* (Martin Greenberg trans.) (New Haven, CT: Yale University Press, 1998), pp226f.

mountain will, in fact, have been moved. All religions have made use of the idea of moving mountains.

Will you put up the Seven Heavenly Palaces *installation in Abu Dhabi?*

It's not completely clear yet because they're busy with other things at the moment, like building a golf course and a Formula One racetrack. But they'll also build museums and will want artists' works for them. I think I'll build towers in the desert like the ones that are standing in water here in Barjac. The dunes will come and cover the towers and at some point the towers will no longer be there. There are enormous dunes not far from Abu Dhabi. You drive two hours to reach them. The area is called the Empty Quarter and there are dunes 300 metres high there. I envision building 20-metre-high towers in the Empty Quarter. And a dune will slowly creep over the tower. That must be wonderful.

And the towers will reappear when the dune has moved on.

The dune will wander through the tower—I picture it as very beautiful and the realization of this idea is what I find most interesting. But we're not that far yet. Right now, they're still busy with Disneyland. These days everything is like Disney.

The United Arab Emirates have undertaken a significant opening to the West.

Culture usually has a political background when the state takes charge. I believe they want to prevent the Americans from dropping bombs there. The Emirates are a very small country with a population of about 4 million. The Americans could take over Emirates because 10 per cent of all oil reserves, if not more, are in this land. If they build museums, Western museums, the Louvre is already there—not as a material museum but as an idea—then it won't be so easy to drop bombs on it.

In that case, art would be a protective shield.

Yes, art is a protective shield. That makes think of an old story. In the Middle Ages there was a war between Muslims and Western military commanders. All of a sudden, the Western commanders made tents from paintings. The Muslims were so appalled, they retreated. A fabulous story. I don't remember what the paintings were of. They probably took them from churches. They didn't have any more canvas and so they made tents of the paintings—there too art was a protective shield.

How do you plan your works? Paul Klee went about it like the construction of a house—from the bottom to the top.

I like the design to be kept fluid. I worked that way in Barjac, too, and with the buildings I constructed here. It was all primeval forest here. I went through the area,

mowed everything down and drew the plan for the house with stones. That's the most beautiful moment. What follows is always disappointing, but the beginning is the most wonderful part. That's why I like Abu Dhabi so much. The island that is being created is the very beginning of something special and all further concretization will be a disappointment.

The disappointment also comes, as Proust once put it, when a wish cannot be fulfilled immediately. In order to avoid disappointment, the fulfilment must follow immediately on the wish itself. The time that elapses between a wish and its fulfilment changes the one making the wish.

Not only that—a wish is never instantaneously fulfilled, the wish and the fulfilment never correspond. The idea of what it is you want never corresponds to what you get. The towers' foundation is lead. In Japan, lead was used for a long time to protect skyscrapers from earth tremors, so the tremors would be absorbed. At first, skyscrapers in Japan were built on lead foundations. The lead offsets the shocks from the earth, softening them somewhat. The lead between the levels in the *Seven Heavenly Palaces* softens the shockwaves and gives the concrete, which is completely brittle, a softer moment.

Between the individual levels of the Seven Heavenly Palaces, *there are lead books to give the towers stability.*

Flexibility. But for me there's an ideological reason: lead is a fluid element. Concrete, by contrast, is the metaphor for brittleness.

When I was walking through the premises of your studio in Barjac, I had the impression that there's a coincidentia oppositorum, *a coincidence of opposites, in the materials you use*: *the fluidity of the lead and the rigidity, the brittleness of the concrete, a* materia oppositorum.

Exactly, a *unio mystica* still interests me deeply, as does paradox. Lead is a fluid medium. It takes very little energy to melt it: lead turns liquid at 350 degrees. Lead also wanders. I don't know of any material like it—where a building is heavier below than above (*laughs*), that is, something has shifted, has liquefied. As for my towers: the idea of wandering in the *Seven Heavenly Palaces* is of an initiation journey. It's also incorporated in the elements the containers are made out of. The container is the symbol of globalization, the transformation of capital into something liquid, into something that is no longer solid but absolutely fluid, transformable. Capital, money is a medium of change. It is constantly changing. When I exchange something, it changes by means of money.

People also say: *Are you liquid?*

Yes, people say that, too, having liquid assets. We're seeing now how much it can change from one day to

the next with the collapse of the hedge funds and derivatives. How did we get to the topic of money? From containers and liquid lead. The foundation of the *Seven Heavenly Palaces* towers isn't just lead but also books made of lead. The books say this is not a tower, it's a tower of towers. A tower of history. The foundation of the towers is millennia of knowledge.

How heavy is one of the lead books you use for the foundation and intermediate levels of the Seven Heavenly Palaces *towers?*

Between 200 and 300 kilos.

And how heavy is a concrete section?

Seven, eight tonnes. I bought the crane that lifts these sections in Spain, a beautiful, old crane that is extra wide. It took three days for the crane to get to Barjac. Toni, one of my co-workers found it at a used equipment dealer's.

The square structure of the concrete sections represents the model of Cartesian thought. The lead books, on the other hand, are the soft, liquid element.

The two materials can be distinguished in two ways. Lead is something very flexible. The state of lead is always a liquid one. In the early 1980s, I bought the roof of the Cologne cathedral. I was told that, over the centuries, the lead plates had become heavier below than

above. Lead always flows inwardly, the molecules are not fixed, they flow downwards. The lead of the 1-by-2-metre plates is thicker and heavier below than above. Lead is a fluid material. Lead itself is metamorphosis. The alchemists saw it that way too. Lead is the raw material of gold and all the processes that they use. Because in my work the lead is in book form, it is more protean than a concrete block which is rather erratic and not at all multifarious. Incidentally, all the concrete sections are taken from containers. I shoved two containers together and poured concrete in the middle. It's the work of a sculptor: you make a form and pour concrete in it.

Cartesian thought works more geometrico. *Were you shaped at all by such thinking?*

The right angle has determined our culture. It brought us progress. There's the famous sentence: Nothing without reason. *Nihil fit sine causa.* Everything can be explained, everything has a reason. It's the ancient Western principle: nothing that is exists without a reason.

For Martin Heidegger, the question 'Why is there being at all, and not nothing instead?' is the fundamental question and it determines his philosophy from the beginning.

Heidegger wrote an entire lecture in which he discusses the '*Satz vom Grund*', the famous *Satz vom Grund* [The Principle of Reason].

Did building the towers always start with lead books?

Yes. I built two towers in the courtyard of the Royal Academy. There were strict safety regulations, fifteen people performed structural calculations, but here I don't do any calculations, I do it by feel. Not one of towers has fallen yet, unless I wanted it to. I made three towers fall, one for the Grand Palais.

How many tonnes is one tower?

Each unit weighs 7 to 8 tonnes, for a big tower that makes about 120 tonnes. With the books. There's also the concrete slabs for the levels.

How did you make the towers fall?

I fastened a cable around it and gunned the crane when I drove away. I tried it with dynamite first but that didn't work so well. You can't use much dynamite in peacetime—it causes trouble with the neighbours. There are shots of the tower falling on film. First it hesitates a bit and then topples—a wonderful moment. I fastened the cable around the tower way down by the base. I almost pulled one of the bases away. The crane is very powerful.

Walking through the premises yesterday, it seemed to me as if the towers were swaying in the wind.

Or as if they were about to collapse. I checked the balance exactly: the towers are *on the edge.* If you look at a particular tower from the side, it's astonishing even today that it doesn't fall.

How are your towers fastened?

Before, Alain used the hook of the crane. That's his work, he loves it. He did it to all the towers. At first, we didn't have the proper equipment which comes from America. Now we can release the hooks from below. Alain was always having to get on the hook.

One of the towers stands in water. Water makes it a paradox.

I created a basin that holds water. I built the tower in the basin so that the tower could be mirrored below into infinity. Water is also a mirror. It's beautiful when you can not only climb up but climb down as well. The tower descends exactly as far as it rises, which is very interesting with regard to the *Heavenly Palaces.* The initiate who makes his way through the *Heavenly Palaces* is also descending into the depths. He journeys into his own interior—into the microcosm in the same way as into the macrocosm. The microcosm is exactly as large as the macrocosm. With a suitable electron microscope, you can still see particles at 10 to the minus 17 power. Going inward as far as outward. That's a reference made by the tower standing in water. Because the tower

is mirrored in the water, it goes downward. The tower has intermediate floors that are perforated. They allow you to look into the sky and into the water.

One of the towers has a concrete section on top with a door frame: it's like a gateway to heaven, you can go through it.

This opening is also connected to a shock. I was on an island off the Amalfi coast. I went into a house and through the window I saw only the sea. The window was filled with the sea. It could just as well have been the sky. That was like a shock: that you had a frame or an entry straight to the sea. Wonderful. And it's the same with the towers on the grounds of Barjac: the concrete frame makes the sky a subject.

When I saw a boat way up on one of the towers, it looked to me as if the boat had been stranded in the sky.

Yes, or when you see it in a completely mythological-practical way, it's Mount Ararat where Noah's ark was stranded. You can interpret the boat stranded in the sky in different way. It's true that one thinks less often of Mount Ararat here than of a sky ship. At Christmas, in the Catholic Church, they sing a hymn that dates from the Middle Ages: 'A ship is coming laden to its highest board bearing God's Son, full of grace, the Father's everlasting Word. The ship goes quietly into dock, it carries a precious load; the sail is Love, the Holy Spirit the mast.

The anchor clings to earth, there is the ship at shore. The Word has for us become flesh, the Son has been sent to us.'

The ship in this hymn is an image for Mary, bearer of the coming salvation. Jesus' birth is spoken of as God's parturition.

The ship is associated with the sky. It's a real *Niederkunft* [parturition]—a beautiful word. When you live abroad, you have a different access to German words. *Niederkunft* is an. especially beautiful word, meaning birth, arrival, future. It's also a paradox that a ship is sitting on a tower. The ship is quasi sailing in the sky, and so it's a sky ship. Not a sky vehicle. It's interesting, of course, that a boat, which usually sails over the sea comes down from the sky. It's like the shamans who choose a tall tree. They sit halfway up the tree to be between heaven and earth.

Rituals have great importance in your work.

Yes, because rituals are often tied to mythology. They often come from mythological stories.

The idea of time that circles back on itself is tied to this.

Yes, in some rituals there's the concept of circular time. Even repetition is a thing people trust will continue.

Repetition banishes fear.

Through rituals, one can win back some of what one has lost from that power.

In your acceptance speech for the Peace Prize of the German Book Trade, you talked about how each work begins with the experience of a shock. Were you working on the Seven Heavenly Palaces *when you experienced the shock of looking through a window and seeing only the sea?*

There is a shock at the inception of every work. With the *Heavenly Palaces*, when I was preoccupied with Merkabah mysticism, the shock was rather an intellectual one. The shock is repeated in the material.

Is the shock connected to something being seen or observed from a different perspective?

To coming upon something you hadn't expected. It's often a surprise as well. Or a recollection of something experienced earlier, when still living by the sea. It can be that, too. The experience of the shock disrupts one's previous perceptions and raises the level of attention drastically. And I believe a shock is always also the memory of something you don't remember in your head but in your cells, something you remember at a profound level.

The shock frees up access to this profound recollection?

That's right. I once spoke to a mountain climber who had come very close to death. He just missed falling but was saved. This is what happened: he was climbing a mountain with his brother. His brother fell, he was tied to his brother with a rope. His brother fell past him, into the depths. At that very moment, the mountain climber found a crack into which he could pound an anchor. He had to release the rope. He just barely saved himself. His brother was dead. In that moment—only seconds— he saw his entire life in shock. That is similar, a forced recollection.

A compressed recollection.

You can also say that this recollection alters time. Either something is crammed into a time in which it doesn't fit or time is stretched out. You can say that, too. I prefer to think that time expands.

When time is stretched out, a space is created, but when it's compressed, that space closes.

If time is stretched out, more occurs than usual: one's entire life happens. You could also say that it becomes concentrated like just before a big bang. When you're dying, you see your entire life again, it happens once more in a very, very brief moment. It is compressed into one point.

A point that then explodes?

The explosion is death. We humans don't explode, we're just suddenly gone. We're probably gone in death. We don't really know. Life concentrates itself in the seconds preceding death—one's entire life in a moment of time. The opposite of the darkness of the lived moment, truly the opposite of that.

Since you've connected the image of the big bang with death, one could imagine that something new arises: creation continues or a new creation emerges.

We don't know what happens. I can't speculate on that. I try occasionally, more and more often, in fact, to achieve the state in which I will probably be afterwards, that is, to feel as one with everything. To re-enter the atomic union from which I came.

Through yoga?

Yes, for example.

Have you ever had a near-death experience?

No, never. I once flew 20 metres into the air with my motorcycle after a head-on collision with a car. But I didn't have a death experience. I fell very softly, it was amazing. I was 25, 26 years old. I was driving like a pig and wearing a very thick winter coat. I'd stuffed newspaper under my coat against the cold, for insulation, and I had gloves on. I literally flew through the air. When I hit the ground, I had the impression of a soft

landing, as on a runway. I went up to a taxi with a customer in it. We exchanged addresses. She asked me: Aren't you dead?—No, no, I'm fine.—But you must have had a shock?—No, no. I told her the shock would come later (*laughs*). The woman was pale and sallow, she was completely beside herself. Nothing happened to me. Not even a scratch.

And no shock came later either?

No. Back then I was as naive as Siegfried. I couldn't do that today.

Did you always drive fast on your motorcycle?

Like a madman. I had the fastest motorcycle you could get at the time. I spent the money I received for the sale of 14 watercolours on the motorcycle.

Do you love speed?

I used to love it, but not any more. Driving that fast is absurd. Today I no longer drive at all.

Do you have an energy that always saves you?

In Christianity, they talk about guardian angels. I definitely had a guardian angel because I behaved so foolishly.

The theatre and opera director Klaus Michael Grüber was very interested in the Formula One Grand Prix.

A Grand Prix is so very abstract when you watch it on television. The racetracks are built like tracks for a toy-car set. Everything is secured, the corners are softened, there are gravel run-off areas. It's all rather abstract. There's no direct contact. I used to watch car racing. There were races on Schauinsland Mountain, not very important ones. I was very interested in the races when I was little.

At the end of 2008, you will leave your studio in Barjac.

Shots were fired into my houses several times.

Would someone try to murder you if you were to stay?

This area has something anarchic about it. The workers over there on the towers are like the horsemen, Castor and Pollux. The holes in this concrete unit were made for explosives. We wanted to blow up one of the towers. It didn't work very well. The concrete units only broke apart a bit. At one point, I wanted to bury a large amount of explosives in the ground and light it. We'd have got real bomb craters. Bomb craters are wonderful things.

Because there's an opening into the depths . . .

Have you ever seen any? You're younger than I am.

I was born in 1960.

75

By then there weren't any bomb craters left. The bunkers had rods sticking out of them to detonate bombs before they hit the wall. Sometimes the bunkers are shaped like cartridge cases, pointed on top, and rods sticking out. The bombs or missile exploded before it could stick to the wall. A preventative measure, because if the missile hits the wall, it has a lot more power.

In my impression, beneath the dress in your Argonaut *painting in the amphitheatre, an explosion is visible as if a bomb had hit.*

In the First World War, soldiers excavated trenches under the enemy frontline. They dug ditches and buried explosives in them, crazy amounts. The enemy didn't notice because the explosives were buried so deep. They lit them, leaving a huge crater on the enemy side. An enormous surprise. The First World War was the most absurd war of all. War is always absurd, but this one really was. After a year, the frontline retreated and was reconquered. Utterly absurd.

In the First World War, pilots followed regulations before they attacked. They didn't just shoot blindly.

It was different in aerial combat—it was like a chivalrous battle. In the Second World War, too, the Luftwaffe was a different organization—it was like a club. There were other codes of conduct. Look at the crane, it's

amusing when the braces come out of the sides to give it stability. If the Egyptians had had machines like this, the pyramids would look different but not more attractive, not more attractive. That's really the question with progress. What would our lives look like if the world were still a disc? There wouldn't be much of a difference.

You're asking what progress does for us?

In the play, *Life of Galileo*, Brecht's inquisitor is not badly drawn at all. Brecht showed a lot of understanding for the Church's side in that play. How much does a farmer's life change if he knows that we circle the sun?

We're now at the entrance to your crypt, which is almost finished. From the entrance, you can see several massive concrete pillars in the darkness.

That's an interesting direction, it leads nowhere. They've made a bit of progress in their work, they dug out some dirt. There's here a tunnel that leads to the big studio. If we were to break a hole open here, we could enter the big studio. Here everything is connected. And behind this spot there's another tunnel that leads to the lead room and into the large studio. The crypt is now being connected by tunnel to the lead room, the studio and the amphitheatre.

Like threads in an underground net.

Now we're coming to another tunnel. This one used to lead from the garden to the lead room. You know, the lead room with water. And now we're connecting the crypt through this block to the amphitheatre. We're connecting more and more.

The designation 'crypt' refers to a room that's beneath a church.

There are so many columns there—like a forest. The crypts in churches are often like forests.

People also used to hide in crypts when they were threatened, when a catastrophe befell them.

Yes. Sometimes you can find graves there. I'll arrange to be buried here. Maybe . . . if I don't find anything better (*laughs*).

Do you associate the crypt with the thought of your own death?

I finished this section here seven years ago already. Do you know how it's done? A huge hole is drilled into the ground and filled with concrete. It's like sculptural work, negative and positive. The earth is carted away and the column remains as a positive mould.

The space created with the massive columns is underground land reclamation.

Yes, E.T.A. Hoffmann and Novalis often discussed mining. A mine is always something metaphorical for them: the mine as world under the ground. But because in this world, underground, there are crystals and diamonds, you can also see a mine as an inverted starry sky. That made a big impression on me in Novalis' and E.T.A. Hoffmann's work. In the Hoffmann story *The Mines of Falun*, which was published early in the nineteenth century, a young and particularly hard-working miner falls in love with his boss' daughter. On the day before the wedding, he wants to go into the mine one more time before he's married. Suddenly he disappears. No one can find him, he's gone, therefore dead. The young woman doesn't marry but remains true to her fiancé even after his death. After some 50 years, the fiancé's corpse is discovered by chance in the mines. The young miner's body has been preserved. He looks like he's 20 years old. His fiancée has grown old, she's 70 or 80. She sees her fiancé, unchanged, as a young man. He is brought up to daylight and crumbles into dust. A wonderful story: when the form is visible in daylight, it cannot last—then it's over. And the shift in time is interesting too: the miner is preserved in youth and his bride grows old, saving herself for him—for the ashes (*laughs*). Adelaide, ashes of my heart. One day a flower will bloom on my grave, ashes of my heart . . . the song goes something like that. A sweet song, a bit kitschy. Who wrote it?

Beethoven composed the music in the late eighteenth century for an early Romantic poem. The last verse says: 'Einst, o Wunder! entblüht auf meinem Grabe, / Eine Blume der Asche meines Herzens. / Deutlich schimmert auf jedem Purpurblättchen: Adelaide!' [One day, oh miracle! a flower will blossom, / Upon my grave from the ashes of my heart, / and on every violet petal will clearly shine: / 'Adelaide!']

Sophie Fiennes filmed in the crypt when there was drilling there. She filmed the crypt in June 2008 and now it's already 100 years old.

That's another huge leap in time.

Things move quickly with me.

What do you feel with regard to time? Do have the sense that you are moving out of time?

I don't move away from my point in time. It's a conscious acceleration to get more from time.

As a follow-up to the filming for the construction of one of the Seven Heavenly Palaces *towers, I read a poem by Paul Celan last night called 'Unterwegs' [Underway]. You just spoke about being underway beneath the ground here, of the labyrinths, paths and tunnels. The poem goes: 'Mit unsern Ketten hebt uns nicht / die Nacht in ihre roten Stürme . . . / Was für würgende Wildnis flicht / Gitter in Türme, // die wessen Wolkenfaust zerschlug? / Nun ist ihr Ruhm wieder*

Wunde . . . / Schwester, vom Trost aus dem fremden Krug
/ wölkt sich die Stunde. // Aus wimperlosen Tümpeln weht
/ der Blick der Steppe uns entgegen: / Welchen zerschlägt
sie? / Welcher widersteht ? // Welcher wird Regen?' [Night
does not lift us / with our chains in its red storms . . . /
What kind of choking wilderness braids / grilles in
towers, // destroyed by whose cloud fist? / Now its fame
is raw again . . . / Sister, the hour is clouded / with solace
from the foreign jug. // From ponds without eyelashes
/ the steppe's gaze wafts towards us: / Whom does it
destroy? / Who resists? // Which become rain?]

The lines about the ponds without eyelashes is wonder-
ful, the image is fantastic. Ponds without eyelashes and
then the steppe—that's very good.

Yesterday, when you spoke about the wind that blows
through the towers, it occurred to me that the wind could be
blowing here over the grounds of your Barjac studio from
the steppe.

There's a certain directness when you say 'without eye-
lashes'. Heinrich von Kleist once said the following
about the effect of a painting by Caspar David Friedrich:
It's as if one's eyelids had been removed—because the
foreground is missing in his paintings. Conventional
landscapes always have a foreground: a repoussoir, a
cliff or a figure. 'Without eyelashes' is wonderful, a pond

leads directly to the steppe. This verse brings in the expanse and implies all of nomadism.

The image of the pond without eyelashes: a tower that stands in a pool of water in Barjac also leads directly to the steppe. And the wind from the steppe blows through these buildings, ruffles the water.

Howls through the houses, howls like wolves (*laughs*).

There's also a poem by Paul Celan about the steppe. Its last two lines are: 'Flammende Steppe—mein Mantel, mein Mut: / Zünde mein Bild in ihr ratloses Blut!' [Fiery steppe—my cloak, my courage: / spark my image in her helpless blood!] *I have the impression that your work is also a sparking: in the landscape of Barjac and into these underground spaces.*

The sparking is an initiation, a beginning. You ignite something or illuminate it. You can also light dynamite under a mountain which then goes flying and leaves behind a crater (*laughs*).

'Steppenlied' [Song of the Steppe] continues: 'Wer wird es sein, der die Schwüre auch hält? / Wo, sag, war Heimat, und was sag, war Welt? [Who will it be who also keeps the vow? / Where, tell me, was homeland and what, tell me, was world?] *Here, in this place, you've been very concerned with that last question.*

Where was homeland, what was world? *Heimat*, homeland, is something you carry with you. Homeland is not something that is bound to a certain location, which you leave and return to, but something you carry with you, in your memory. The Jews' idea of the diaspora has always interested me very much. Jews are essentially outside their geographical homeland but they carry their homeland with them, their rituals, their culture, their stories, and so on.

They also carry their metaphysical baggage.

They are underway with hope. They always have a hope, a longing, namely of returning to Jerusalem. 'Next year in Jerusalem!' The return to or the arrival in Jerusalem is something they always carry with them. You can also arrive elsewhere.

'Next year in Jerusalem!' is said during the Passover seder in reference to the coming of the Messiah. In closing your Frankfurt speech, you referred to a battle being fought over mankind.

It was Rabbi Eleazar who said that man is a piece at whose ends Satan and God are pulling and in the end, of course, God wins. As Messianists, they have to say that. For me, it's not clear. For me, the outcome remains open.

On the contrary, for you there is no eschaton.

No, there's no eschaton, no. That's an idea we came up with to reassure ourselves: that things are headed towards a goal and fulfilment—an idea Marxism embodied above all, namely, the end of history.

A classless society will be achieved through the escalation of the antagonisms between classes. It's a teleological perspective that envisions a good ending—an idea of paradise.

That's also the core of Communism. But Ernst Bloch draws a slight difference on this question. He says: this ultimate goal cannot be reached as a static goal, peace is an empty vessel, a vacant space, a completely vacant space that must be filled, with an idea, with work, with battle. Peace is not a state of calm, above all not deadly calm. Bloch once said that man can find help in nature. According to his view of nature, nature—like man—is something unfinished, nature itself is moving towards a goal that is unknown to us. Nature is itself unfulfilled but it longs to reach the goal. That differentiates Bloch from the other Marxists. It makes his theory more flexible.

To return to the idea of homeland, Bloch speculates that man everywhere still resides in prehistory and no one yet has had a homeland.

That's a daydream or even a dream. A homeland is a dream that does not exist. It only exists as a utopia, as a

distant goal, ultraviolet, Bloch says. The not-yet is the actual.

Your work resides in this tension, too.

I'm not someone who produces objects and says: Now they're on the market, now my work is done. For me, pictures are never finished. They sit outside in containers and wait.

Snakes are your favorite animal.

I'm most fascinated—and terrorized—by snakes (*laughs*). I've always had both a strange phobia of snakes and a strange fascination with them. I once bought a boa constrictor and put it in a large terrarium. I thought I could overcome that phobia. You can keep snakes as pets, like a watchdog. When you can tell them properly to go in the corner, they go to the corner. I could never bring myself to touch a snake. It was a catastrophe. Snakes are mythological creatures. In the Old Testament, there are constantly snakes, bronze snakes. And the miracle before the Pharaoh: turning a staff into a snake. The image of the snake has been engraved in our cerebellum from time immemorial. That's why we cringe when we see a snake. It's not a conscious reaction.

A while ago, you had snakes under the table in your library, though not live snakes.

No, they were stuffed. I'd like to keep a snake but I haven't come that far. I couldn't do it, snakes still terrify me too much. I'd like to have one as a pet.

The snake is also the animal for the underground space here in the crypt, for the labyrinthine paths, for the tunnel.

Fantastic. I hope they move in when I'm gone: a brood of snakes, yes, a viper's nest (*laughs*).

You once said that peace will be bestowed on man. In Sophocles' play, Oedipus at Colonus, *peace is a gift of the gods. Men can't give it to themselves. Through Oedipus' admittance into heaven as one of the gods, Athens is granted peace.*

There is an oasis of peace, in this world it's one. I don't believe peace is granted by the gods. Mankind has to work towards it.

It made me think that mankind is not able to achieve peace.

Yes, humans are incapable in any case. There are always attempts to establish a state between wars but it's never real peace. It's always merely a time in which that war is not breaking out. During the Cuban missile crisis, we came within a hair's breadth of nuclear war. It was truly very close. The Russian nuclear submarines were already in contact with the American submarines that were forming the blockade.

In The Book of Franza, *Ingeborg Bachmann describes how peace came to Austria. Four tanks rolled along the country road and enveloped two children in a cloud of dust. The point in time that Bachmann describes, spring of '45, is the time of your birth. When peace is established in Grüber's production of* Oedipus at Colonus, *dust falls from the flies and envelops the space.*

The connection is amusing. You could say that peace is a cloud of dust. Your sight is obstructed. The matter or the world is obscured, so you can no longer clearly see what's going on. You can't see the war any more. You create an artificial space of peace but it's never complete peace.

Like an emballage.

A disguise. War disguises itself—as peace (*laughs*). Dust is a disguise. Fog. All tanks have smoke grenades and can shroud themselves. It's a disguise that lasts a certain amount of time. You could say: war disguises itself as peace.

War and peace in your engagement with Velimir Khlebnikov: naval battles follow in a definite rhythm of 317 years or some multiple of it. Accordingly, the interval of 317 years would be the period of time a disguise lasted until a new war broke out?

Khlebnikov's work in particular shows the forced geometrization of the correlation of war and peace. It shows that there is no peace. Geometry shows that, after a certain amount of time, the next battle is guaranteed to take place.

You once told me about the war and that after war you had a very close relationship with your grandfather.

And with my grandmother as well. I grew up with my grandparents. Maybe my mother didn't really want me. She couldn't feed me. I almost died, I came very close.

Because there was no food?

No, my mother couldn't produce any milk.

How were you fed then?

At the last moment, some powder came from Switzerland. What was it called—milk powder? With the powder, things got better. I really did come within an inch of dying, I'd almost passed over (*laughs*). Grandmother was well past the time when she could produce milk. But then this milk powder came from Switzerland. It was probably Nestlé.

Your mother gave you to your grandmother—during the first years after the War?

She gave me away.

Your mother didn't love you?

That I don't know, maybe she loved me from a distance. I don't know, I wasn't with her.

Did you experience love as a child only from your grand-mother?

Yes.

What was her name?

Anna Foster.

Anna, like the mother of Mary.

There's *Anna selbander* and Anna *selbdritt*. Anna *selbander* is Anna with her daughter Mary and *Anna selbdritt* is Anna, Mary and the Christ child.

There's one painting with 'Anna selbdritt' on it in your hand-writing.

Through this I had a personal connection to this trinity, to *selbdritt*.

You described your experience when your grandfather died. Did your grandmother die after your grandfather?

She died in the 1980s, at an advanced age. I lived with my grandmother until I went to school. Once I started school, I had to live with my parents. I don't know why. They probably thought that since I had to go to school, I should be at home.

How was the beginning of school?

A catastrophe. The beginning of the downfall. Completely horrible—my entry into school was a disaster. You can see it in my drawings. When I was five, I drew houses like Paul Klee. Wonderful drawings. After starting school, everything was so fussy, so small, terrible, awful.

Did it have to do with your starting school or with the fact that you were separated from your grandmother?

Surely with starting school. School was never the right thing for me.

School was, in Tadeusz Kantor's words a 'dead class'.

The might not have been dead, but school was the attempt to extinguish my creativity 100 per cent. I believe they succeeded 50 per cent. I would be somewhere else today if I hadn't gone to school (*laughs*).

50 per cent is an extremely high percentage.

I did reacquire some creativity but it was a disaster.

Did you regain your creativity by working constantly?

I don't think I regained it. What's lost is lost. I would probably be somewhere else today, if I hadn't gone to school. Maybe I'd be Michelangelo—now I'm just Caspar David Friedrich (*laughs*).

How did you overcome that shock as a child?

Through dreams, I think. I dreamt of huge, enormous spaces. Where I grew up, I was very constrained, boxed in by the situation and by the architecture. It was all much too small for me, too narrow-minded. I dreamt of vast spaces and transported myself to another world.

An opening?

Yes. Today, fortunately, I have a studio where you can't see the walls. An opening onto vastness: onto the steppe and the firmament.

Your early life was very exposed.

Very unhappy, yes.

Barjac, 11 and 12 November 2008

FIRE ON BRANCHES, WINGS AND STONES

Mr Kiefer, today I'd like to speak with you about the meaning of fire in your work. Last time in Barjac, we spoke about lead, a heavy element on the one hand but also a soft, fluid one that changes and takes on another form. Fire has fascinated you from the beginning as much as lead. There's a painting from early in your career in which you are holding a branch that is on fire.

You mean *Mann im Wald* [*Man in the Forest*, 1971]. A forest of spruce and in the clearing stands a little man—that's me, a manikin in the woods (*laughs*). He holds a branch and it is alight. The forest has taken on the colour of the fire. Using several layers of glaze, the trunks are painted so transparently red that it looks as if they had caught fire from the small burning branch.

As if the entire surroundings were engulfed in the fire's glow, similar, in a different way, to Turner's The Burning of the Houses of Parliament, 16 October 1834.

The forest becomes a conflagration without being consumed by the fire. That's the old idea of a fire: it burns but doesn't incinerate. That touches on the story of the

burning bush in the Old Testament—a fire that doesn't consume. With book burnings, it became clear that books don't burn well. I often burned books earlier, to use them in paintings and sculptures. It takes a lot of energy to burn books. The outside burns but the inside is preserved. That's why, in previous centuries, they were careful to tear books apart before burning them.

In the Old Testament, fire also always had a life-giving and life-saving power. When fire doesn't consume an object, as is the case with the burning bush, it's understood as a sign of God's presence.

The Bible couldn't manage without fire. It signifies construction, inspiration and enlightenment, but also devastation. Sodom and Gomorrah burn. Yahweh leads the Israelites—as a column of fire or a column of smoke. The column of fire in the desert is wonderful, a fantastic thing. The column of fire can't be located because it moves. For the old Germanic people, Loki was the god of fire. Loki, the brilliant one, the intellectual, who has no fixed standpoint, who moves here and there. Robert Walser says that truth wanders, it has no fixed point. Consequently, it can be suspended.

Fire is associated with constant movement, a 'perpetual motion' as it's called in Ray Bradbury's Fahrenheit 451.

The movement of fire at the miracle of Pentecost: language barriers are lifted through the tongues of flame

that descended from heaven. Fire is always associated with erasing borders. When fire spreads, it crosses borders.

And when fire spreads, there's always destruction. An old order is reduced to rubble and ashes and a new one begins to be established.

The last fantastic destruction occurred at the end of the Second World War. After the war had been decided, the Allies, the English, especially the Marshal of the Royal Air Force Arthur Harris, head of the British Bomber Command, decided on bombardment. There were hardly any military goals left at this point. They selected cities according to which would burn best, to unleash a firestorm. It was necessary that there be a lot of flammable material, wooden houses. That's why Würzburg was burnt down even though the city was militarily insignificant.

The English followed the principle of area bombing in their air-raids. An entire section would be inundated with bombs to effect total destruction. The Royal Air Force sent 791 bombers in their first air-raid and more than 700 bombers were sent in the second and third air-raids that flattened Hamburg.

First exploding bombs were dropped to uncover the pipes, so that gas could escape. And above all, the water pipes had to be destroyed so the fire couldn't be put out.

94

It was strategic bombing. Arthur Harris was very proud that he knew how to create a firestorm. What did the Americans call their strategy in the Iraq War?

Pre-emptive strike and decapitation strike.

One tactic in the Iraq War was called *shock and awe* in order to make an impression. You can also feel awe before a divinity. You could almost call the last bombing raids in the firestorm *art for art's sake*. There was no longer any justification for those air-raids. And the civilians didn't rise up against the regime because they were busy trying to save what meagre possessions they had left. That was even a kind of occupation therapy. They had to run around constantly and rescue their things—they could hardly achieve the awareness that they could overturn the regime at the last minute.

Do you know the two Zurich lectures that W. G. Sebald published as On the Natural History of Destruction *(1999)? Sebald shows how little was written on the* Luftkrieg *in German literature. He reports that the firestorm in Hamburg rose 2 kilometres in the air, the water in the canals even boiled. The fire spread everywhere, it reached even the coal cellars. People were traumatized by the firestorms and became unbalanced. Sebald quoted a passage from Friedrich Reck's diary dated 20 August 1943. Forty or fifty refugees try to force their way into a train station in Upper Bavaria. A cardboard suitcase 'falls on the platform,*

bursts open and spills its contents. Toys, a manicure case, singed underwear. And last of all, the roasted corpse of a child, shrunk like a mummy, which its half-deranged mother has been carrying about with her, the relic of a past that was still intact a few days ago.'[1] Do you have memories of air-raids? You once told me that your ears were stuffed with wax so that you couldn't hear the roar of the airplanes and the explosions of the bombs.

My parents told me they put wax in my ears because I was terrified by the air-raids. Like Odysseus with the sirens. Donaueschingen was being bombed in March 1945, when I was born there. The neighbour's house was hit. When they emerged from the cellar, it was flattened. In our house, all the windows had been blown out. The heavy sewing machine lay in the street. No one knew how it happened. Funny, a sewing machine—an old surrealist subject: sewing machine-umbrella. The heavy Singer sewing machine lay in the middle of the street.

It's said that war gets into your bones. Do you have any memories of living through the war when you were a child?

I certainly did experience the war. I was born in the cellar, in the air-raid shelter. My father was away in the

1 W. G. Sebald, *On the Natural History of Destruction* (Anthea Bell trans.) (New York: Random House, 2003), p. 29.

war. My grandparents had to go into the forest during the day. They went into the forest with a wheelbarrow, to protect themselves from the strafers. At night they came back into the city and hid in the basement air-raid shelter.

Did your grandparents take you into the forest?

I assume they didn't leave me alone. That certainly leaves an imprint. Afterwards, I lived through the aftermath of the war. There were ruins, in Donaueschingen there were a lot of ruined buildings. As a child, you see the ruins but you don't attach any value to them. The ruins are simply givens—houses that are only half-standing, walls that are still standing with holes as windows. Because of that, ruins are for me a normal condition—nothing unusual.

In photographs taken of the bomb attacks after the war, you can see the grass is already growing back.

Spring that year was apparently a very fine one, in April '45 (*laughs*). That's what I was told.

Did it also have to do with the fact that the earth was torn up by the bombs and so the grass grew back greener than usual.

Of course, burning encourages aftergrowth.

In this context, I'd like to read you a passage from Sebald's study of the bombing of Hamburg on 27 July 1943 by the Royal Air Force supported by the U.S. Eighth Army Air Force and called Operation Gomorrha: '*The fire, now rising two thousand meters into the sky, snatched oxygen to itself so violently that the air currents reached hurricane force, resonating like mighty organs with all their stops pulled out at once. The fire burned like this for three hours. At its height, the storm lifted gables and roofs from buildings, flung rafters and entire advertising billboards through the air, tore trees from the ground, and drove human beings before it like living torches. Behind collapsing facades, the flames shot up as high as houses, rolled like a tidal wave through the streets at a speed of over a hundred and fifty kilometers an hour, spun across open squares in strange rhythms like rolling cylinders of fire. The water in some of the canals was ablaze. The glass in the tram car windows melted; stocks of sugar boiled in the bakery cellars. Those who had fled from their air-raid shelters sank, with grotesque contortions, in the thick bubbles thrown up by the melting asphalt. No one knows for certain how many lost their lives that night, or how many went mad before they died. When day broke, the summer dawn could not penetrate the leaden gloom above the city. The smoke had risen to a height of eight thousand meters, where it spread like a vast, anvil-shaped cumulonimbus cloud. A wavering heat, which the bomber pilots said they had felt through the sides of their*

planes, continued to rise from the smoking, glowing mounds of stone. Residential district so large that their total street length amounted to two hundred kilometers were utterly destroyed. Horribly disfigured corpses lay everywhere. Bluish little phosphorous flames still flickered around many of them; others had been roasted brown or purple and reduced to a third of their normal size. They lay doubled up in pools of their own melted fat, which had sometimes already congealed.'[2]

Incredible. Who wrote that?

That passage is from Sebald himself. Sebald quotes various reports, but there are hardly any literary descriptions of the Hamburg firestorm. When you look at pictures of taken after a bombing raid, you can see right through windows and doors. In the pictures, you see houses of which only the facades remain. Did the freestanding doors and windows, walls without any living spaces behind them shape the aesthetic of the Seven Heavenly Palaces?

Of course. You often see freestanding walls with windows in Caspar David Friedrich's paintings. He painted a lot of ruins. There's no structure left, just a facade with holes. That's philosophically very interesting: the border to infinity. Friedrich's paintings were done in the Biedermeier period and some label him a Biedermeier

2 Sebald, *On the Natural History of Destruction*, p. 26f.

artist, which is preposterous. You don't have a view of the sky from a gazebo but a view through a wall with holes in it. That's something else entirely than an open view of the sky, of course. When you usually look out a window from inside a house, you're in a secure space. When all you've got is a wall, you're no longer surrounded by a house. Instead, you're facing the wall like a philosophical symbol. That's something completely different. That's why Caspar David Friedrich's paintings of ruins are so interesting, even though they come from the eighteenth-century ruin Romanticism. Hitler had a taste for ruin Romanticism—he had the models for new construction in Berlin drawn as ruins from the start. The new buildings had to be designed to look good as ruins as well. Do you know Alexander Kluge's book *The Air Raid on Halberstadt on 8 April 1945*?

In the beginning of the book, Kluge describes a very bizarre and odd situation: a bomb has hit a cinema. The manageress doesn't let that get in her way. She cleans up the rubble and debris and does all she can to make sure the 2 p.m. showing can take place.

That need to obey orders doesn't exist any more. The defensive structures against the bombs still work. A major or a general insists on reaching a certain street, even though it's completely flattened because his sister or one of his children lives there. He uses military

command when he absolutely shouldn't. Through some detour or other, he finally reaches the particular street, the telephone is still working but no one in the cellar has survived. He knows the telephone still works but no one answers it. Kluge always brings out these kinds of details. Technically, the means of communications still work but there's no one left to talk to.

In your self-published book, Die Himmel [The Sky, 1969], *there's a page with a red square on a white background in the upper half. In the lower half you've written: 'The sky over a German city in flames, seen from the cockpit of an English bomber.' As I read Sebald's book in preparation for this conversation, I hadn't yet fully realized the vast scale of the firestorm.*

The firestorm was immensely important to Harris, who invented it. He was very proud of it. Harris was completely out of his mind. The firestorm was meant to demoralize the population but it had the opposite effect. The firestorm was terror. After the War, you couldn't talk about terror—after what the Germans did, that's clear. But firestorms are monstrous. There were descriptions of firestorms early on by a few writers. Arno Schmidt wrote about it.

Sebald claims that, given the extent of the trauma inflicted on the German people by the firestorms, there are relatively few literary accounts of them. Volker Hage, the literary

editor of Der Spiegel, *wrote a book called* Zeugen der Zerstörung: Die Literaten und der Luftkrieg [Witnesses of Destruction: Writers and Air War] *and edited the volume* Hamburg 1943: Literarische Zeugnisse zum Feuersturm [Hamburg 1943: Literary Reports of Firestorms].

The English started the bombing of Berlin and the terror attacks on German cities. Hitler responded by saying: We will obliterate them.

One Royal Air Force flight was broadcast on radio. You could hear the crew take off and fly towards Hamburg. The commentator saw a 'wall of searchlights, in hundreds, in cones and clusters. It's a wall of light with very few breaks and behind that wall is a pool of fiercer light, glowing red and green and blue, and over that, pools of myriads of flares hanging in the sky. That's the city itself!'

That must have been incredibly striking. Flames shooting up 2 kilometres. Horrible. Many people suffocated because the fire-storm sucked away all the oxygen.

In his interpretation of Paul Klee's Angelus Novus, *Walter Benjamin writes of a storm blowing from paradise.*

A storm from paradise that piles up rubble. But Benjamin could not have known about firestorms yet (*laughs*). The storm blowing from paradise is a kind of firestorm. In his propaganda, Goebbels said, 'Now,

people, rise up and let the storm break loose!' (*laughs*). That is horrifying.

When you also think of what kind of destruction occurred in the bombing of Dresden in the night from 13 to 14 February 1945, the heaviest bombing of any German city.

You could still understand that kind of bombing in 1943, but not in 1945. In the end, they really did seek out those cities they knew would burn well. A city's combustibility was the decisive factor. The stock of flammable material was more important than the military goal.

The director Peter Zadek, who emigrated to London in 1933 with his parents and his half-brother, once told me that the English were so angry at the Nazis that they said: More bombs on German cities—that's good.

Yes, it was revenge, certainly.

In his 1989 documentary film Architektur des Untergangs [The Architecture of Doom], *Peter Cohen shows how much the Nazis' plans were directed towards the end. You're no longer looking out at nature from an enclosed space but are yourself located in an open space.*

There is no longer any polarity of inner and outer because the inner was simply blasted away—it no longer exists. You could say the rearguard is missing.

You grew up with the feeling that interior space had been blown away?

When you look at a house with panes of glass in the windows, then it's something entirely different from looking at walls with holes in them. But these holes have become meaningless because there's no one living inside to look out of these holes. You could also say these holes in the wall are a reproduction of the world. There's no longer any inner space, from which to look out. Instead, you see arbitrary sections of the same infinity. In this respect, Caspar David Friedrich's paintings of ruins are very interesting, as are real ruins. I'm always fascinated by. photographs and films shot in 1945 from planes flying over the cities of Munich and Hamburg that have been reduced to rubble. You can see into the buildings. It's as if you suddenly have special powers of sight. From the plane you no longer see any roofs. That's fascinating.

Planes often appear in your work, small ones, too, if you think of your works on Jason and the Argonauts' journey to Colchis. Were images of airplanes that flew in the air-raids seared into your consciousness? War in various eras plays an important role in your creative work: Die Heereszüge Alexanders des Grossen [Alexander the Great's Military Campaigns, 1987/88], *the sea battles inspired by Velimir Khlebnikov, and the Second World War, to name a few of the military confrontations you use as subjects.*

That comes not only from my personal experience during and after the war but also from my education and cultural inheritance. After all, history is made of a series of conflicts, military campaigns, naval battles, and so on.

You reenacted a naval battle, a naval operation in a bathtub you found in storage. It was one of the zinc bathtubs allocated to the population during the Nazi era to promote hygiene.

I only learnt later that the bathtubs—like the Volkswagen—were part of the Nazi regime's programme. Every household was to have a bathtub. They were simple zinc bathtubs, not expensive. Everyone was expected to do something for hygiene. It was a programme for the entire nation. I found the zinc tub in the schoolhouse attic where I lived and worked at the time. The idea for *Unternehmen Seelöwe* [*Operation Sea Lion*, 1975] came from Hitler's attempt to invade England. It was a real problem for Hitler since he couldn't swim (*laughs*). They rehearsed the. landing in Ypern, I believe. Hitler didn't have proper landing craft. They took Rhine barges and poured a layer of concrete in the bottom to make them sit lower in the water and better protected against the waves, because there are no waves on the Rhine. They had to cross the English Channel, after all. Inspired by these exercises, I reenacted them in the

bathtub. Interestingly, it was a reenactment of an operation that never happened. Operation Barbarossa, the invasion of the Soviet Union, did take place. The invasion of England, on the other hand, did not. So it was doubly virtual: at one level because it was in the bathtub and on the other because the operation was never implemented.

You wanted to create the impression that gravity had been suspended, as if you could walk on the water that filled the zinc tub.

That was part of the *Heroische Besetzungen* [*Occupations, 1969*]. There's a joke from the time of the Third Reich: Goebbels, Hitler and another—probably Göring—take a boat out to sea. Suddenly Hitler steps overboard and sinks. They pull him back onboard. All Hitler says is: Then the other one couldn't either. Because of this joke, I said to myself: I'm going to practice walking on water. The story of walking on water in the Bible is a wonderful story, fantastic. The only one who filmed walking on water well—because it's hard to do right, it easily become kitschy and ridiculous—was Pier Paolo Pasolini in his movie *The Gospel According to St. Matthew*. I can still see clearly was Christ looks like in Pasolini—like a fata morgana. Pasolini caught that extremely well. My depiction of walking on water was completely naive: I put a footstool in the tub, filled it with water and stood

on the stool. I made sure you could see the stool in the photograph.

After the War, the zinc tubs were carried up to the attic. Was the zinc bathtub for you a readymade?

Millions of the zinc tubs were made back then.

You transferred these millionfold fabricated objects into the realm of art.

For me it was not so important that the bathtub be a *readymade.* I didn't use the bathtub as an *objet trouvé* the way Duchamp did. It wasn't a decisive factor for me that it was already made. I used the zinc bathtub because it was there. I could have used a different bathtub. Though it is amusing that it was that particular bathtub.

To return to the connection with the roof over fire. In one of your paintings, Vater, Sohn, Heiliger Geist [Father, Son, Holy Ghost, 1973], *we see three chairs with flames rising from them in an otherwise empty attic.*

There are three chairs with flames: the Trinity—Father, Son and Holy Ghost. The chairs are on fire but aren't burning, of course. There's also the painting *Quaternität* [*Quaternity*, 1973] with three flames and a snake. In that painting, Satan is contained in the concept of the god-head. There was a theological school of thought that declared that evil was also contained in God.

There are verses in Jeremiah that say: 'Is not my word like as a fire? saith the Lord; and like a hammer that breaketh the rock in pieces?' If God sees Himself as fire, does it mean that God is committed to constant transformation?

Yes, as mover, as transformer, as a constant driver. There are also verses in Isaiah about a word like a burning coal. It's in Isaiah's vision: 'And the posts of the door moved at the voice of him that cried, and the house was filled with smoke. Then said I, Woe is me! for I am undone; because I am a man of unclean lips, and I dwell in the midst of a people of unclean lips: for mine eyes have seen the King, the Lord of hosts. Then flew one of the seraphim unto me, having a live coal in his hand, which he had taken with the tongs from off the altar. And he laid it upon my mouth, and said, Lo, this hath touched thy lips; and thine iniquity is taken away, and thy sin purged.'

This is a God who is always melting and recasting something and touching mankind with His fire.

The Holy Ghost, in particular, is signified with fire. It is the one in the Trinity that actually governs everything. Christ was born from the Holy Ghost. And in the miracle of Pentecost are the tongues of flame of the Holy Ghost when the apostles are sent out to proselytize.

In your painting Ich bin, der ich bin [I Am Who I Am, 2008], *flames burst from the stones that are associated with*

the Holy Trinity. There are tongues of flame on the wings carrying a heavy stone in your painting Regina in caelum assumpta [Mary is Assumed into Heaven, 2008]. *In the painting* San Loretto (2008), *flames leap from a pair of wings. Again, the two wings are carrying a heavy stone. And when I visited you in your studio last year, I saw a painting with tongues of flame rising from several branches. Fire is an element that goes into many different areas and in many directions in your creative work.*

There are also several works with the title *Malerei der verbrannten Erde* [*Painting of the Scorched Earth*, 1974]. The scorched-earth tactic: when the armies retreat because they've been defeated or can no longer hold the front line, they burn everything so the enemy can't use it. That also means that the landscape is completely transfigured and is at first completely unusable. So fire has transformative power, too. Indigenous tribes in Brazil burnt, and are still burning, sections of the virgin forests in the Amazon to cultivate the fertile ashes. The virgin forests changed from a naturally growing forest into something cultivated and subservient to man. Fire turns the forest into ash, and the ash is again fertile ground. Ash is also a very mobile element that can be dispersed everywhere—it is carried on the wind like loess. There's the wonderful film by Andrzej Wajda, *Ashes and Diamonds*. Do you know it?

Wajda's film covers only two days, the 7 and 8 May 1945, on the last day of the Second World War and the first day of peace.

The film is about the communists who are regrouping. The connection between ashes and diamonds has always fascinated me. Ash is so light, it can be carried off by the wind. Diamond is the hardest thing in the world. One is dissolution in the wind and the other is the extreme concentration of hardness. Crystallization that is no longer flexible, that has become rigid. The title *Ashes and Diamonds* has haunted me since the film came out in 1958.

The rural district of Buchen was dissolved in the district reform, effective 1 January 1973. You refer to that in your work Das Ausbrennen des Landkreises Buchen [The Burning of the Rural District of Buchen, 1974].

I suffered a great deal in that district at the time because it was the area of Germany that was most underdeveloped. It was still supported by the European Economic Community. I believe I can also say that the region was very fascist in the 1930s. I did some research into it. A synagogue was burnt down there and so on. I suffered a great deal in the district. I wasn't respected at all. I had nothing. I was an artist—that means nothing. From that feeling of not belonging, of being excluded and rejected, I created the *Burning of the Rural District of Buchen* books

and through that, a radical reshaping of the district. That's what was meant. But the funny thing was, the mayor of Buchen interpreted it completely differently. He thought I made those books because the district had been merged with the District of Mosbach through an administrative reform. The mayor thought I was angry that Buchen's charter had been rescinded. That hadn't occurred to me—I couldn't care less if Buchen was an administrative district or not.

Another thing associated with fire is the firing of bricks. In your studio today I saw a painting in its early stages of countless bricks.

Fire—aside from its philosophical, esoteric or spiritual dimensions—is the beginning of civilization. Once man tamed fire, he was able to cultivate crops. We don't know exactly if man got ahold of fire from lightning striking a tree and setting it on fire. Everything began with that—and with it came the ability to create something durable: cuneiform writing, vases and also bricks. My paintings are based on photographs I took in India where bricks were still fired in a completely primitive manner. A building is constructed with air channels. Then a fire lit inside it fires the bricks for days or weeks. The bricks are then used as bricks and in the process the factory is dismantled. Not like here where the fired bricks come out of the factory and new bricks are taken

in. The bricks in the firing house are the factory itself. In 1994, I crossed China on the Silk Road, but along the lower route. The upper one is accessible to tourists, the lower one was not because, as I later realized, many of Mao's prisoners still lived there. They were housed in the desert and ran around in chains. In one particular area, we came upon remains of brick factories every 30 kilometres. Mao had roads in this region built with bricks. Naturally that was, like so much else, an insane idea because bricks don't hold up in roads—they soon break down again. At regular intervals you saw pits where clay had been excavated, where the bricks had been fired and the roads built. There was a new factory for every stage of the road.

And so new spaces were always being made.

You can also say that as the road grew, new milestones were created where the bricks were fired. I saw these brick factories in China, and in India they still fire bricks this way. I've always been fascinated by bricks. In the 1970s, I found a book called *Der Normziegel* [*The Standard Brick*] in an antiquarian bookstore. In the past, bricks in German states, regions and counties were all different shapes and sizes. At some point they decided to establish a standard brick, the advantage of which, of course, is that all bricks have the same proportions. A brick is something very interesting. Earth is malleable, it's

sculptural and when fired, it becomes fixed. Then you can use it to build churches, houses, bridges, everything.

You have reddish painter's palettes that

. . . are made from fired clay . . .

. . . and have broken into pieces . . .

. . . shattered—shattering: art is fragile, the idea of art is. First, it's difficult to define what art is. And second, art always seems about to perish. Every new movement in art has wanted to nullify, to destroy the preceding one. The Futurists even wanted to bomb museums.

Filippo Tommaso Marinetti exhorted, 'Set fire to the library shelves!' in his Manifesto of Futurism *published on 20 February 1909 in* Le Figaro.

Yes, of course (*laughs*), this call comes from the fact that art always wants to supersede itself, to destroy itself. That's why art is incredibly fragile and difficult to establish. It's not easy to bring art to a standstill—it's always in motion.

Where does this self-destructive impulse come from?

On the one hand you want to make something permanent, establish it, as a kind of reassurance, to surrender to the illusion that everything will stay the same. But we

know deep down that nothing stays the same—everything is always changing, at every moment. The universe is constantly changing. New stars are being born, others are collapsing into a black hole, and so on. It's preposterous to say that nothing changes. And art—as one of the nearest manifestations of the real driving force—naturally must particularly reflect this process of alteration. The moment art is recognized or established, the will, the desire to abolish it again springs up immediately.

And that's why the National Socialists came up with the idea of producing a fireproof sublayer for painting, so they wouldn't burn and could be preserved for eternity.

I was always deeply intrigued by the idea that the Nazis invented a fireproof foundation for paintings—completely insane (*laughs*). The pictures painted in the Nazi era have all been dismissed, no one wants to see them, they aren't even art. I looked through the paintings in issues from the entire span of the magazine *Die Kunst im Dritten Reich* [*Art in the Third Reich*] and didn't find a single picture that has endured in any way. It's different with the architecture, there were interesting achievements. None of the fireproof paintings have survived. I don't mean physically but intellectually and spiritually. No one's interested any more.

In the Nazi era, there was a particular way of referring to fire, especially in folksongs, like Flamme empor [Flames Rise Up], *book burnings.*

Not just during book burnings—after coming into power the Nazis, organized torch parades through Berlin. Torch parades at night have something spellbinding about them. Or leaping over fire at the solstice.

The fire on Johannis-Nacht, the eve of the summer solstice, is associated with a change in people. When jumping over the fire, the following saying is pronounced: I leap over the fire and become another.

Yes, of course. For the Nazis, this cult of fire was also a return to the past. They wanted to eradicate Christendom. They believed Christianity was a false path, that Teutonicism predated it and was the proper culture. They also believed that Charlemagne was the greatest criminal.

Because of the Christianization?

Yes, Christianizing the Saxons, and so on. The Nazis had the idea that the Teutonic people, the Aryans from Atlantis, had survived and that Christianity had merely covered and dried out those roots. Atlantis is a nice idea but the way the Nazis used it, it immediately turned an autochthonous brown.

The Nazis wanted their ideology to spread throughout the world like fire. Like a light, a fiery glow that would create a new race of men.

Other important words for the Nazis were purity, purgatory and purification through fire.

Since you just mentioned purgatory: in one of Epistles of Paul, men are tested by fire to see what will remain of them at the end of days.

Or in trials by fire you had to walk on burning coals. That existed previously. Christianity adopted the practice. The story of the youths in the fiery furnace from the Book of Daniel in the Old Testament is another such test: you have to withstand the fire, survive it. That's the idea.

Is this idea also an image for your artistic work?

Fire is absolutely a medium, a material for me. I often burn off the top of my paintings and paint on the ashen surface. I start over again. I can't imagine creating anything without fire.

The reddish material on the lower part of your painting displayed in the Louvre, Athanor (2007), *looks like it was burnt.*

It's a thick layer of clay that was dried with powerful flames. That's why it has cracked fissures like the ones

you see in the arid parts of the Sahel. There you see cracked earth everywhere.

The painting shows you lying in savasana, the corpse pose in Hatha yoga, on fired ground.

You can also say it's ground that has been made porous by fire. The ground is permeable through these fissures. It also reveals deeper layers. Like crevices that extend all the way to the centre of the earth, where you reach the lava, the magma.

These crevices are filled with liquid, with media or materials of transformation. The Athanor *painting has three sections.*

Yes, they're the three steps in the alchemical process: on the bottom is Nigredo, that's the lead age; then it's Albedo, that's silver; and finally Rubedo, that's gold, red-gold. Those are the three steps in the alchemic process of turning lead into gold.

The alchemical process is powered by fire.

By the alchemical furnace. The furnace plays a central role in alchemy—the oven in the *hortus philosophorum,* in the *hortus conclusus.*

In a wall niche to the right of the Athanor *painting there's the sculpture* hortus conclusus.

That has thirteen dried sunflowers, the thirteen gates to the *hortus conclusus.* On the opposite side of the room

there's the sculpture with the lead books from which a sunflower rises. It drops gilded kernels, seeds. It's an allusion to Danaë. Danaë is a Greek myth that Christianity adopted. Mary was made pregnant by the Holy Spirit. It's a similar situation. In Ovid's *Metamorphoses*, it was a golden shower. Gold as the very spiritual substance that falls and impregnates Danaë. And in Christianity, according to John the Evangelist, it is the word. A spiritual activity is also involved.

The word of God acts like fire that steers a process in a completely different direction than expected.

And the word can manifest itself and become flesh, creating something new in the world: 'In the beginning was the Word, and the Word was with God, and the Word was God. The same was in the beginning with God. All things were made by him; and without him was not any thing made that was made.' That's the prologue to the Gospel according to John.

Are you moved by the idea of a conflagration at the end of time?

Yes, sure. This idea can be found in all cultures. In Norse mythology, the *Ragnarök* relates the history and the downfall of the gods at the end of the world. The Teutonic people also believed in a great conflagration at the end. The Midgard Serpent sprays its poison and sets

the air and sea on fire. These end-of-the-world scenarios are everywhere.

The end-of-time conflagration has the function of testing man's essence. In the final conflagration, each person's essence is burnt out of him or her. In 1 Corinthians 3:12–15 it says: 'Now if any man build upon this foundation gold, silver, precious stones, wood, hay, stubble; Every man's work shall be made manifest: for the day (of Judgement) shall declare it, because it shall be revealed by fire; and the fire shall try every man's work of what sort it is. If any man's work abide which he hath built thereupon, he shall receive a reward. If any man's work shall be burned, he shall suffer loss: but he himself shall be saved; yet so as by fire.'

In Christian mythology, a distinction is made between those who were good and those who were evil. The conflagration will divide the two groups. Fire as division. In addition, the fire is there to bring out their essence: to burn away everything superfluous from one's spiritual essence.

In Virgil's Georgics, *fire is credited with baking out blemishes and sweating away useless moisture.*

Yes, the false paths, the mistakes.

We spoke about book burnings. Acts 19:19 tells how the Ephesians who had been converted by the apostle Paul burnt their magic books.

I found that fascinating. As a child or in school, I'd always heard of the Nazi book burnings. At first I didn't know that the Christians had done the same. They simply wanted to burn all other views or truths. I first saw a painting of a book burning in the Louvre, done by a painter whose work is not very well known. In the upper part of the painting sits Saint Anselm—there are two Saint Anselms. He's holding books in his hand and below are the heretics, all contorted, whose books are burning. In this case it's centred on one question—they want to prove that Mary was not a virgin (*laughs*). And these books had to be burnt. It's interesting that Christianity also resorted to burning books. There's hardly anything new under the sun. The Nazis actually just took over the book burnings.

Book burnings have a long history. It begins with Augustus in the year 12 BCE and extends throughout Europe. The Austrian cultural historian Hermann Rafetseder speaks of in this context of 'book executions'. The book burnings were conducted with a certain amount of ceremony. In Madrid, the books slated to be burnt were loaded onto a donkey. The animal was preceded by drums and trumpets and, behind it, marched the executioner. When they reached the square, the books were thrown into the fire. Rafetseder also cites examples of book burnings in England and France, and documents how the burnings continued after the war. American comics were burnt in East Berlin— a journalist found a

charred Mickey Mouse comic book among the ashes. The Americans and their comic books were seen as the evil that had to be incinerated. In Düsseldorf in the mid-1960s, young evangelical Christians burnt books by Albert Camus, Jean-Paul Sartre and Günter Grass.

The mid-1960s—unbelievable! (*laughs*). Outrageous (*laughs*).

In America, Wilhelm Reich's works were burnt.

As pornography?

In America, there were always book burnings now and again and President Eisenhower called for them to end by saying: 'Don't join the book burners.'

Eisenhower didn't want it because it went against America's democratic self-image. St Paul's Cathedral commissioned two large paintings from me. And I'll make one of them a book burning. In book burnings, it's very clear that fire contains the idea. Not one of the books that the Nazis burnt disappeared. On the contrary, the books they didn't burn are gone. Perhaps you can say that burning helps.

You could see it as a trial by fire.

Yes, a trial by fire (*laughs*), yes, that's the real meaning of a trial by fire: separating the wheat from the chaff,

however that's not how the Nazis saw it, rather under different auspices.

One interesting aspect of book burnings is that the books could have been destroyed in a different way: they could have been pulped.

Or thrown into the sea or submerged in water. That's much more effective. Then the books really are destroyed. Fire can't harm books as much.

When books are thrown in water, it's called 'book obliteration'.

Practically speaking, it's much more effective than burning books.

The worry with book obliteration is that someone might fish the books from the water and dry them. Then the contents of the proscribed writing could be recovered and disseminated. That way the contents would be preserved.

A book burns along the edges and remains very legible in the centre. When a book falls into water, then the pages stick together. Water would be more efficient, but, of course, fire has much more symbolic power.

Because the book burnings are also staged as a spectacle that can be held with a great deal of pomp. It allows for the enactment of a visible sign within a community, sometimes burning the author along with the book was considered.

Burning brings associations with hygiene. Clothes and sometimes even entire buildings are burnt to stop infectious diseases, to burn away the germs and so on. One talks of fumigating the illness. The smoke they spread through the house was supposed to bring blessings. Incense was very important in church. When carolers came to sing at people's homes, they carried incense to return the house back to a healthy state. All the farmers had their smokehouses where they protected their hams from the fire by smoking them.

When did you come into contact with fire as a child?

I can remember being strangely fascinated by fire even as a child. I believe everyone is captivated by fire from the start. A three-year-old is fascinated by fire, wants to light it, to burn something, and so on. I see it all the time with children—it's an urge or a disposition that is simply inborn. Fire belongs to us, to our culture, to our imagination. We're obsessed with fire.

This obsession is tangible in your transformation of the Balder-Lied [The Balder Song, 1977–1988]. *Flames blaze from simple wooden poles.*

In *The Balder Song*, fire is tied to a secret as such. In the *Edda* it says: 'What did Odin whisper in Balder's ear when he lay on the pyre?' Balder lay on the pyre and was cremated or was in the process of being cremated. He

could no longer hear anything. Odin said something to a form that could no longer physically hear. And no one knows what he said. So it's a double mystery: Balder didn't hear it and we don't know what Odin said. But it's very important that Odin said something. Balder was the light god. He was the favourite of the gods. He brought light to the gods, he was friendly and loved by all. He was killed by Loki, who is himself a kind of fire and is associated with fire. The sentence 'What did Odin whisper in Balder's ear when he lay on the pyre?' is wonderful because it doesn't say anything. No one knows what Odin said.

So the secret remains in the world.

That is the secret as such. Here the secret is connected to fire. Odin spoke the secret into the rising smoke, so to speak. On the one hand the secret is there, on the other it departs with the smoke. It moves off and is no longer discernible to us. It withdraws from recognition. It also says: If we don't know this, we know nothing at all.

Where do you think the general fascination with fire comes from?

There are surely many explanations. There are certain things that always fascinate human beings, like the stars. They couldn't explain what those points in the sky

were. Or lightning. It must be horrible when you don't know what lightning is, to see, as a Neanderthal or as *homo erectus*, a bolt of lightning set a tree or an entire forest on fire. That, of course, is a scary sight. Most people are afraid of snakes and fascinated by them at the same time. The image of a snake is imprinted in our brains, it doesn't go through the hemispheres but right to the cerebellum and immediately says to us: Danger. This imprinting doesn't come from human history but lies much farther back in time. These are primordial experiences, connected to snakes and fire, and it's from them that humans have shaped their mythologies: with fire, the snake and the dragon, Midgard, Utgard, etc. The dragon and fire—that is the signature in our cerebellum. Together, fire from lightning and the dragon give you the fire-breathing dragon.

I can understand the fear of snakes perfectly well. But I'm drawn to fire—I don't fear it.

Of course, most people are pyromaniacs. The culture of chimneys in wonderful living rooms: domesticated fire. You sit in front of the chimney for hours, staring at it. Something develops, something takes place without leading anywhere; it's wonderful. You sit and daydream by the fire.

Is it the wish that fire prompt the unconscious to dream?

Yes, with the knowledge that one has tamed fire. The fire doesn't leave the chimney, it doesn't spread. It stays in the hole, in the fireplace. It's like watching a crime movie. You sit on the sofa, out of danger, and have the danger presented to you.

The figurational and process sociologist Norbert Elias once said that we can only enjoy nature when we aren't threatened by it. When you look out from a sheltered space and delight in the cold outside. The cold gives you a sense of coziness because you yourself are in a warm room, looking out at a frigid landscape.

There are primordial experiences, That's why winter landscapes are used in liquor ads. You see a house with yellow lights, with yellow windows, in an ice-cold winter night: the archetype of coziness. You know it's cold outside but there's a place where it's warm.

The desire for security is granted by fire.

Yes, certainly, fire warms as long as it's tamed. When you look at a fire in a fireplace, you notice something strange: the flames never completely touch an object. They appear to hover a bit over the wood or the coal. The flames are no longer connected to the object itself. First, they're lit by the gas that streams from the object. The wood and the coal themselves don't burn, the gas

catches a bit above them. That's interesting. It's already an area that isn't related to the object.

At the same time, fire is an independent entity.

Fire feeds on certain a material but the connection to it is no longer completely clear. Something is vanishing. Fundamentally, however, nothing vanishes. The material is preserved as warmth, warmth in outer space. Entropy is present. We have the subjective feeling that something is diminishing.

Do you think the explosion in the big bang is connected to fire?

The big bang is no longer a sensual or physical idea for me. For me, the big bang—I can't even say it's an idea—is an exaggeration of everything I can imagine. It's the same as with a black hole: so much energy is concentrated in a small space. If you take a neutron core and transpose to normal objects, it has so much weight that it would be immeasurably heavy. The big bang, where all matter is not yet present, is concentrated in that one point from which infinity develops, is such an exaggeration, that I can't associate it with anything. It's beyond everything.

If you think of the core of the earth . . .

. . . it's liquid earth, lava comes from the centre.

I recently read a report on hotspots. Until now it was believed they stayed in one place, but now it has been proven that they move, 3 to 4 centimetres a year.

The hotspots in Greenland?

There are around 50 hotspots throughout the world.

I would have been surprised if they really were fixed, because everything underneath is fluid. The hot spots are fed by liquid magma. The big bang, in contrast, is for me an intellectual, mathematical, almost abstract idea—I can't reach to any sensual or physical idea for help.

Both matter and antimatter were created in the big bang.

There's a bit more matter than antimatter—therefore something does exist. That means that what we see and what we can identify, the Milky Way and so on, is just a small part of all that was created.

In mythological thought, the crossing of that infinite space is tightly bound up with the idea of the journey, in Merkabah mysticism with the fiery chariot-throne.

The chariot-throne eludes our praxis. Fire should lead to an end, but the fire remains. It's like the fire in the burning bush— it burns but does not consume. The burning thorn bush doesn't consume itself. Merkabah mysticism is dangerous for the initiate. He can perish.

However, the chariot-throne endures. The initiate must make a decision. He is vulnerable, the journey can also lead to his end, his destruction. Or he could fall. The dualism is more present again. It can succeed or not.

Does fire help the initiates pass the test?

First the hands burn, then the feet. In the end, only spirit remains. The initiate himself becomes spirit, an abstraction, air. In throne mysticism, that means one's feet are burnt. At some point the initiate can no longer walk and no longer needs to walk.

To return to the snake. Your installation 20 Jahre Einsamkeit [20 Years of Solitude, 1971–1991] *is displayed in the Kunstmuseum Wolfsburg. On one of the upside-down paintings, about halfway up the pile, there is the skin of a snake.*

Snake skins are very interesting. A moulting snake that sheds its skin every month and becomes new. That's the idea. The snake is very ambiguous. On the one hand it's the earthy, the chthonic, but it's also the spiritual. It's the one that seduces Eve. The opposite of God. So, not only something chthonic but also intellectual. The snake debates with Eve. It says to her: You want to become like God—this is how. It is a tempter and so on. Now what does the snake in the stack of paintings in *20 Years of Solitude* mean exactly? Maybe it's the binding

element of all the layers. I once did a gouache with photographs of pictures piled on top of each other and then associated the various layers with geological eras, Mesozoic, Paleozoic, and so on. The snake as the connection between the layers and the geological eras.

Does the often changing skin of the snake also mirror the artist's moulting?

Yes, of course. The moulting of the artist, his development, his layering. I once had a snake and wanted to raise it. I wanted to know what life with a snake meant. I felt a strong attraction and a deep physical revulsion, no, not revulsion. I couldn't bring myself to touch the snake. I wanted to change that. So I bought myself a boa constrictor, built an enormous terrarium and raised it in there.

Were you able to touch it?

No, I couldn't. I broke into a sweat and my heart started racing. The boa constrictor was small, seven weeks old, 70, 80, 90 cm long, easy to handle, but I just couldn't touch it. And then it died.

Were you afraid the boa might wrap itself around your chest and suffocate you when it was grown?

I hadn't gotten that far at all. I surely would have had that fear. The fear is real, the snake is strong. You have

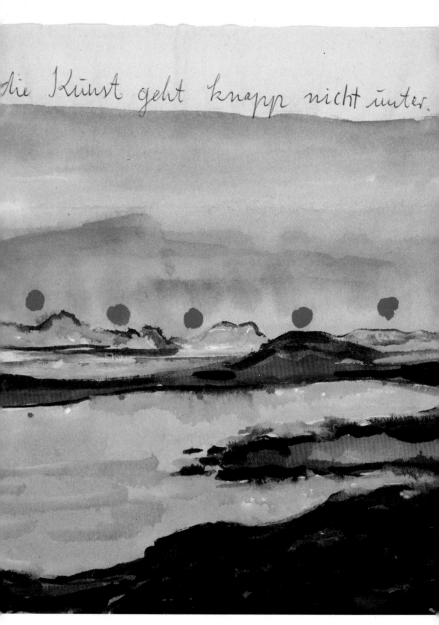

Nordkap (North Cape)

1975. Watercolour on paper. 23.8 x 19.8 cm.

Landschaft mit Kopf (**Landscape with Head**)

1973. Oil paint, cardboard, charcoal on burlap. 210 x 240 cm.

COPYRIGHT Anselm Kiefer. Private collection. PHOTO: Atelier Anselm Kiefer.

FACING PAGE. *Athanor*

2007. Emulsion, shellac, oil, chalk, lead, silver and gold on burlap. 1015 x 438 cm.

COPYRIGHT Anselm Kiefer. Collection Musée du Louvre, Paris.

PHOTO: Editions du Regard / Musée du Louvre éditions.

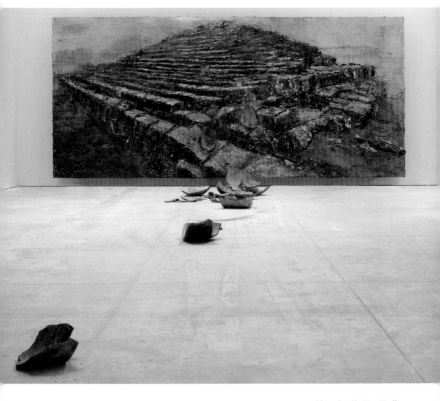

Shevirath Ha Kelim

2009. 330 x 760 x 1300 cm. Terracotta, acrylic, oil and shellac on canvas.

Für Paul Celan – Ukraine (For Paul Celan – Ukraine)

2005. Lead books with aluminium sunflowers. 140 x 70 x 70 cm.

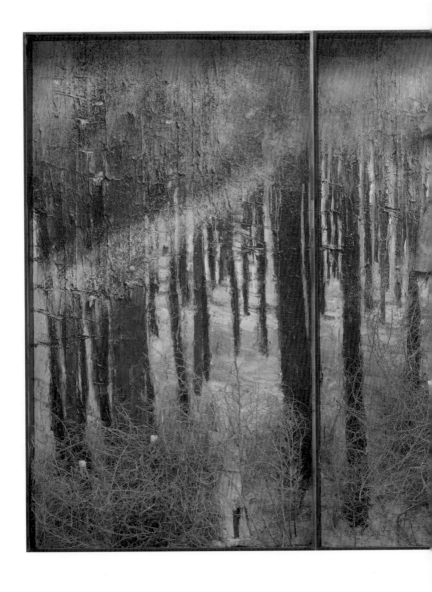

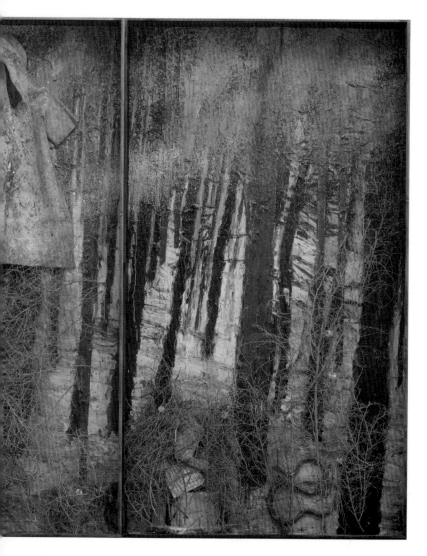

Karfunkelfee (Karfunkel Fairy)

2009. Gold paint, chemise, jesmonite, snake, brambles, concrete, acrylic, oil, emulsion, ash and shellac on canvas in steel and glass frame. 332 x 576 x 35 cm.

Die Himmelsleiter
(The Ladder to Heaven)
1990–91.
Emulsion, shellac, lead, ash,
broken pieces of ceramics
and glass, linen and snakeskin
on canvas. 330 x 370 cm.

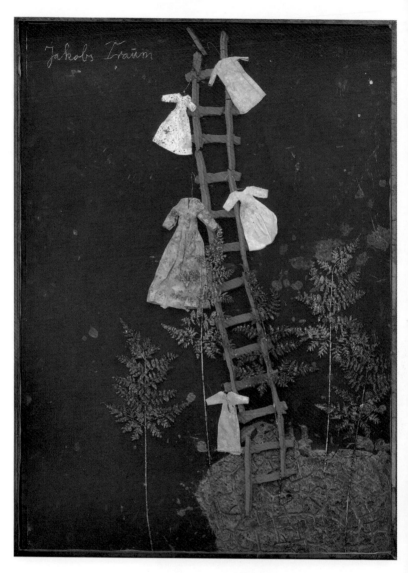

Jakobs Traum (*Jacob's Dream*)

2008, Oil, emulsion, acrylic, resin-coated ferns, clothes, wire, sand, ash and clay on cardboard on plywood under glass. 191 x 141 cm.

Vater, Sohn, Heiliger Geist (Father, Son, Holy Ghost)

1973. Oil, charcoal and synthetic resin on burlap. 288,7 x 189 cm.

COPYRIGHT Anselm Kiefer. Collection Sanders, Amsterdam (On permanent loan to Van Abbemuseum, Eindhoven, The Netherlands). PHOTO: Atelier Anselm Kiefer.

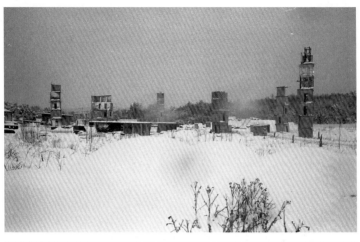

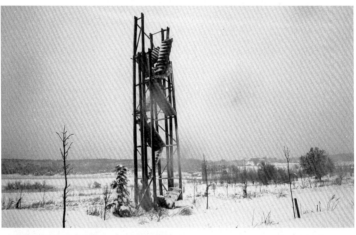

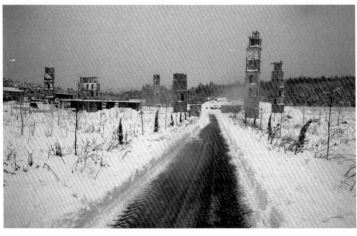

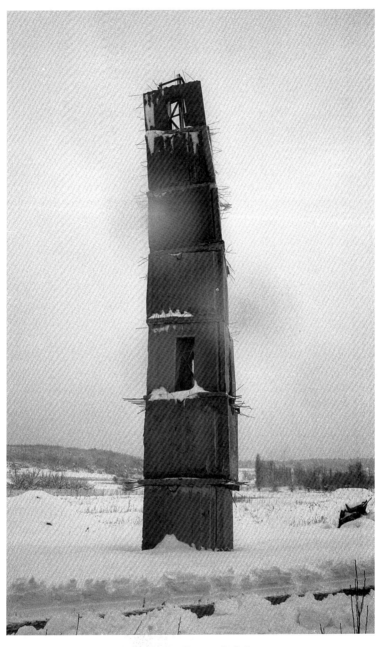

THIS AND FACING PAGE: **The Seven Heavenly Palaces**

2006. Barjac.

COPYRIGHT Anselm Kiefer. PHOTO: Anselm Kiefer.

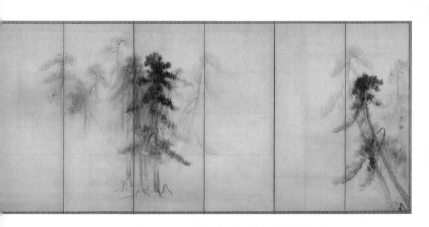

THIS AND FACING PAGE: **Hasegawa Tōhaku (1539–1610),** *Pine Trees*
(left and right screen).

Sixteenth century, pair of six-folded screens; ink on paper. 156.8 x 356 cm.

COLLECTION Tokyo National Museum. PHOTO: Available at Wikimedia Commons.

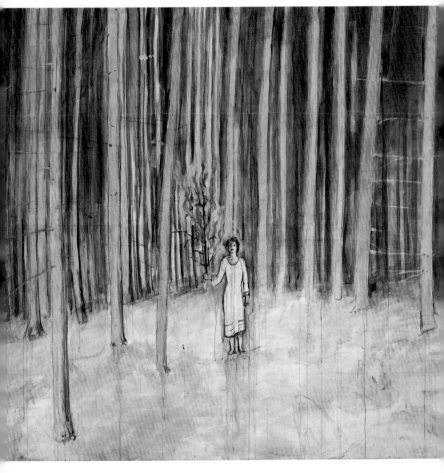

Mann im Wald (Man in the Forest)

1971. Acrylic paint, oil paint on nettle. 174 x 189 cm.

COPYRIGHT Anselm Kiefer. Private collection, San Francisco. PHOTO: Atelier Anselm Kiefer.

OVERLEAF *Quaternität (Quaternity)*

1973. Oil paint, charcoal on burlap. 298.5 x 432.4 x 3.5 cm.

COPYRIGHT Anselm Kiefer. Modern Art Museum of Fort Worth, Museum purchase; The Friends of Art Endowment Fund. PHOTO: Atelier Anselm Kiefer.

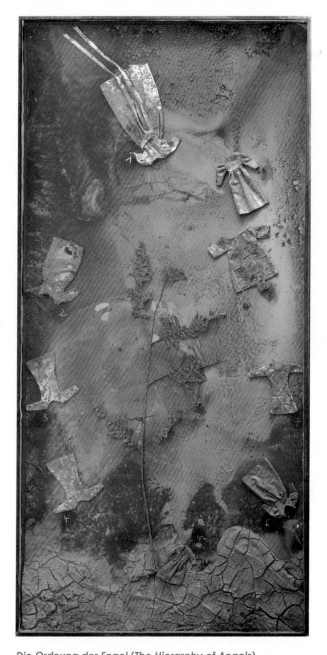

Die Ordnung der Engel (The Hierarchy of Angels)

2007. Oil, emulsion, acrylic, shellac, resin-coated fern, ash, clothes, lead and clay on cardboard on plywood under glass . 286 x 141 cm.

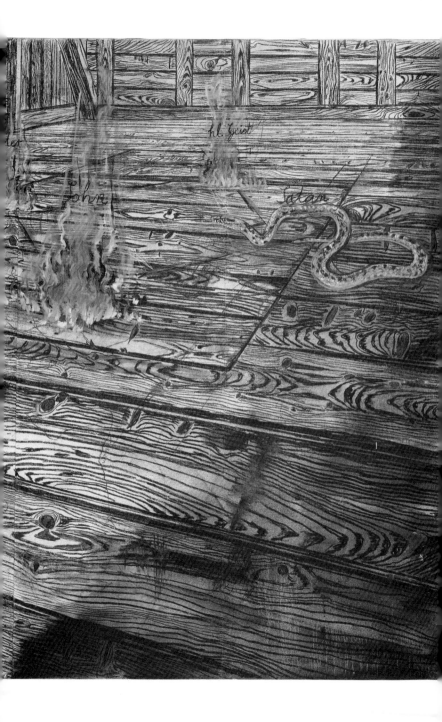

Siegfried vergißt Brunhilde (*Siegfried forgets Brunhild*)

1975. Oil on canvas . 130 x 150 cm.

FACING PAGE: **Cover for Programme Ödipus in Kolonos**

2003. Burgtheater, Vienna.

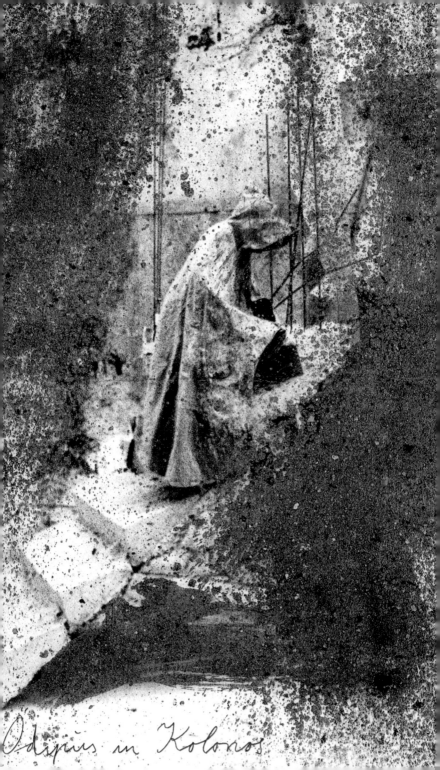
Oedipus in Kolonos

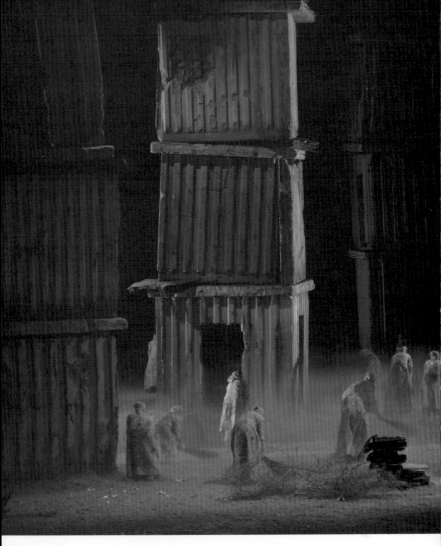

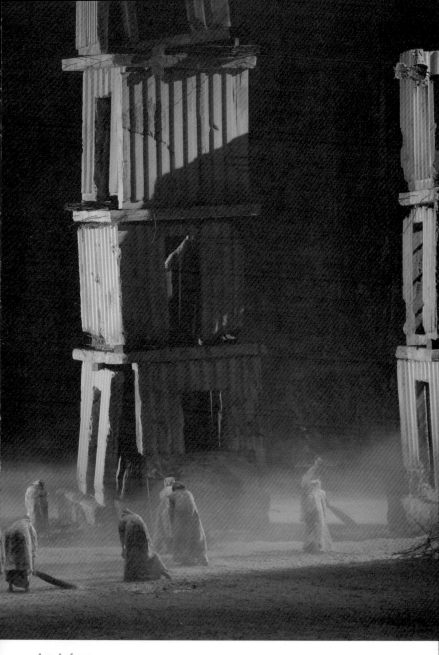

Am Anfang

2009. Opéra Bastille, Paris. PHOTO: Charles Duprat.

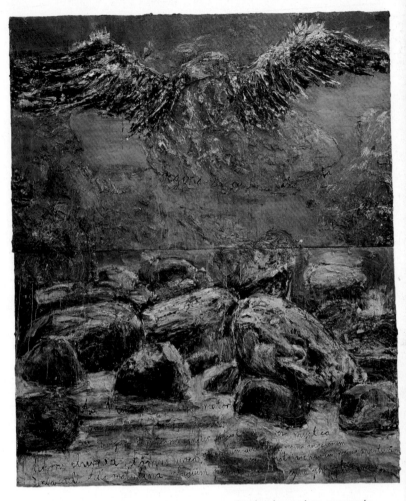

Regina in caelum assumpta

1977–2008. Oil, emulsion, acrylic, shellac on canvas. 380 x 330 cm.

FACING PAGE: *Ave Maria Virgo Intemerata*

2008. Oil, emulsion, acrylic, shellac, lilies and clay on cardboard on
plywood under glass. 215 x 140 cm.

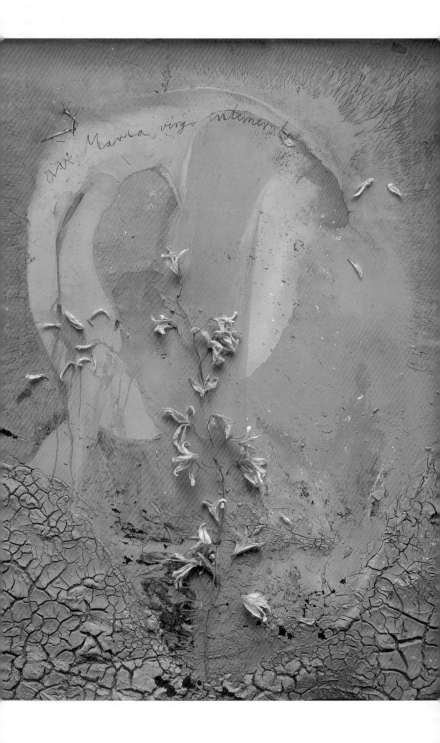

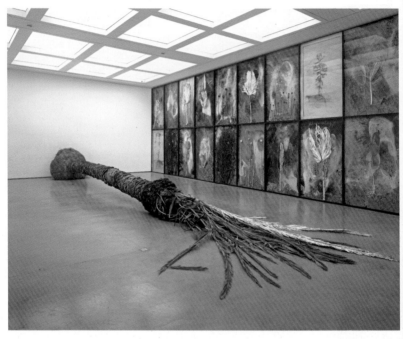

Palmsonntag (Palm Sunday)

2006. Installation, mixed media. Dimensions variable.

COPYRIGHT Anselm Kiefer. Private collection.

PHOTO: Stephen White (Installation view at White Cube, London).

FACING PAGE: *Palmsonntag, detail (Palm Sunday, detail)*

2006. Palm, plaster, clay, charcoal, emulsion. 285 x 140 cm.

COPYRIGHT Anselm Kiefer. PHOTO: Atelier Anselm Kiefer.

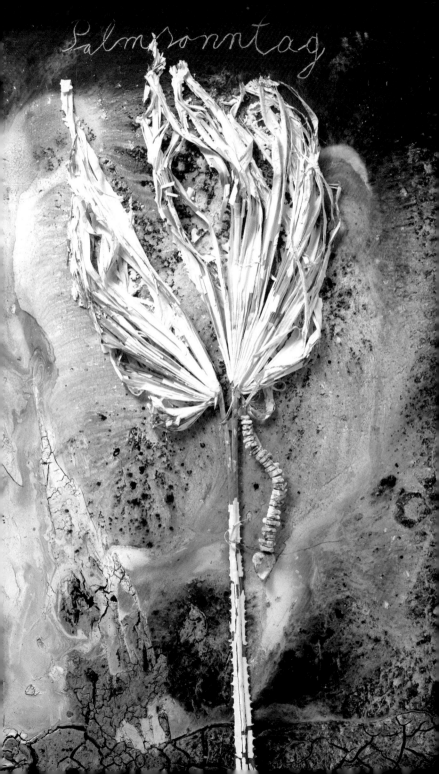

Die Meistersinger (The Mastersingers)

1981. Oil, acrylic and straw on canvas. 185 x 330 cm.

Parsifal

1973. Oil paint, ingrain wallpaper on nettle. 300 x 553 cm.

Wustrau · Gusow · Saretz · Cranienburg bei · Möglin · Xinerdorf · Backow · Freienwalde · Samuel · Kloster Lehnin · Neuruppin · Freilinden · Wust · Kentzrode · Rheinsberg · Kossenblatt

Märkischer Sand (Sand of the Brandenburg March)

1980–82. Oil, paint, photography (paper print), emulsion, sand,

cardboard, charcoal on canvas. 300 x 553 cm.

COPYRIGHT Anselm Kiefer. Stedelijk Museum, Amsterdam. PHOTO: Atelier Anselm Kiefer.

Aus dunklen Fichten flog ins Blau der Aar
(From Brooding Pines, an Eagle Upward Swept into the Blue)
2009. Lead, photographs, brambles, acrylic, oil, emulsion, ash and shellac
on canvas in steel and glass frame. 332 x 576 x 35 cm.
COPYRIGHT Anselm Kiefer. Private collection. PHOTO: Charles Duprat.

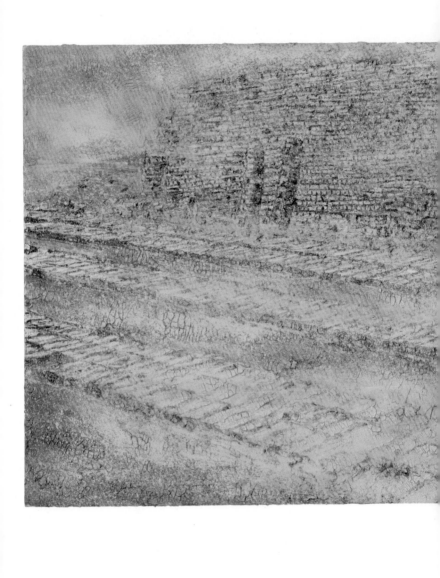

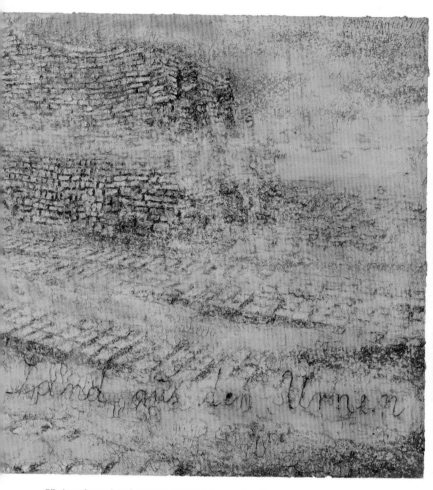

Für Ingeborg Bachmann: der Sand aus den Urnen
(*For Ingeborg Bachmann: The Sand from the Urns*)

1998–2009. Emulsion, shellac, sand on canvas. 280 x 560 cm.

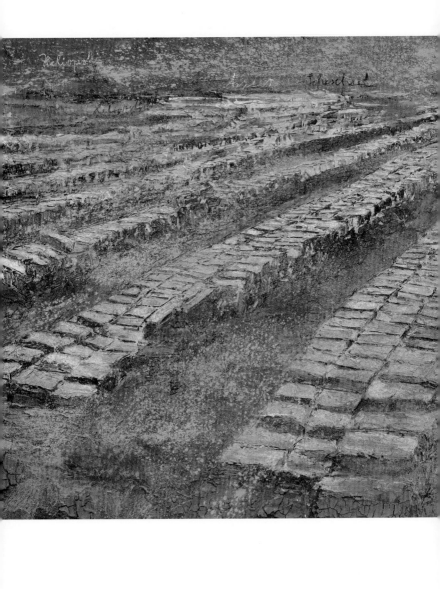

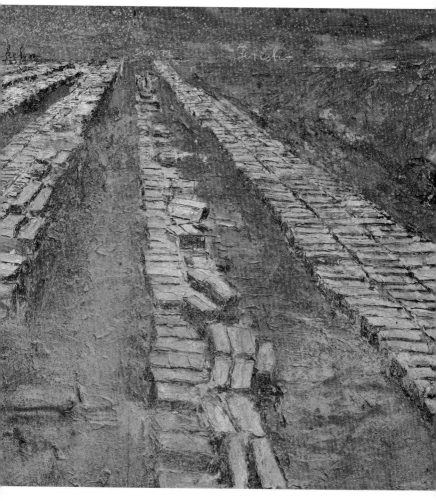

Heliopolis

2009. Acrylic, oil, shellac and sand on canvas. 280 x 570 cm.

COPYRIGHT Anselm Kiefer. Private collection. PHOTO: Charles Duprat.

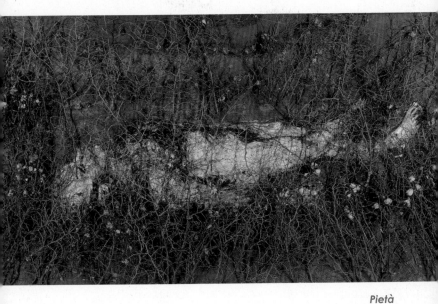

Pietà

2007. Oil, emulsion, acrylic, shellac, brambles, cardboard, dried roses on
canvas in steel and glass frame. 191 x 381 cm

COPYRIGHT Anselm Kiefer. Private collection.

to allow for that. But this other fear: even without having touched it, I was in all possible states. I also collected a lot of its skins because the boa constrictor moulted every two to four weeks. That was always fascinating. That was also the time when it was most fragile. When they moult, snakes retreat into the jungle or the forest to a place where they won't be disturbed. When snakes shed their skin, they're very fragile.

When you were travelling through many countries in the early 90s, constantly underway, was that a kind of moulting for you? When you came to Barjac in the south of France, you wanted to live and work in a different way. What did you have in mind back then?

My idea was to stop making those heavy paintings, to make lighter works that I could roll up and carry around on my car. That was the idea (*laughs*), but it didn't work out that way. Heavy themes were one thing, but the materiality—I wanted to free myself from the materiality. But that didn't work out. Impossible (*laughs*).

Because in your thought, being is contained in materiality, in matter.

I thought using a few grams of lead, using less of everything would be enough. But it turned out that I couldn't achieve the level of abstraction I was aiming for.

Would it even have been possible to reach that level of abstraction if your work were almost free of materiality?

In the end, Duchamp did nothing but play chess (*laughs*).

That would be a kind of auto-da-fé of your existence as an artist.

Whatever you call it, I couldn't do it. Fifty-two buildings now stand in the Barjac landscape, some of them very large. I wasn't able to completely liquefy the material. It will have to be what it is. In retrospect, you can see what developed. The idea was right, but the path towards it, the decision was not. Maybe the things that I've created will now dissipate on their own (*laughs*). Perhaps at some point it will give rise to an idea that doesn't require matter—could be. On its own. From someone looking at what I've done—or simply on its own.

Not just a kind of dissipation but also a kind of unfolding?

Unfolding or concentration. It could be that the buildings, paintings and sculptures that I've made in Barjac will now dissipate or will develop with someone else. I won't be going there any more. Maybe someone will come to Barjac and complete it.

Complete it how?

I don't know. Maybe someone will complete it in the sense of a liquidation. I can't determine how it will continue to have an effect. Visitors will no doubt come to look at the works and so on. Maybe some idea that I can't predict will develop from this laboratory.

Paris, 26 January 2009

SNOW OVER BARJAC

Mr Kiefer, I once saw a photograph of the concrete steps in Barjac. Snow fell in the winter of 2006 and covered the steps. There was also snow on the towers of the Seven Heavenly Palaces—*an unbelievably beautiful photograph.*

That's almost what I was talking about at the end of our last conversation. It actually never snows in Barjac, down in the south of France. One day there were 7 centimetres of snow everywhere. That changed everything completely, of course—it was an entirely different landscape. All the objects, towers, sculptures and stairs were suddenly utterly transformed. I hope someone will come and bring snow: snow over Barjac.

The Japanese poet Hashin wrote the following poem: 'no sky | no land—just | snow falling.'[1]

When it snows, it's exactly like the description in the poem you just quoted. I took a lot of photographs and painted a lot of gouaches with photographs of the snow over Barjac.

1 Kajiwara Hashin (S. Kazuo, P. Donegan and K. Tadashi trans). Available at: https://bit.ly/3mf44xF (last accessed on 1 March 2019).

I was in Beijing in the early 1990s. At the end of my trip, there was such a heavy downpour over Tiananmen Square that after less than ten minutes there wasn't a soul left. The rain had enveloped the Gate of Heavenly Peace. The Chinese poet Bei Dao told me that, in Chinese, rain and snow are synonyms for friendship. He said, 'Old snow—old friend.' When I saw the snow pictures of Barjac, I was reminded of snow's enveloping dimension which the Chinese language associates with friendship.

I wrote about snow over Barjac. It's a complete anomaly because it never snows in that region. It's as if Krushchev had brought the nightingales of Kazakhstan to Moscow (*laughs*). Krushchev was born in Kazakhstan and said he would bring the nightingales of Kazakhstan to Moscow.

But the snow did come to Barjac.

Snow over Barjac is enormous. You can tie it to the following hope: I left Barjac and hope that someone will come and finish what I wasn't able to, that is, create works that have almost no matter. The opposite is what happened.

I'd like to show you reproductions of two Japanese paintings: first is Pine Trees in the Snow *by Maruyama Ōkyo from around 1781 to 1789.*

Maruyama Ōkyo didn't do anything where the snow is, he just left the canvas blank—dematerialization. When this interview is published, we'll have to have a reproduction of the painting. Maruyama Ōkyo also used gold dust to represent the shimmer of sun on the snow. What's interesting about this painting is that where the snow is, there's nothing. This painting is fantastic.

I thought of it when I saw the snow pictures of Barjac.

Absolutely. Snow obliterates everything—every structure—but shapes them at the same time. Because the structure emerges all the more clearly where there's no snow. When the snow has almost melted, the bits of snow left in the furrows bring the structure of the field to fuller expression. The paintings I made in London last year—*Aperiatur terra et germinet Salvatorem* and *Rorate caeli et nubes pluant iustum et germinet salvatorem* [Let the earth be opened and send forth a Saviour *and* Drop down dew, ye heavens, from above and let the clouds rain on the just]—do indeed have red and other colours, but they are painted on a background of photographs I took in Buchen of traces of snow. You can see it as a complement to the *Balder-Lied*. What did Odin whisper to the dead Balder? The point when nothing more is said is when it gets interesting. That's snow again: what was is obliterated. No one hears what Odin says, neither Balder nor anyone else in the world but it creates a white snow-space over the funeral pyre. It's

also interesting in connection with Paul Celan's poem 'Ich bin allein' [I am alone]: 'I am alone, I put the ash flower / in the glass of ripened darkness. Sister mouth, / a word you speak lives on before the window, / and what I dreamt climbs silently up to me on my dream. // I stand in the bloom of the wilted hour / and put amber aside for a belated bird: / it carries a snowflake on its life-red feather; / a grain of ice in its beak, it will survive the summer.' Snow in summer, which melts, which doesn't last long, which the mysterious empty space indicates. Even in summer when it's hot, the bird carries the empty message in its beak—the silent or empty message: an interesting connection to snow over Barjac. The white page.

I'd like to show you the reproduction of another painting: Hasegawa Tōhaku's Pine Trees in Fog *from the late sixteenth century.*

The needles of the pine trees in Hasegawa Tōhaku's painting are rendered with circular strokes of the brush tip. The fog stretches into infinity, it's tiered into infinity. There's Caspar David Friedrich's famous fog landscape in the Riesengebirge. It's not like this painting, but it's a similar idea—that the layers of fog extend out and dissolve into nothingness. Between the two very distinctly drawn pine trees in the Hasegawa Tōhaku there's a clearing. Heidegger wrote wonderfully about clearings.

The clearing evokes a deep, extensive space—the void that plays a central role in Zen Buddhism. Just as the white of the canvas in the other painting depicts the void, here too the clearing between the two pine trees in the fog is an empty space.

That's what Hölderlin means when he speaks of the space left by the gods who have fled from us.

You could see a link to the mysticism of Isaac Luria here.

Yes, when God withdraws, an empty space is left in which something can develop.

What in the one painting is snow on the trees is in the other the fog between the trees.

In *Pine Trees in Fog* there's ink, which is, of course, water. Very thin layers of ink, one over the other, that's probably what they are when you see the original painting. I also do that. I often lay the painting on the floor and pour water over it, water with a bit of loam in it, with a little white or grey, and I let the water dry for several days. That's a clear instance when the material creates its own effect. *Pine Trees in Fog* is a folding screen, a large one with dimensions of 150 by 340 centimetres. 150 centimetres is probably the average height of a Japanese person. The painting is really rather large.

Poland fascinates you. The title of one of your paintings cites the first verse of the Polish national anthem: 'Poland has not yet perished.'

Poland is the most abstract country of all. I've visited Poland several times. The Polish national anthem was written when Poland no longer existed. The soldiers went to fight in the war under Napoleon. They had hoped Napoleon would restore Poland. Poland is a country that is in part completely abstract and irrational. The Poles are irrational. Their borders changed constantly, they've never had fixed borders. The Poles were always the pawn of the mightier powers, and their somewhat exaggerated national consciousness comes from that void. For a long time there were no Poles. The country was in a precarious situation for a long time until Willy Brandt recognized the Oder-Niesse line—until it was set down in writing that this was the new border. Andrzej Wajda's *The Wedding* is a fantastic film that shows the mythology of Poland very well. The film *Ashes and Diamonds* is, too, of course. For me, Poland was a synonym for borders that aren't borders, for borders that are always shifting.

There's a painting by Tadeusz Kantor which shows him dressed in a soldier's uniform head down on a cross. The cross with the soldier lies on a map of Poland with the country's borders torn.

I once made a palette, broke it and recorded the dates of the three partitions of Poland. I shot some film in Poland when I was there in the 1980s. I took long shots of ice floes on the Vistula River—for me a synonym of

Poland, everything in motion, the parts of Poland. And I filmed people studying the train schedules in the station. That was during the time of martial law under Jaruzelski. Berlin and other cities that the Poles couldn't even travel to were listed on the schedule. Under martial law there was hardly anything to eat. On one trip there were only beets, borscht and more beets, just beets, hardly anything else. On another trip there were only potatoes. I filmed a scene from a hotel. In front of my hotel in Warsaw, there was a memorial that always had a guard. For weeks in Warsaw, they carted the snow away with small trucks. The soldiers had to keep the memorial square free of snow. It was wonderful. Every day the snow was loaded into a small truck and carted away. I filmed it—work that was truly futile.

Paris, 26 January 2009

I MAKE MATTER SECRETIVE AGAIN BY EXPOSING IT

Mr Kiefer, in the last few months you've been preparing the exhibition Mary Walks Amid the Thorn. *An earlier title was* Ave Maria, *the beginning of the* Hail Mary *prayer.*

The title referred to the *Litany of Loreto*, which says: 'Sancta Maria . . . Mater castissima, Mater invioláta, Mater intemeráta, Mater amábilis, Mater boni consílii . . . Turris ebúrnea . . .'. Mary is compared to all sorts of things, to philosophers and towers. The *turris ebúrnea*, the ivory tower, comes from the Old Testament, of course.

Where did this orientation towards the Mother of God in your creative work come from? You were deeply engaged with Gnosticism and Jewish mysticism. A year ago, in Salzburg, I saw your painting Palm Sunday (2007), *which has great transformative energy. The Virgin Mary also has an energy that upends and transforms circumstances.*

My work addressed that topic or field from the beginning. I painted the works *Father, Son, Holy Ghost* (1973) and *Quaternity* (1974) very early on. The Virgin Mary accompanied me throughout my childhood, she was very important to me while I was growing up. Here I'm

141

thinking of the May devotions, when the altars are decorated with an enormous number of flowers. The scent is bewitching. The song 'Maria, breit den Mantel aus' [Holy Mary, open wide your cloak] clearly alludes to the physical body. I grew up with this sensual imprint—it's my childhood, my past. Later I learnt that Marian devotion was not invented by Christians but goes back to other cults, to that of Isis, for example. I had a very Catholic upbringing. I was an altar boy. I used to know many poems by heart (which I've since forgotten). But I can still recite the Latin Mass. I had it memorized before I could write. My mother taught it to me. When you mention Gnosticism and Jewish mysticism, the Virgin Mary is a part of that. Jewish mysticism is rather abstract, *tzimtzum* and *tikkun* are abstract processes.

The Angel Gabriel appears to Mary and tells her that she will conceive a child. The Angel also tells her the child's name.

The child was there almost before the Annunciation. What interests me about Mary today, aside from the biographical events, are the dogmas. There are five Marian doctrines. The last one dates from the 1950s: the Assumption of Mary, body and soul, into heaven. The doctrines stating that Mary was a virgin before and during the birth come from the nineteenth century when everyone knew where children came from. I

always found it foolhardy for the Catholic Church to teach such doctrines—a brazen defiance of common sense. It's rather artistic to advance a claim that is completely indefensible. You can see a parallel to the absolute power an artist has in the act of creation in the Catholic Church which claims that Mary was a threefold virgin, before the Annunciation, as well as during and after the birth. This claim has always fascinated me. I'd almost say that it's like Dada. It's insane. It's completely insane.

Mary—semper virgo. *The doctrine of the perpetual virginity of Mary is intended to prove that Jesus is God's son. Jesus is the Son of God, come to the world to redeem mankind. The Word is made flesh as it says in the prologue to the Gospel of John.*

The Gospel of John is the most abstract. The verses 'In the beginning was the Word, and the Word was with God, and the Word was God . . . And the Word was made flesh, and dwelt among us, and we beheld his glory, the glory as of the only begotten of the Father, full of grace and truth' describe a fantastic process, recount an abstract event. Jesus' birth of Mary is a material matter. It's not abstract when you claim that Mary was a virgin. Last year in the Louvre, I saw an exhibition of various drawings centred around a theme I'd chosen: 'Borders'. I chose a lot of drawings of the Virgin Mary, the

Annunciation, the Immaculate Conception, and I noticed how much variety there was in the depictions. Sometimes Mary is shocked, overwhelmed by the events, sometimes it seems the angel is the one who is shocked because he knows Mary is already carrying the Son of God, that she's carrying God. The different theological dimensions of these drawings were absolutely fascinating.

In the fifteenth century, there was a heated argument about whether Mary was the Mother of God or the mother of Christ. The Bishop Nestorius saw Mary as the mother of Jesus and yet his view was condemned as heresy at the First Council of Ephesus in 431 CE. According to Catholic doctrine, Mary is the Mother of God.

Your explanation is tied to an impossible claim. How can a human being bear God? Mary gives birth to a part of God, she bears a part of the Trinity. That always concerned me deeply as a definite impossibility, since it involved a denial of established scientific knowledge. There's something artistic about neither renouncing scientific knowledge, not denying it, but setting it on a different level where it is relativized. Every scientific discovery is provisional, then falsified or modified over the years. To claim that Mary was the Mother of God and a virgin, without original sin is, of course, impossibly bold and it's also impossibly bold to claim that this is an eternal truth. That is placing myth above science, if you will.

Is the mythological structure a stronger one than rationality?

Mythology is always more complete than science. In science, it's always a question of partial knowledge, especially today, when everything is compartmentalized, when everyone works only on his own small part of the whole. Mythology contains knowledge that is not immediately legible, it must be interpreted, but it is more integrated.

The sociologists of religion Peter Berger and Thomas Luckmann have demonstrated in their studies that mythological structure serves a deep-seated desire in man, namely, for the reduction in complexity. Since the positing of mythological structure is absolute.

It's a simplification and yet I wouldn't say that a mythological image is simpler. The image is simpler but its background is more complex than scientific knowledge. Yet the difficult point is that a doctrine is essentially impossible, impossible by definition because you can't establish anything permanently with words. Language is always changing, it can change within a decade. So doctrine is impossible and the artistic aspect of its impossibility has always fascinated me. Today we can still just about understand claiming in the nineteenth century that Mary was a virgin when she conceived, but that Mary remained a virgin after the birth as well is outrageous—it's insanity. But this insanity was put to

use not as lunacy but to create an illusion for mankind: 'Holy Mary, open wide your cloak, and make of it a shelter and a shield, we will stand under it secure, until the fiercest storms do yield' and so on. It's simply our need for illusion. For protection and security. All sense of security is an illusion. We assume this need as children. My interest in Mary is no longer a childish one. My interest is in the artistic, the absurd element in the claim. Artists make claims, mythology makes claims, without being able to prove them. I focus on what I have. I focus on what I am. I'm a person to whom the Virgin Mary has appeared. She appeared to me as a Nazarene figure. I believe I was six or seven years old at the time, maybe even eight.

Had you been praying just before the apparition?

No. Mary appeared to me one morning. It wasn't a dream; I was already awake. The vision appeared in the room where I slept. I can tell you exactly how Mary was dressed: she wore a light beige and blue dress. It looked exactly like a depiction in a Pre-Raphaelite or Nazarene painting. Today I'd call it kitsch. Mary didn't speak to me, she only smiled. I remember that her mouth moved. Marian apparitions are often linked to a call to build a church. When Mary appeared to me, there was no call, no command either. As a child, I didn't know about the Marian apparitions in Lourdes. I'd neither read nor heard about them. Not long ago, I asked my colleagues

to research Marian doctrines because I couldn't remember exactly when each dogma was decreed. The Catholic Church has only proclaimed five dogmas, but a great number of Marian apparitions have been claimed. They're a psychological phenomenon, of course.

Apparitions of the Virgin Mary always have a similar structure. Most are associated with a prophecy. When the Mother of God appeared to the three shepherd children, Lúcia dos Santos, Jacinta and Francisco Marto on 13 May 1917 in Fatima, she prophesied the consecration of Russia. A Marian apparition always sets a process of healing in motion. When Mary appeared to you, did she wear a crown of stars?

No. There was a glow around her head, but she didn't have a crown of stars. That would have been an exact reflection of a depiction because Mary is often portrayed with stars.

Did Mary's connection to the cosmos interest you? Mary is situated in the universe through her crown of stars. In the Litany of Loreto, *she's called* stella matutina, *the morning star. In the Catholic Church's Liturgy of the Hours, she's called* stella maris, *after the hymn* Ave Maris Stella *from the eighth or ninth century.*

Mary is also on the moon. Her integration in the cosmos is, of course, interesting. It was previously established with Isis who bore Horus' son, Osiris. With Mary there's an interruption: one era has ended and a new

one has begun. For the first time, original sin is over-come. That contains utopian potential. Original sin was necessary because Christian theology couldn't explain the existence of evil in the world. It was impossible. In Jewish mysticism, the world is explained differently. Naturally Mary, who gave birth to God, had to be free of original sin. That was an abrogation of theodicy, of the explanation of the world.

The question theodicy sets out to answer is: If God is good and all-powerful, why is there evil in the world?

That is the fundamental question: from Adam to Christ, who crosses this line—from birth in original sin to its overcoming. It's actually a two-fold interruption, because the Old Testament is abstract: I am who I am.

Or, in a different translation: I am who I will be. I was always more drawn to the translation with a dimension pointing towards the future and find it deeply moving.

That translation, though, is less radical. Because 'I am who I am' is a cynical response. Someone asks, who are you, and gets the response 'I am who I am.' That's utterly cynical. A self-importance, a cynicism that completely disarms people. At the same time, it's very interesting as the source of the prohibition of images. I was always very actively working against this prohibi-tion, this abstraction. The Son of God's descent is an

incarnation that had never happened before. The Eucharist—*hoc est enim corpus meum*—is also an absolute transubstantiation.

Bread and wine become the body and blood of Christ through transubstantiation. In the Eucharist, a new body is created. The question of how one substance alters its state of existence is also central to your work.

Yes, transformation. Mary was incorporated into theology in the fifteenth century or even later. It became clear that something else was needed. It was all humanized, particularly in popular piety and religious observances.

At first, Mary was portrayed as a very sensual woman, full-breasted and loose-haired. From the nineteenth century on, a process of desexualizing the Mother of God began. And to broach another range of topics: Mary overcomes earthly laws, suspends them. She opposes the dominion of the powerful and welcomes sinners and the poor. In the Magnificat, *it says: 'My soul doth magnify the Lord. And my spirit hath rejoiced in God my Saviour. For he hath regarded the low-liness of his handmaiden. For behold, from henceforth, all generations shall call me blessed. . . . He hath put down the mighty from their seat and hath exalted the humble and meek. He hath filled the hungry with good things and the rich he hath sent empty away.'*

Mary is also interesting with regard to moving between two worlds. Because of the Annunciation she belongs to

another world. There are many stories about Mary. One of them says that she ascended to heaven, body and soul, and returned after three days: her descent. I made one picture about her ascent and one about her descent. Mary's return to earth is extremely interesting. There are wonderful drawings by Tiepolo in which Mary descends in the company of angels from the three highest angelic orders, the Seraphim, the Cherubim and the Thrones. These three angels accompany her on her return to the human world—this transition, this crossing of borders from above to below.

Mary's transition between worlds is suffused with light. Mary is seen as a figure of light who brings light into a dark earthly vale.

Yes, Mary brings light—in contrast to Gnosis that takes light from the world and leaves the earth to its own darkness and morass. The Manicheans, especially, advocate this idea.

Mary's descent to earth isn't followed by any final stay. She then ascends again to heaven. Mary ascends with redeemed humanity.

I see Mary as ascending and descending. I see her as constantly crossing the border between the two. She rises, she returns to earth. She endures everything we must endure on earth. As a succouring deity, Mary rises

again with the redeemed. Mary is constantly transitioning between the two.

Until the final redemption.

In Christianity, history ends at some point. Eschatology is realized, the end of history. I don't have the sense that there will be an end to history. I believe that it constantly rises and falls. It's a continuous cycle. I first found the cycle of ascending and descending in Tiepolo, in his drawings held by the Louvre. They're wonderful drawings. I thought it fantastic that Mary ascends then descends again. She doesn't remain in heaven but returns to earth. I see a rhythm in this, a cosmic rhythm, if you will. I don't believe in a final ascension. I don't believe in the end of history.

That's a similar view of history to the one developed by the philosopher Giambattista Vico. The corsi *and* ricorsi *alternate and advance.*

I don't believe in progress. I believe that it all just goes on. We're not the latest discovery or the latest development the world will witness. If there is a catastrophe—and at some point there will be a catastrophe, it's predictable—we will no longer exist. Then there will be a new evolution from some bacteria in Greenland frozen in ice 3,000 metres thick.

An evolution with higher intelligence than humans?

No, I don't believe that. Evolution may start over from the beginning. I can't say at what level intelligence will end up. Intelligence is not connected to any specific place. It's not only in our heads—it's general. It's in every gene particle, in each and every cell. There's an intelligence field that knows what is happening everywhere.

This intelligence has no teleological dimension?

I wouldn't say it's teleological, but that it's something that connects everything to everything else. It's present everywhere and to that extent is close to a theology, but isn't one. I can't say what it is. I can only say that everything is connected. I feel very connected to people who lived much earlier. I feel connected to Ingeborg Bachmann's thoughts and to the thoughts of others who lived even earlier. That's a connection that isn't spiritual but also isn't purely material, a connection it's difficult to define, but I feel that it's there.

What does the name Mary mean to you?

For me, Mary is like a country I grew up in, like a country I once visited, where I once travelled. For me, it's a memory I can seek out. I have images and sensations on all levels of sensuality concerning fecundity and creativity as well as the yearly cycle. I don't know if there are still May devotions. They're held in the spring when everything begins anew and later dies. The entire cosmic process is contained in this memory.

The Ave Maria *is set between birth and death. It says 'Blessed is the fruit of thy womb' and ends with 'Pray for us sinners now and at the hour of our death. Amen.' Both poles of the human life are named in this prayer.*

Birth and death, sin and salvation and intercession.

Sin has no role in your cyclical thinking. Does it only have meaning in eschatological thought?

Yes, later than redemption. Sin has no meaning for me. Sin is the reason I reject the Catholic Church. The threat of sin, the threat of damnation, the threat of Hell and gnashing of teeth was predominant for me as a child. Perhaps no longer. It was or still is, I can't really judge, a perversion of Christian religion. For me 'sin' is a difficult word, because it immediately implies guilt.

In the Easter Virgil, there is mention of the felix culpa, *or 'happy guilt, that has earned so great a Redeemer'. Were you unable to access a happy guilt?*

As a child I experienced the Catholic religion as an absolute threat, as a menace and a threat.

Of extermination?

Yes, extermination and eternal Hell. The entire theory of guilt is very difficult to comprehend. Many moments come together in guilt or in an offence. Your entire life is decisive, how you grew up and so on. It's incredibly

complicated. I still remember this from my legal studies because we often attended court proceedings. The concept of guilt is extremely complex. Judas should be sainted because he brought on the entire history of salvation (*laughs*). Without Judas' betrayal, there would be no Golgotha and no redemption. Judas was destroyed.

He hanged himself.

He hanged himself and whoever hangs himself goes straight to Hell. In the past, suicides were never buried in cemeteries.

I know that suicides were damned. The Russian film director Alexander Sokurov once said: God especially loves suicides.

That's a different opinion, not official theology. One who commits suicide is, of course, a coward according to Catholic doctrine.

I thought you could justify the act by saying those who commit suicide want to be with God sooner. In his Letter to the Philippians, *Paul sees himself faced with the following decision:* 'For to me to live is Christ, and to die is gain. But if I live in the flesh, this is the fruit of my labour: yet what I shall choose I wot not. For I am in a strait betwixt the two, having a desire to depart, and to be with Christ, which is far better. Nevertheless to abide in the flesh is more needful for you.'

But according to the Catholic Church, suicide is a provocation: Thou shalt not tempt me. It's the negation of

154

creation. It can be interpreted as you just did, as shortening the time we wander on the earth—that's not the teaching (*laughs*).

The German psychoanalyst and psychotherapist Tilmann Moser published the book Gottesvergiftung (*God Poisoning*). *What you mentioned about the menace and threat of eternal damnation is in the general sense of God poisoning. But if you consider Latin American liberation theology, God is seen as the liberator. Gustavo Gutiérrez, the father of liberation theology sees Christ as the liberator. Gutiérrez also sees God in the Old Testament, in Isaiah and Jeremiah, as a liberating God who leads his people out of captivity and bondage. Was the way to a liberating God difficult for you, or perhaps not even possible?*

No, God was a threatening god.

An Old Testament god? Is that associated with an image of God from a time when believing in Him meant fearing Him?

In Isaiah and Jeremiah the threat often recurs: I will send your enemies, I will dry up the Euphrates so they will reach you more quickly. I will punish you through the third and fourth generations. That's a strange passage in the Bible. I often listen to the Books of Isaiah and Jeremiah. I have a recording. It's not clear to me what the writings of Jeremiah and Isaiah actually are.

They're music when you read them, almost a minimalist music. They have a strange power. The repetition, the constant repetition almost seems like a suspension of the threat.

So that you're thrown out of the cycle by the repetition.

There's a centrifugal force in the repetition. It's very strange when you read it that way or listen to it. I may stage a play soon with passages from Isaiah and Jeremiah because they've always fascinated me. 'Over your cities grass will grow'—I often worked with that. I'm still not sure what it means. The repetition that actually suspends the threat is deeply fascinating. It becomes theatre. There's something of divine theatre about it.

The rhythm of repetition in the books of the two prophets comes up in another form in the rosary prayer as well.

Saying the rosary is, in fact, a form of meditation. This prayer is also astonishing because the worst things are said in the prayers. There's flagellation and crucifixion. And they're also suspended in the repetition. It becomes nothing more than a mantra. The event described is no longer apparent. An act of dematerialization takes place. The space becomes empty. A certain emptiness and withdrawal into oneself is the result. Rise, rise, descend again.

Empty space takes on important meaning in your creative work. You once told me that you've written at length about the empty space of childhood. In this context, empty space is created by dematerialization, which in turn . . .

. . . comes from meditative repetition. Empty space is very important for me because my childhood was filled with impressions and odours. On the other hand, it was a very empty space. A very, very empty space, not limited by time. Seen from the outside, it becomes clear that nothing happened. I grew up in a village where there was no radio, no television, no diversions at all. It was a very empty time, but a very rich time. This space, which was not a privation but a source of richness, was filled later. I'm still in the process of filling it with what can be named.

To express it paradoxically: it was a full empty space.

Yes, a full emptiness, that can now, when I speak or give interviews, be named. The empty space is named. When you say your rosary, meditate or repeat a mantra, empty space is created.

I was once in Kamakura, in Japan, and I went to see the giant Buddha statue there. I entered the statue from the back and what was most moving inside was the emptiness. The Buddha is at rest. He's smiling. A different image is associated with Christianity: the ecce homo. *Mary is associated with the pietà after the descent from the cross.*

The *ecco homo* is a brutal thing. I'm still taken aback today whenever I see a crucifix. You see crucifixes much more seldom now. They've become abstract. But earlier there was a crucifix with blood dripping down at every crossroad. Seeing a crucifix like that is both brutal and comical. The idea of empty space on the other hand encompasses much more because we consist of empty space. We are empty. If you look at it in terms of astrophysics, there's an empty space the size of a football field between electrons and neutrons—in other words, there's nothing between them. We are essentially empty space. Once you realize this, you come to a different understanding of everything. Just as there are gamma rays that penetrate the earth and come out the other side of the globe. This would be a banal explanation of empty space or an associative one with the help of the latest scientific knowledge. Still, this feeling of empty space is one I've had for a long time now.

Can you still remember when you first felt the urge to name the empty space?

I only became conscious of it twenty years ago—at the most. Of course, the scientific knowledge about this was already available. I first formulated it twenty years ago, especially the reciprocal influence between empty space and named space.

When I look at your paintings, I have the feeling that they are both empty and quiet spaces. They're spaces in which silence is present.

Yes. I used to be drawn to old factories, abandoned, disused. In the old factories, the interplay, the opposition of emptiness and fullness was very tangible. There was no longer anyone there but traces of the work remained, traces of thousands of workers. That's an obvious example of the interdependence of empty space and filled space, for an empty space that is very full, almost claustrophobically full.

Of a space in which horror is preserved in the traces.

When you think of war, it's horror that's preserved in the traces and when you think of work, it's labour and sweat, maybe not so much in actual traces but as something that you know.

In your stage set for Grüber's production of Oedipus at Colonus *in 2003, at the end of the play, the traces of men who had passed through the sacred grove were visible in the sand and dust that covered the stage.*

Yes, negative forms were created above all by the ash that fell continuously from the flies. As it went on, a negative form suddenly appeared. Like those hands or silhouettes on the wall in Hiroshima.

I once asked myself if the peaceful, smiling Buddha wasn't superior to the Christian ecce homo, *marked as it is with blood and suffering, with horrible torment. The effect this* ecco homo *image can have on a child when it begins to leave an imprint on the child's soul. Have you ever thought that Buddhist philosophy is superior to Christian theology in a certain way?*

It's certainly more comprehensive and it goes further—it simply encompasses more of being. This image of suffering is just one part of being. It's the brutal side of being, the unredeemed side.

Which comes with being human.

It's one side, but it's not all.

Does one's perception of the world shift over the course of one's life?

Essentially there's always a shift. One's conception of the world is never permanent. It's always changing. It cannot stay the same.

Did Buddhist theology influence you more than Christian theology later in life?

I never studied it more intensively than any other. I don't have a deeper knowledge of Buddhism but I believe that some of what I think is compatible with Buddhism.

In Tokyo, I saw a Kabuki-theatre production in which cherry blossoms were designated as a symbol of transience. A Kabuki actor said that what comes into existence in the morning, passes away in the evening. As he said it, he waved his fan like a cherry blossom falling to the ground. That's a beautiful image of creation and dissolution in nature without that ideological superstructure of redemption and . . .

. . . probation, where you have to resist the devil—the ever-present possibility of failure, of damnation, and so on.

Did you engage with Dante in connection with your 2008 exhibition Mary Walks Amid the Thorn? *Mary plays an important role in the last Canto of the* Divine Comedy, *as does the image of love that 'moves the sun and other stars.' The first lines of* Canto 33 *say: 'Virgin Mother, daughter of thy son; / humble beyond all creatures and more exalted; / predestined turning point of God's intention.'*[1]

When I look at the Gospels, Mary seems to me as the strangest of all people in them. Jesus' character is more or less familiar—everyone knows what he did. Mary, on the other hand, appears completely neutral—nothing is known about her. You don't know who she was. You don't know anything about her. There's no description of Mary in the Bible. Mary Magdalene is described in

1 Dante Alighieri, *The Paradiso* (John Ciardi trans.) (New York: Signet Classics, 2009), p. 346.

much more detail than Mary is. Mary is actually a hollow mould.

Mary is a woman who submits to divine will. Mary stands at the cross: 'Stabat mater dolorosa.' And then there's the pietà.

Mary suffers and holds her son in her arms. That doesn't show her as a living woman, but as the Mother of Sorrows which is part of her role. Mary Magdalene is much more alive—she anoints Jesus' feet and dries them with her hair. She is sensual. She wants to embrace Jesus after he was resurrected but is not allowed to—*Noli me tangere*. With that, it's made clear that a transformation has taken place. He is now Christ—another being. The time the resurrected Christ spends on the earth is very interesting. He appears to the disciples on the road to Emmaus and accompanies them part of their way. He appears briefly here and there and then is gone again. Christ is there and not there. When you consider this presence and absence from a writerly point of view, you have to admit that it's cleverly done. The Evangelist creates a time, a space, in which Christ can be present and not present. Christ is there, but not for all—only for certain groups, for certain people and then soon gone again. Christ also doesn't enter through the door—he just suddenly appears. It's interesting because it creates an intermediary space. He's there and not there.

Christ is present as the resurrected one.

He isn't resurrected as the one he was before—he appears rapidly, in a flash. You can easily imagine that Christ really did appear. You can imagine that a man died and then his relations and friends suddenly see him in the corner. That happens, you've heard of it, people who are so close to the dead person that they really do see him. That's also how the Gospel is composed. You can also consider the appearance of the resurrected Christ from a psychological perspective. But when you look at it philosophically, you're dealing with an intermediary realm. Jesus is one who has been broken down into individual pieces, into atoms. The dead are no longer constructed—through entropy they crumble into pieces that form again, from time to time, into another shape. Jesus is dissolved into pantheistic universality and can materialize now and then. Women came to his grave, entered his grave and couldn't find his corpse. Two men in shining garments, as it says in the Gospel according to Luke, came up to them and asked: 'Why seek ye the living among the dead? He is not here, but is risen.'

The question of the empty tomb is connected to the resurrection of Jesus Christ. The tomb is empty and yet the presence of the resurrected Christ is alluded to.

The hole, the empty space of the grave is proof that he was resurrected. Of course, you can't insist on that because his corpse could have been stolen.

The possibility that Jesus had been taken away is considered.

Yes, that was the first idea—that someone had stolen his corpse. But then it became clear. He appeared, he was there. As a result, the empty grave represents the miracle of the resurrection.

It represents the miracle that overcomes history. God's resurrection of Jesus brings a new perspective to the entire history of mankind.

That he will return as the Messiah at the End of Days. Jewish thought offers the idea that he will return, redeem the world and judge.

You don't share this notion?

I can't conceive of a final reckoning, a final decision, a final redemption.

Why do you think you were born?

That's the main question—I don't know. Our despair is that we don't know. We are conscious, we can think, we can understand so many things, we can express them— but we don't know why. It's a yawning abyss, an inconceivably deep, dizzying abyss. I don't have an answer. I can't say why. To me, simply being, just carrying on is

interesting enough, but I can't give you an answer. I have absolutely no answers.

How can you bear this?

Yes, it's difficult (*laughs*), by making my own world. I create space in the void. But it's all an illusion.

An illusion that is materialized in your work.

In my case, yes. I sometimes act as if there were an above and a below. I'll make a painting in which there is an above and a below, but it's all just an illusion. I simply claim that it's so.

In the paintings I saw in your studio today there is the movement of wings between the above and the below, a movement of rising or sinking.

I've borrowed that from iconography. The two levels, those are angels in the ancient mythological conception of above and below, of the divine and the human, of spirit and body, and so on.

The ascent and descent is also in your painting with the San Loreto motif.

I've always been fascinated by San Loreto. I saw it for the first time in a Tiepolo painting—the church flying at night from Nazareth to San Loreto. That's a marvellous concept and a very modern one: a physical body that moves, that dissolves and reforms elsewhere. That

is as crazy an idea as Mary's virginity. And so one of these paintings will be in the exhibition, since it fits so well.

Does it represent the defiance of gravity?

Certainly. It's the same with virginity. It's about overcoming laws of nature known even then, overcoming physical conditions. That's why San Loreto fits our topic perfectly.

Let me jump from the Virgin Mary's name to your name. In your first name, belief and understanding are constantly merging, their boundaries are fluid: Believe in order to understand, understand in order to believe, according to Anselm of Canterbury's statements. Can we say that you create using the interplay between mythology and reason?

Yes, because I've now explained mythological truths with scientific examples. When you talk about DNA, about the intelligence in each cell, you speak of knowledge we have established through science. We've only known this for fifty years. I've taken this as an illustration of fundamental mythological experiences.

Fundamental mythological experiences happen on a synchronous level whereas scientific findings occur within a diachronic time structure.

In my work, these are always blending with each other. Some knowledge helps illuminate mythological experience and some knowledge is gained through a mythological experience. For example, Alexander the Great marched off to find Prometheus' chains in the Caucasus. He believed they were there, so he set out for Turkey to find the chains. In his case, the impetus, the motivation came from mythology. This is how established knowledge and mythology overlap—they're constantly dovetailing.

The Russian poet Velimir Khlebnikov once proposed that everything is contained in the first letter of one's name. Do you believe that in relation to your name?

No, I don't associate meaning with particular letters. I was always fascinated by Hebrew mythology: every letter is holy. You can combine letters however you wish, there will always be a meaning, though it may not be deciphered for 500 years. This idea is connected to numerology. There is numerology in the Cabbala. There's also the proportion of numbers in Pythagoras, the ratio of the sides. There's a science of number relations and there's a mythology in the Cabbala. The two have enriched each other and that enriches my creative work.

Your family name is connected to nature. In Japanese poems, the pine tree is seen as a tree that is granted a long life. An

anonymous Zen poem says 'The pine tree lives a thousand years, / The delicate morning-glory blossom survives but a day. / But each fulfils its purpose.'

I'm hoping to last 100 years.

The pine tree is a nice image for strength, for longevity and endurance. For enduring longer than its own lifespan. And the pine tree is also central in a poem by the tea master and Zen monk Sen no Rikyu, who lived from 1521 to 1591 and is considered the founder of the wabi aesthetic: 'The courtyard is covered / with needles / from the pine tree. / No dust whirls / and my soul is calm.' Have you felt connected to these images in the Japanese poems?

I never thought about my name.

Did you never think that your first name is a beautiful name?

It is a beautiful name. When I realized what kind of name I had, I mostly thought of the entire Feuerbach family, the philosopher, the artist, the historian, the archeologist. This family produced a great many important artists and scientists, the critic of religion Ludwig Feuerbach. And there's also a well-known legal scholar Feuerbach. The Feuerbachs covered the entire spectrum of science and art and many of the Feuerbachs were named Anselm. The one I was named after was the classical painter.

The name Feuerbach contains two elements that play a central role in your creative work: water (Bach) and fire (Feuer). In your work, one could speak of a coincidentia oppositorum. *The collision of the two elements creates a third reality.*

Fire and water—which extinguish each other. In any case, I see myself as living in complete contradiction. Simply being alive is a contradiction. We don't know why we exist. Faced with this abyss, we should, in fact, quit living, and yet we stay alive, so it's a contradiction. We're living in constant contradiction.

The horizontal tilting to the vertical is a strong dimension of your work. While Hans Holbein's painting of Christ's corpse holds a horizontal plane, there's an energy in your Palm Sunday *paintings that shoots upwards.*

It flips. It happens constantly: the two-dimensional suddenly has three dimensions and what is horizontal becomes vertical. If you take painting, as artistic activity, there's the horizontal level on which something is represented, whether a field, a forest, or a sea. In the course of painting, as it proceeds, there's a point when the picture flips vertically and acquires what we call a meaning. That's when I know why I'm painting the picture or what the picture means. That's the vertical level. It stands like an exclamation point. Before that, it's just a landscape.

And what is the source of the secret?

The secret is something the artist instils in things. A tree or a forest is at first just a tree or a forest. But when realization sets in and tells me why it's there or when the picture tells me why, then the tree is made secretive. Novalis coined the word *vergeheimnissen* for 'to make secretive'.

In your work, secrets have a revelatory significance.

Yes, if you take significance in the meaning of 'sense', it plays a revelatory role. By sense I always mean an illusory sense. A secret is something veiled. I don't unveil the secret—I create the secret.

Could one speak of a process of manifestation?

Yes, or one could say that it's the appearance of the secret's outer skin. Or as the novices of Sais have it: the appearance of the curtain. A secret is something one creates.

From what?

From nothing.

From the void?

Yes, but also from matter. Matter also has a secret. I don't believe that the secret is above and matter below and that the idea first gives a thing life. I mean that the

idea is inherent in the thing. Things already contain the secret.

If you consider the problem of universals in the Middle Ages in this context, would you say the secret is in rebus?

Yes, that's right. In one group you had the realists and in the other the nominalists. I'd say I'm a materialist, not a nominalist. At the time they were arguing over an interesting theological process. It was about overtaking Platonism, or, more exactly, about ending Platonism. According to my perception, essence resides in matter. That's how Gnostics see it. Gnostics believe you have to extract it from matter so that it will then deteriorate.

So your work can be seen as an entering into matter?

An opening of matter, an exposing of matter. You could perhaps also say: I make matter secretive again by exposing it.

The image of the dress and the associated undressing brings a veil to mind. The veil simultaneously hides and draws attention to what it covers. The veil before the Ark of the Covenant. And to bring the conversation back to Mary: in the hymn Ave Maris Stella, *Mary is praised as the Ark of the Covenant.*

The Ark of the Covenant is the secret per se. It begins with the burning bush: I am that I am. The Ark of the Covenant is the secret materialized.

The burning bush—in your studio today, I saw flames on the branches of black trees.

The burning bush that doesn't burn. With me it's the fields that burn.

Even the petrified form of matter burns.

Stone itself burns. The Romantics portrayed this: the Romantics dismissed the difference between animate and inanimate objects. At least Adalbert Stifter did. He described things—trees, stones—as if they were alive and human relationships as if they were dead, as if they were stone. Stifter described the effortless transition from inanimate to animate. He declared the animate to be dead and the inanimate to be alive. That's what's interesting about Stifter. He's not the Biedermeier writer many take him for. He goes much deeper.

I get that feeling from your paintings too: sand, ash, stone— alive.

Yes, that's right. It's simply very limited to think that only what is animate is alive. Stones are also alive. I find that especially in Stifter's work. That's why I've always been fascinated by Stifter, contrary to the general opinion that he's a Biedermeier writer and unreadable. In this respect, you could say that Stifter was a Romantic in the philosophical, not the Biedermeier, sense.

As we mentioned earlier in relation to the tea master and Zen monk Sen no Rikyu, there's the wabi aesthetic in Japanese traditional culture, an aesthetic determined by the central tenet: things like leaves, twigs, and so on crystallize their true essence in the transition to withering, on the threshold of decomposition.

Yes, of course, matter decomposes. A stone disintegrates; it turns to sand; it is carried out to sea, and so on. This decomposition is essential to things. Everything disintegrates. A thing's true essence is revealed in decomposition. I've always been fascinated by mountains, by 6,000-metre mountains that disintegrate into sand and are carried out to sea. That's fantastic.

You have a special affinity for the mountains in Salzburg.

The photographs you saw in the studio are ones I took last year. I've always been drawn to cliffs. There are passages in Hans Henny Jahnn's novel trilogy *Fluss ohne Ufer* [River without Banks], with descriptions several pages long of walks through a rocky landscape. It's almost like Stifter, who describes it differently. The passion for these crags and boulders that become inflamed in Jahnn's writing as if they were alive. The cliff paintings are new beginnings. Some have wings and fly away or have flames shooting out from them.

In a few paintings the mountain massif and the individual boulders are portrayed on two levels. The boulders below and above them . . .

. . . the piles behind them . . .

. . . a painting of eternity . . .

. . . that is no eternity . . .

. . . that is disintegrating . . .

. . . constant change . . .

. . . that's why I thought you'd been influenced by Buddhist philosophy because it has constant transformation as a central tenet.

I've certainly been influenced by it. You also come to this realization if you've lived long enough and been observant long enough.

The impermanence of things.

Constant transformation, naturally. My paintings all change as well. They aren't as technically well made as some others' paintings. Mine are constantly transmuting, things are always falling off them.

The falling ash was a very beautiful sight in Grüber's Oedipus at Colonus.

The idea behind the ash was that everything was playing out in dissolution.

174

And the human body is also prey to decrepitude. It turns as fine as a layer that disintegrates into another state, into another form. The transition from one state of being into another strikes me as central to your work.

I am preoccupied with constant change. It's most obvious in mountain ranges. The most banal instance of transformation is when mountains are worn down and carried off to sea. But there is also transformation on other levels, with photons that come from the sun, rays of light that turn into warmth, points of light, waves. It's impossible to comprehend certain atomic phenomena and movements. You can't record them because they're always in flux. You can achieve new findings in astrophysics and especially in atomic physics. It's impossible to photograph anything solid in particle accelerators. You can't capture and hold anything. You can only reconstitute indirectly what is caused by the collision of two particles.

Committing yourself to the process of transformation—is that how you see your work?

That's my kind of mimesis, if you will, mimesis not as the reproduction of a face or an object, but mimesis as the reproduction of what I see as the fundamental movement of the world.

Paris, 10 April 2008

For your staging of Am Anfang [At the Beginning, 2009], you selected verses of the prophets Jeremiah and Isaiah. At the start of the Book of Jeremiah, Yahweh charged his prophet in the following words: 'See, I have this day set thee over the nations and over the kingdoms to root out and to pull down, and to destroy, and to throw down, to build, and to plant.' Does Yahweh's command to Jeremiah contain the fundamental movement of the world in your eyes?

Yes, but not that of the later Christian world. Because the Christian ideology or idea is like a rising line, like Ernst Bloch's rising lineage of salvation in Marxism. In the Old Testament there's a continuous cycle of building and destruction. Yahweh is constantly destroying everything and leaving only remains as a catalyst for a new process of development. If you look at this in a larger context, it's the emergence of a new evolution. It's impressive and shocking to see the zeal with which Yahweh constantly destroys everything, with what level of vengeance he does it. You can't call it hatred. The idea of revenge is always very much in the foreground. I always found Yahweh's wickedness, so to speak, in the

Old Testament provocative, the ritual of destruction, too. In the Old Testament, He is always saying: I will destroy everything, I will devastate all, jackals will live in the ruins. But a small twig, a tiny seed will be left—in Jeremiah and in Isaiah—from which a large people will grow.

In Isaiah there's the image of a tree chopped down to the roots. This stump is then designated as a 'holy seed'. You chose that particular verse in your selection.

There's the famous root of Jesse, from which the twelve tribes descend. I see the development of the holy people from a biological perspective as well. Just as the wide range of animals developed from an amoeba in the sea, so too the twelve tribes that make up the diversity of Jewish culture originate from the root of Jesse. The remnant is the starting point for a new evolution.

The number twelve also stands for the entire universe. Is that why you decided on twelve towers for At the Beginning?

That's right. Twelve is recognized as a very important number. Initially, there are thirteen apostles. The thirteenth is eliminated, he decides against it. That's Judas, the evil one. There are thirteen entrances to the *hortus philosophorum*, the philosophers' garden. Twelve and thirteen are important numbers. Seven is as well. There's a rich system of number symbolism in Platonism, in

Neoplatonism and in the Cabbala. Numbers are very important in alchemy, too. Numerical proportions are extremely significant in the universe. In music there are the twelve tones. There are also theories according to which the stars and the satellites follow a numerical system. The music of the spheres is the relationship of the celestial bodies to each other.

Are the twelve towers a model for the history of the world?

Yes. What I'm representing in *At the Beginning* is a very small segment of history. My play is set in the so-called Fertile Crescent that stretches from Egypt, across Palestine and Syria, over Anatolia to Mesopotamia and from Iraq all the way the Persian Gulf. This area is very important in the evolution of mankind. This is where humans settled for the first time. For example, they found settlements in Jericho that date from 10,000 years before Christ. It's in this region that our culture and our humanity developed. It's the region in which the Jewish people spread out. The individual tribes were torn apart. Some went to Egypt, others were abducted to Babylon by Nebuchadnezzar. It was a very violent time. And the prophets Jeremiah and Isaiah were active in this turbulent time. There was enormous political confusion. For Jeremiah, it was the abduction to Babylon. At one point the Assyrians were governing under Nebuchadnezzar and in the end Cyrus came to

power. He, in turn, fought against the Assyrians and granted the Jews a certain autonomy. So there was always some back and forth.

In those politically virulent times, Yahweh gave his order to Jeremiah.

Isaiah is called to become a prophet with a live coal that is taken from the altar and touched against his lips.

Yahweh's words are fire in Jeremiah's mouth and the people are compared to grass, to dried-out, desiccated grass.

This grass is very vulnerable to devastation. The image of the fire on his lips shows that most prophets didn't want to be prophets. They understood what they were getting into. The prophets resisted. They hid in the desert and hoped Yahweh wouldn't see them. They said: No, Lord, leave me in peace. Isaiah returned to his properties. I think the comparison of the prophet's role with the artist's is interesting. Artists—like prophets—don't create things from within. There's always something there that works through him. What you create as an artist is often incomprehensible at first, even to yourself. You have to step back from the canvas and see what has happened. It's hard work. Sometimes you really don't even want to make the particular work. With prophets, it's often the case that they're frightened by the words that are put into their mouths.

Did you have a similar experience of being called to service, since you just drew a parallel between the prophets' fate and that of artists?

I'd always had an aversion to my petty-bourgeois background. I've always felt like a cuckoo's egg laid in that nest. I knew that only artists can transcend being born into a particular social, ethnic and ethical situation. But for me it was more the reverse: I wanted to leave whereas something comes to a prophet.

There are similarities between a prophet's work and an artist's: there's the decisive impetus to stop the political process and the process of destruction. Just as Jeremiah pointed to the coming destruction in his prophecies, you show in your paintings, sculptures and installations, in your own way, what kind of destruction is now taking place or has already occurred. They also show where extermination and eradication, ruin and destruction lead.

I feel that in every painting. While producing each painting, I often despair over the results. In the meantime, I've developed ways to wipe out everything except for a few remnants. Either I use fire or ashes on the painting or I cover it with sand and so on. In the very process of making a picture there's a creation and a retraction, destruction, too. Something new can emerge from destruction. I've often worked on a painting with

a hatchet, with an axe and such. With this rhythm I obviously feel at home in the Old Testament.

Could your work be seen, in light of the Old Testament, as an aesthetic of the remnant?

Yes. I often leave my works in the open air and wait until there's not much left to be seen. Then I start again from the beginning. Or I go at the paintings with a flamethrower so that they're completely covered with soot. And from this, too, something new is created.

In the Book of Jeremiah, there's the image of something new arising from the sheaves left lying on the croplands: from the remains.

It's a cycle, sometimes even a cycle without any expectation of results. The grain is left unthreshed on the field because there's no time to gather it. From this result—ripe crops are a result—something new arises because it rots. The idea for the project in the Opéra Bastille came from the thought that the 'remnant' is a frequent theme in the Old Testament. It says there will be a remnant. And from this remnant, from the cinders, out of the ashes, something new will arise. Remnants fascinated me from very early on.

The tower ruins in At the Beginning *are marked by human destruction. You can see black traces from smoke and fire.*

Or you see rusted reinforcing bars. The rusting reinforcing bars crack the concrete and the rust runs down the wall.

There's also a broken vessel in the landscape of ruins, another image for the breaking of the vessels.

Yahweh says to Jeremiah: Go and stand in the gate, take a clay pot, smash it and say, this is what will happen to you. Isaac Luria probably took up the parable of the broken clay pot for his *Shevirat Ha-kelim.*

Will there be a Tikkun?

No. I don't believe there will be a *Tikkun.* The idea of the Messiah is not in the Bible in the beginning. It came later.

In the Book of Isaiah there's hope for a messianic kingdom.

The famous expression *aperiatur terra* is in Isaiah. I still have that phrase in my head from the Catholic liturgy. It's very important in Christianity. But in contrast to the New Testament, there's no endpoint in the Old Testament—there's no end in the sense that history will stop. The message is always: you will multiply, your descendants will be as abundant as the stars in the sky. But it's not the case that paradise will come to be when time ends.

Creation goes on.

The threats continue. And the selection also continues. It's even a specific kind of selection: ostensibly only the best survive.

The faithful who have kept the covenant with Yahweh.

It's like in evolution. There are thousands, millions, of species that have become extinct.

'The survival of the fittest.' According to Darwin, the species that adapt best are the ones that survive.

To their surroundings. You can't say that about the Old Testament (*laughs*). In the Old Testament, the ones who are least adapted, who are best at setting themselves against others are the ones who survive—but that's just a detail. Still, the principle of selection is present in the Old Testament: separating the wheat from the chaff. That's a common expression in German. Not many know that it comes from the Bible.

In the centre of your stage set there's a pile of lead books. On top is an open book.

The towers are built with lead books. Between the individual levels there are always lead books as shock absorbers. The Shekinah sits on the pile of books because she can't always be moving around. At some point she has to sit and listen to the music.

Is the Shekinah meant to evoke the image of an angel?

An angel is not vulnerable. It doesn't break. It can fly away from the rubble field. The Shekinah is more like a child walking through the ruined landscape in a white robe. The fragility and openness to new opportunities is tangible in the white.

In the Bücher [Books] *exhibition, which Hainer Bastian showed in his museum in Berlin in autumn 2008, there was a painting with the title* At the Beginning (1985). *In the painting, an open book was mounted on the line where the sea meets the horizon. Why did you choose this title for your staging as well?*

There is no beginning for me, just the end, which is simultaneously a beginning. The stage set strikes some in the audience as ruinous but for me it isn't. To others it resembled the fallout after some great catastrophe. For me that's exactly the beginning. I want it to show that the beginning is always the end and the end is the beginning.

This idea argues against a creation theology that originates with a creatio ex nihilo.

I have a hard time picturing this 'nothing'. Much has been written about this 'nothing'. For Heidegger it was the *nichtende Nichts*, the nihilating Nothing. *Nichten* is a verb and we stand in opposition to this Nothing—the engendering of existence. Using my work as a departure

point, I cannot imagine Nothing. The paintings come from my memory spanning millions of years. No one can imagine Nothing. There are many, many ideas about the void in Schopenhauer, Kant, Heidegger, all the philo-sophers have laboured over this question. Nothing as nothing is completely unimaginable for us.

In At the Beginning *there are quotes from the Old Testament, from the prophets Jeremiah and Isaiah, also references to the Trümmer-frauen, the rubble women, in Berlin and Germany, who collected and cleaned bricks after the Second World War, and started the rebuilding of the devastated buildings and cities.*

In my notes and sketches for the staging of *At the Beginning* at the Opéra Bastille, there's the following note next to a reference to the rubble women: 'Ernst Reuter in Berlin when the Wall was being built: People of this world, look upon this city.' Reuter's pronouncement is that of a prophet. There's also the following association: the leper's rattle. In the past, ratchets were used at Easter. I have to keep the ratchets' rattle in mind.

Kantor used Good Friday rattles in Wielopole, Wielopole *to drive the dynamic of Christ's death and resurrection to a climax.*

I was an altar boy in Rastatt and I can still recite the prayers in the Latin liturgy by heart. During Holy Week,

I would make noise with the ratchet as an altar boy. We rode our bicycles through the area and rattled the ratchets. It was eerily beautiful. At eleven and at noon, because we had no bells from Good Friday to Easter Sunday.

The church bells were flown to Rome at night after the Last Supper and were returned to the church in time for the Resurrection mass.

Can you still say the Latin prayers?

Yes, some of them. At the start of my service as altar boy I had to memorize all the prayers the priest gave us. My mother tested me.

It was the same for me. I didn't understand a thing, the Introit antiphon, for example: 'Rorate caeli, desuper, et nubes pluant justum: aperiatur terra, et germinet Salvatorem.' The most difficult prayer from me was the opening of the Offertory. I always stumbled over that one: 'Suscipiat Dominus sacrificium de manibus tuis ad laudem et gloriam nominis sui, ad utilitatem quoque nostrum totiusque Ecclesiae suae sanctae.'

At the end of your staging, the rubble women sweep away the dust with bent backs and birch brooms in hand—it's a beautiful image for a new beginning.

With those dresses, the rubble women are practically encased in stone. Almost a unity.

The destruction in your stage set is not limited to the area of the 'Fertile Crescent'. For you, the rubble women and the bricks comprise the 'latest nanolayer on the rubbish heap of history'.

The idea of the rubble women came to me while I was working on the project. They're the visual representation of what I want to show. In Germany, the rubble women are a new mythology, a very modest mythology. In the federal states there are statues of the rubble women holding hammers. In photographs, you see the rubble women standing and working on the sides of roads, roads that look like paths. Back then everything was razed to the ground. Not long ago I read in *Schicksalsreise* (Destiny's Journey), Alfred Döblin's autobiographical book from 1949, what he wrote about the dead and the devastation: 'The debris also hides many corpses. They lie there and make the streets horribly silent.' Döblin noted about Pforzheim that the city didn't exist any longer: 'It is flattened, erased. One skeletal building stands next to another and behind these skeletons is a chaotic mass of rubble. You get the feeling you're walking through a film set, backdrops, accessories and foreground structures—a dead city, deserted. But if you look more carefully and linger a while, you will notice, to your surprise, that even here life stirs underground.' The rubble women piled the bricks into a kind of wall for them to be carted away and used again.

In a BBC film in the 1980s, I had rubble women come to my brickyard in Höpfingen and clean bricks. I was fascinated by the sound of bricks, even then. It's like music. The composer Jörg Widmann used the sound. He thought that the way this sound can be incorporated into music was fantastic.

In the BBC film, the rubble women were models who had to clean the brickyard.

I'd ordered twenty models. They all came wearing red nail polish and make-up. First they had to take off the nail polish and the make-up. They had to put on ashen dresses and ashes were strewn on their hair. They were disappointed (*laughs*). Their job was to clean the bricks. They knocked the bricks together and made music. Later they swept the floor over the kilns.

At the end of your staging, when the floor is being cleaned by the rubble women, the swinging motion of their bent torsos resembles that of a metronome's hand.

Right, or of a windshield wiper that clears a new view, that sweeps away debris and opens up an empty space again. It's almost like *tzimtzum*. An empty space is created and then the play is over because it's the beginning.

The sweeping rubble women reminded me of monks in India who take such care of all living beings that they sweep the ground before each step so as not to step on even the tiniest creature.

They're mostly Buddhists.

Respect for new life is also inscribed in the image of the sweeping rubble women.

The rubble women leave and, in a counter movement, the Shekinah reemerges at the end.

The image is very dynamic because the rubble women retreat into the depths of the room with a sweeping motion and the Shekinah emerges from those depths, making a new beginning possible.

But she retreats again immediately. The beginning ends on the ground with a collapse. When I was working the production with Jörg Widmann, my idea was that the music should keep starting and stopping. The idea of an interrupted beginning always intrigued me.

What leads to the constantly interrupted beginning?

The interrupted beginning has to do with fragments. We can no longer conceive of anything whole. All science, all ideas are too disparate. I see this phenomenon, to name another example, in the Internet as well. You open it up and look inside—and it is only ever a beginning. There's such an incredible amount of information in the Internet that you only ever begin and then stop again. There's another view, too: that there's not just cycles of the same thing occurring over and over again but also that the beginning is always immediately

torpedoed. There's chaos and also impermanence. You also find this impermanence in the Old Testament. Yahweh is always saying: I offered you everything, I gave you my oath and all for nothing, you disobeyed yet again. It's not just about vengeance and threats but also about futility. He is a disillusioned God (*laughs*). He doesn't give up, but He's very disappointed.

In his study of Jeremiah, the Old Testament scholar Walter Brueggermann stresses that Yahweh never destroys his people completely. For Brueggermann this is the central tenet: God's devastation is never complete.

Yes, there should always be some remnant. The end is never final because God can't conceive of a complete end. He's still not sufficiently prepared philosophically for a complete void. He's not philosophically at the level of a complete void. Just as we can't ever be either. All of creation is an imperfection of God's, it's not just that creatures are imperfect. Yahweh would prefer that nothing existed any more, but He can't do it—he can't do it because of his philosophical impotence.

Or because of his love?

I deeply mistrust this perverse kind of love (*laughs*). These threats have nothing to do with love. Actually it does—with perverse love.

In Heinrich von Kleist's play, The Broken Jug, the jug breaks because there's a moment of love between the village judge Adam and Eve. What do you think causes the jug to break in Kleist's play?

It's because the relationship between the young woman and the judge is a misalliance.

Might there also be, in your view, a misalliance between God and man?

Absolutely. The proof is everywhere (*laughs*). Things never add up. It's a misalliance: God creates man and sees that it is good. And what comes of it? The worst possible result. Men are always killing each other, even now, by the millions with bombs, with primitive hatchets, with swords, men are killing themselves all over the world. This extreme situation, this extreme attitude runs not only through the Old Testament but also through Arabic literature, through Sufism, through the writing of Fariduddin Attar. When I engaged with this question, the fact that there were literal parallels in the Old Testament, especially in Job, and in Attar who also argues with his God and partly curses him in his *Book of Suffering*, in which he travels through the world and only sees evil. Attar lived in the twelfth century. Later there are literal parallels in Heine, too. The Jew Heine came to a strange kind of faith in Paris. He was confined to bed for seven years, suffered from syphilis and I don't

know what other illnesses, in any case, his life was quite horrible. In this situation, he became a believer and railed against God like an Old Testament prophet, like Job. There are literal parallels in Jeremiah, Attar and Heine. Here's my thesis: for 2,500 years, the same words have expressed why it's impossible to understand why the world is the way it is, why there's no meaning. At the end of Job there is meaning again, it is restored but only at the very end and it's not clear if it hasn't just been added on. I was always captivated by the fact that Job says almost the same thing as Attar.

In the introduction to At the Beginning, *which you yourself recite in French, you also quote the poet Andreas Gryphius who laments the destruction the Thirty Years' War brought into the world.*

The Thirty Years' War wreaked destruction of an unimaginable scale across Europe. Churches were destroyed, everything was broken. Hardly any relics of art from that period have survived. In Gryphius' poem 'Tears of the Fatherland, Anno 1636', there are images similar to those in Attar and Job: 'We are now utterly, still more than utterly destroyed! / The brazen hordes, the blaring horns / The sword bathed in blood, the thundering cannon / have devoured all our toil and sweat and our reserves. // Our towers are alight . . .'

The metaphor in the Book of Isaiah of the prince of peace, Immanuel, 'God with us' as well as the metaphor of Jerusalem's resurrection—do you see these as visions given to humans so that they will carry on?

That's the carrot in the hamster wheel that you chase after but never catch. You run and run, but the carrot is always just out of reach. The prophets also had their political interests. Jeremiah didn't want the Jews to go to Egypt—he wanted them to go to Assyria with Nebuchadnezzar. That was his political decision, but the king didn't want that. There are many parallels between prophets and artists. I don't know how often Jeremiah and Isaiah were imprisoned. Jeremiah was confined without drinking water in a deep pit full of mud. But he was rescued in a near miracle. And later, he was seated next to the king again. The constant back and forth corresponds to the history of art. To some extent, artists are disdained, held in contempt, persecuted and destroyed, their works available only in samizdat. And on the other hand they're also revered. Both situations existed at the same time and one after the other.

Jörg Widmann's composition sounds like the rush of the wind.

Initially, we'd only planned on using four instruments. Jörg and I decided we wanted wind, light wind too, that you can barely hear. To produce that soft sound, you

need a lot of instruments. Any one of them can be loud, but you need many of them playing softly to hear the restrained sound.

Why do you think Confucius claimed he knew where the wind comes from?

If you know where the wind comes from, you've got the coherence of the world. Thoughts go very far. They're comprehensive, encompassing. Back then they didn't know the earth is round. When you're busy with the wind, letting the wind take you, you always end up moving in a circular motion. The wind brings something from far away, where you can't be. For example, the wind brings sand from the Sahara to Spain and Italy. The wind transplants matter and reminds us of things past, of places and times that are far removed from us. When you know where the wind blows from, you have universal, all-encompassing knowledge.

If this is your view of the world, why did you choose verses from the prophets Isaiah and Jeremiah and not from Ecclesiastes?

I didn't open the Bible and look for quotations. I used verses I'd carried in me for a long time. And those were mostly from Isaiah and Jeremiah.

And what does the wind do when it's not blowing?

Then there's constipation, a blockage (*laughs*). There's no more news—everything comes to a standstill. The wind is calm before a huge storm. In this calm before the storm, there's a great buildup of energy.

Just as the Spirit hovers over the waters in Genesis, you could say that jeremiads hover over your stage set like a wind blowing through the towers.

It's words that the wind carries off—away over it all. When there's a strong wind, you can feel the sound waves travel. You can also feel the words being deformed or torn by the wind. That's another instance of destruction. Speech is formed in the larynx, it's something malleable, supple. Some people are described as supple speakers. In matter, this malleability is ruptured, torn into individual units and is heard only as noise.

When words are carried off by the wind, it sounds like stammering or stuttering.

I often used the words stammering and stuttering in my conversations with Jörg Widmann. The shock of an experience is there, but you don't have the means to express the experience. So you have a stammering, a stuttering. In the Old Testament, the insane were very important and were partly seen as holy. They only spoke gibberish but back then people knew that something was hidden in it, something that transcends what

they themselves could conceive at that moment. Stammering and stuttering are signs, indications of something greater, more important, that humans can't grasp in the moment.

A response to the shock?

No, not a response, but the expression, the impossible expression of it or you could also put it as Heidegger did, the inauthentic expression of that which is not yet contained in normal speech. It's a not-yet, something that is showing itself but has not yet been objectified.

That would be the interrupting motion at the beginning. The destruction is caused by a misalliance, two beings cannot be joined and their collision brings about the breaking of the vessels.

According to Isaac Luria, God pours his grace onto the Sefirot, onto his creation, and half cannot withstand this and break immediately. It was created in such a way that it could not withstand.

According to rabbinic interpretation, as presented in André Neher's study of Jewish identity, the world was not created by God's hand. 'On the contrary, twenty-six attempts were made before the Genesis, all of which failed. The world of men emerged from the chaotic centre of the earlier rubble; but it has no 'warranty'. It also runs the risk of failure and returning to the void. 'Halváy SheYa'amód,' 'If only this

one would last,' *God called out when he created the world. This hope accompanies the history of the world and of mankind and makes clear that this history was marked by extreme uncertainty from the very beginning.' In Isaac Luria's cosmogony, the vessels cannot contain the energy of the light poured into them and they shatter.*

There's no correspondence between the grace that God emits and the vessel meant to receive it. The vessel shatters. That is expressed in the word misalliance.

Broken communication.

Broken communication sounds too weak for what happens. It's much more of an annihilation.

That's one form of destruction, another could come from cosmic powers, a meteor colliding with the earth, for example, or more specifically, with the towers.

Not only that. It's very interesting how we are protected from the sun's rays. The sun emits so many gamma rays that it could destroy everything on earth in a hundredth of a second. We're protected from them because the earth has a magnetic field that filters these hard rays from the sun. They would kill everything on earth immediately if the magnetic field weren't there to protect us. We live in a very precarious balance on earth.

The balance can also be upset by earthquakes.

In the Book of Jeremiah it says that the earth will tremble.

This type of destruction lies beyond human destructiveness.

Yes, but I see it all in context. I see the fragile cosmic situation mirrored exactly in society. I see human societies as very fragile. As soon as there's a slight change in society, the entire balance is threatened. When there's a bad financial situation, as there was in the 1920s, it takes very little for disastrous tensions to take hold. We know how intricate, how fragile the entire system is that mankind has built to protect itself: laws, constitutions, states. Thomas Hobbes and Carl Schmitt have pointed out that strong laws are necessary to keep men from devouring each other: *Homo homini lupus.*

In the realms of destruction, there's a woman who walks among the ruins, who finds respite in the ruins: Lilith.

Lilith does not find rest. In the apocrypha and in the Old Testament, it says that Lilith dwells among the ruins, in abandoned cities. Lilith is the antithesis of God who created a supposedly perfect world. Lilith is the one who challenges God's perfection from the very beginning. Lilith is in principle what the devil is. She causes unrest. She brings into this world the seeds that are always bringing disruption.

Lilith gives birth to the devil.

Every night she gives birth to 3,000 devils by the Dead Sea. She collects men's semen and makes little devils with it. Lilith is that which in *Faust* is called the spirit that denies. She does not want to beget children with Adam. She does it differently.

Lilith is a counter-reaction.

She's not a counter-reaction, but the opposite that is contained within God Himself, the personification of the opposite of God contained within God. Because God is all, it is said. In Goethe's *Faust*, Mephisto says of himself that he is a 'part of that great power that always intends evil but always does Good.'

With Lilith there's no longer any good done.

That depends on how you see Lilith. There are a great many visions of her. Feminists see Lilith's actions as very positive, namely, as a denial of the patriarchy. Lilith is not just negative. She's a negative figure in the Old Testament, but as a mythological figure she offers enough room for a positive interpretation.

Why did you decide to present the voice of the prophets Jeremiah and Isaiah as female in your production?

Initially for me, the Shekinah was a decisive idea. She is the personification of God in the world, and so of the diaspora, the Jewish people that wanders through the world without a place of their own. The Shekinah

wanders the world until the Messiah comes, until the end arrives. That was that original idea. Before that I had the image of the towers. I asked myself what I should put in the landscape with the towers. The idea of the Shekinah occurred to me and I thought that she could also embody the sayings of the prophets. She wanders through the world without a homeland. She's also the one who suffers all the destruction. She represents the people. I let the prophets' words speak.

The Shekinah wanders the world in a particular way—in a spiralling motion?

She makes two spirals, one behind and one towards the front of the ruined landscape. The Shekinah strays through the world. A confused wandering, completely chaotic. Chaos is, admittedly, no metaphor. A metaphor emerges only when there is a collision between chaos and rules, when chaos and form chafe against each other. At first I had the Shekinah run around like a crazed hen. Then I came up with the idea of integrating her into the system, with a spiral that follows the golden ratio, a spiral tangential to each of the towers. You don't know that as a spectator. You can't see the spiral of the golden ratio.

The golden ratio is also called divine proportion.

As confused as the Shekinah may appear, she follows a particular geometrical pattern. In the golden ratio, the

proportion is always 1:1.65. Just as the towers make a geometrical form, so too the Shekinah must also have lines. I still don't know what the path will look like when it's done. Maybe the path is also a little compulsively neurotic (*laughs*). It's known that some neurotics have a geometric principle—they always have to walk in right angles. They walk along the wall and, when they paint, they always depict things with right angles. That could also come into the production. It would bring in the insanity that was seen as holy back then. And also the fear that one will collapse completely.

You're looking for the last possible refuge when you're walking along a wall.

Along towers and lines. That can be compulsiveness and it conforms very closely to the following idea: at first I had planned to draw constellations of stars on the ground, invisible to the spectators. The Shekinah follows the constellations. The spiral following the golden ratio has a correspondence in the heavens. Humans created the constellations. You can't see the lion in the night sky, it takes an effort. Humans created shapes in the starry sky almost compulsively, in order to orient themselves, which of course is illusory. You can have a similar association with spirals. It's a geometrical shape in a completely chaotic picture or in a chaotic landscape.

Something bursts into this landscape.

I thought of the *Shevirat Ha-kelim* in this context, of course. We let liquid lead drip down. These are associations with 'Rorate coeli', 'Drop down, ye heavens from above, and let the skies pour down righteousness,' as the Advent song goes. The sky will melt. There's also a passage in the Bible that tells of the sky turning completely black. The sky even sheds its skin. The idea is that in *At the Beginning* something falls down from above. We haven't worked it out completely, but later there will be puddles of lead. The Shekinah will go from puddle to puddle and kiss what has fallen from above. It falls from very high, splashes down and spatters in all directions. The lead will be melted up there.

Like the seething pot mentioned in the first chapter of the Book of Jeremiah.

That is one association. I thought of something else, but the seething pot is good. It's grace that is streaming out of it. I've had the idea of dripping lead for a long time. I wanted to realize it in the exhibition *Shevirat Ha-kelim* (1998) in the Chapelle de la Salpêtrière. The dome is 34 metres high. I once dripped lead down with no spectators. It was fantastic. It landed, barely still liquid, and spattered in all directions—wonderful. It's also the idea of something immaterial becoming matter and falling down.

There are two metaphors with lead in the books of the prophets: the plumb line of desolation and the plumb line of righteousness.

Both are very powerful, of course. In *At the Beginning* I have the rubble women hold a plumb line to build the wall. It's also interesting in connection with the Sefirot because with the tree of life, there's righteousness to the left and love to the right. When the righteousness becomes too great, it no longer has a shape. Everything becomes chaotic and collapses. It's the connection between Binah and Chokmah.

This connection has become part of your stage set. Transformation is present, too. In the Book of Jeremiah, the measuring line of emptiness will become a measuring line of love. The rubble women use a measuring line to build a wall to the left and right.

A wall is built, the beginning of a larger construction. Originally I had the Shekinah knock down the wall again, but I ended up pursuing that idea differently. The Shekinah reassembles the shards of the vessel and breaks the vessel again. Lilith knocks the wall down in the end. That's how the production ends: with a break.

Will you also have leaves of gold fall onto the landscape of ruins?

First I have to see how the falling golden leaves actually look. If it's too kitschy, I won't do it. The original idea was: just as there are repeated glimpses of a beginning and of something hopeful in the books of Jeremiah and Isaiah, I wanted to have showers of gold fall once or twice. Like manna in the desert. Gold is the third form in the alchemical process, a final stage of refinement. Gold immediately makes you think of the background in medieval paintings. Everything was painted on a gold background then. Gold as the intellectual, the spiritual that nonetheless rains down in fragments, briefly, not much. I still don't know if I'll do it, maybe they'll look like star talers—that would be too kitschy.

The heavens open.

And that renews earth. We know from astrophysics that the earth was heavily fertilized by the cosmos, through meteorites that kept hitting the earth. The meteorites brought metals that were not previously on earth. I think of this also in relation to falling gold. That is also fertilization, an enrichment.

In Jeremiah, corpses are described as fertilizer.

Corpses described as manure for the ground also means that the catastrophes, the wars and all the brutality are necessary for something new to arise. Manure assists something new. Naturally, that's a very cynical perspective in the Bible. In the Book of Job, God makes

a wager that the poor sap will lose everything he has, will suffer and so on, and yet will still believe in Him. A cynical wager.

If you look at it from a perspective that sees something remaining—like the bricks that in the catastrophe have fallen into pieces of a building, then a new formative power can turn old bricks into something new.

It's not just a new power—extermination is already part of evolution. As is restoration. Evolution that marches over a great many species of animals, and will march over us as well. I don't share the view that in these vast spaces, we are the centre of the world. Our solar system is in the Milky Way and a system like the Milky Way appears in space as a small dot. You can't imagine that there's life somewhere in this horribly vast expanse. In light of this expanse and this multitude of celestial bodies, that chance can't only have occurred once. That's why I find it so absurd to say that life has been found on Mars and that there's water on Mars. That's completely absurd because somewhere out there, there is certainly life that we can't perceive. We only see about I per cent of everything anyway. We hardly perceive anything. We are limited to the parameters within which we can survive.

I once discussed this topic with a taxi driver in Kyoto. He said, 'It's so limited, what we know and what we see.' The

taxi driver said it with a conviction that came from a deeply Buddhist way of life.

Naturally, what we know is nothing. There's a form of life that we can't see or apprehend with our senses.

Just as certain pitches are not audible to human ears.

We humans compared to dogs: a dog can hear from a distance of 4 kilometres if it is its owner's car. That's a completely different order of receptiveness. Or a tick—it has only two sensory systems: when a warm-blooded animal passes, the tick senses sweat and warmth. When these two features appear together, it drops and lands on the skin. When we're compared to other possible life forms, with a life form that apprehends far more of the world than we do, then perhaps we are on the sensory level of a tick. Then we should become small, very small indeed (*laughs*). We are the ticks. We react to very few things compared to a life form somewhere else that sees us as ticks.

There's the attempt to make access to the fourth dimension mathematically plausible using interfaces: when you inter-sect a line, you get a point; intersect a surface, you get a line, intersect a sphere, you get a surface. So the question is: What is a sphere the interface of?

It goes higher and higher, and we're only at the beginning. With our brains we've only just recognized that

we apprehend nothing. That's our consciousness, that we apprehend almost nothing. That's how far we've come. We're standing on the lowest step.

Animals are not granted any self-reflexive knowledge.

A dog probably doesn't know it yet. A dog probably doesn't realize that it knows nothing. People say that animals have no self-reflexive knowledge. But on this question you have to be careful. I don't know, maybe animals do.

Is there an anthropofugal philosophy hidden behind your thinking?

Yes, at least, a philosophy that is no longer anthropocentric. I've always seen things that way. Joseph Beuys, my teacher, was one of those who believed that man is at the centre, he must continue to be formed. I always just sat there and said, 'Beuys, I don't feel that, as a human, I'm at the centre. There's more.'

What did Beuys say to that?

His answer was 'No, no, if we accept that, we can give it all up now.'

For Beuys it was about form.

Actually, it was about man as the pinnacle of creation. It's a very Christian mindset.

You're shifting paradigms: away from an anthropocentric worldview to an evolutionary one.

The concept of evolution is not limited to the earth. Space, the cosmos is always evolving. There is constant becoming and passing away. Entire stellar structures collapse and are formed anew.

In the Book of Jeremiah, the process of becoming and passing away is described in this way: because Babylon will fall, something new can arise—Jerusalem. That was the hope.

That hope was fulfilled in part. Cyrus came and conquered the Assyrians. He granted the Jews freedom, freedom of religion. The Jews returned and rebuilt the temple.

In falling, in defeat, energy that can be given shape is released.

All of history demonstrates this, going back 10,000 years before Christ: Jericho, the Hittites, all the countries in the Fertile Crescent—as soon as one power wanes, another arrives.

The field of power is associated with the breath.

With the breath mentioned in the Bible. According to the prophets, Yahweh is not only the god of the Israelites but also of the whole world. Jeremiah speaks for all peoples and nations. It's an opening into the world. But

Yahweh also sends the Jews' enemies because they have sinned. Yahweh is also the lord of warriors. Yahweh wages war even against his own people.

Wherever the fire of His breath falls. When one power fails, when the energy fades, when the breath leaves a person, when someone breathes his last: these are all special moments. Is the energy needed to come to an end concentrated in the breath that leaves one's body at the moment of death?

It depends which image for breath you have in mind. In some cultures, breath is the image for the spirit that leaves the body and goes elsewhere.

In Genesis, it says that Yahweh breathed life into clay.

Breath is a rather abstract form of creation. Inhalation and exhalation form another cyclical system. In some cultures there's a belief in an etheric body above the world that seeks out a person. It's the idea that you select your parents in order to materialize on earth for a certain period of time.

Do you endorse this idea?

Not in so many words, but I do have the sense that I've existed for a long time, not as the person sitting here and speaking with you but as a certain intelligence contained in the constellation of my molecules, receptors and synapses that is part of a much larger intelligence,

a world intelligence, a cosmic intelligence. Every single cell contains the DNA and I believe it's connected to a general intelligence. I can't picture myself separate from it. So I can understand the image of a spirit and an ethereal body above us. Admittedly, though, these are only imperfect images.

An equivalent to the matrix that this constellation illustrates in your work.

I see myself as a part of this much more comprehensive matrix. I believe that, today, we can no longer see ourselves as outside it.

Another interesting thing about the Book of Jeremiah and what you've mentioned in relation to chaos is that order is set against chaos. In the fifth chapter, Yahweh says he has 'placed the sand as the bound of the sea by a perpetual decree, that it cannot pass beyond it. And though its waves toss to and fro, yet they cannot prevail.'

A fluid border, that advances and recedes.

In the universe, of which man is no longer the centre—in relation to your ruined landscape—human 'remnants' or 'remains' of men are visible. We can see hair on one of your towers, footsteps in the ashes, in the dust that falls to the ground through the destruction.

The bricks are covered with traces of humans.

There are also traces of human civilization. Five beds are visible in the back of the ruined landscape.

I'd initially thought of the beds for Lilith, but I'm not yet satisfied with the Lilith figure. At first I'd had her creep under the beds like a snake because snakes often connote dragons. For now the beds are just standing in the back of the space. I think they're good there, but I don't know why yet. I have to think about what the beds mean.

Humans are pushed to the side.

They're not pushed to the side. Humanity is there, but not actual humans. Humanity includes many, all those ever born—more people than are living today. What does the Apostles' Creed say? The communion of the dead?

It says that Jesus Christ 'is seated at the right hand of the Father and he will come to judge the living and the dead.'

All the living and the dead are included.

The dead are at the same time the 'manure' according to the Christian idea of new creation.

When you speak of manure and fertilizer on the one hand and the resurrection of the body on the other, you've got contradictory ideas.

The resurrection of the body is the hope.

But once the body has been transformed, has been metabolized, it can no longer be resurrected. Maybe an intelligent theologian could explain that it is possible.

Why have you called your production for the Opéra Bastille At the Beginning? *Is there some kind of a distinction from the opening of the Gospel According to John, which says 'In the beginning was the Word, and the Word was with God, and the Word was God. The same was in the beginning with God'?*

When it says 'in the beginning was the Word,' it means that it's no longer the beginning. In the beginning is something else. In the beginning was the word—someone spoke the word. I say 'at the beginning' and show the end: for many people, ruins are the end. But I say in response, 'at the beginning,' and that shows the circle. When St John's gospel opens with 'in the beginning', it's *creatio ex nihilo*. 'At the beginning' is only an incidental naming of place. I include both the end and the beginning. I could have said: the end is the beginning and the beginning is the end.

Is the temporal structure also an incidental one?

I'm now, incidentally, at the one hundred-thousandth beginning, at the one hundred-millionth beginning. In the beginning is truly a creation out of nothing. Before there was nothing. I call the production *At the Beginning* to indicate a cycle, a circle.

For the boat that you'll probably mount on the tower, the following association occurred to me: in the exhibition that opened at the Gagosian gallery in Rome in early April 2009, there was a stack of lead books. On top of them was a boat and next to them a broken jug. The title of this sculpture was Verunglückte Hoffnung [The Wreck of Hope, 2008]. *Could one also speak of hope run aground in relation to your theatre production?*

Yes. The sculpture's title is, of course, an allusion to Caspar David Friedrich's painting *The Sea of Ice* (*The Wreck of Hope*). Stranded also means wrecked. In Jeremiah, as previously mentioned, there's an interesting connection drawn between the sea and chaos on the one hand and the beach, dunes and borders on the other. When you see the sea as chaos, then the beach represents order. So the boat that is flotsam in the sea is wrecked, but on the beach it's part of order. That would give me the dialectic of the beginning.

In the Gagosian gallery, a few of your photographic works were also displayed, one of which bore the inscription Atlantis (2007). *I had the impression that in the photo collages, the towers of the* Heavenly Palaces *stood in an underworld.*

Absolutely. It's like they're sunken. Atlantis has sunk.

When I saw the model of the stage set for At the Beginning *in your studio in Croissy-Beaubourg, I felt the towers were submerged, although the peaks of the towers stuck out above the underworld.*

Under the waterline lies the gold, the Rhine gold . . .

When your stage production begins, it's dark, dismal, only then does light come, the first light, the first sound, a rushing sound that is barely audible at first, a wind. Can the twelve towers be seen as an image of Atlantis?

Atlantis is always withheld. Atlantis is the country that no longer exists. Many people refer to Atlantis. The Nazis ruined the myth of Atlantis—they misused it. They claimed that Aryans originally came from there.

The model of the stage set is flanked by pieces of plastic film through which light shines. This film is translucid.

Hopefully. I'd said that when I did a production for the Opéra Bastille, I wouldn't do a model of the set. Above all, I'm not going to create any illusion in the boxes. In the Opéra Bastille, there are nine stages between which the stage sets of various productions are pushed around. I want the whole surface, not out of megalomania, but because I don't want to create a stage set. I want to create a landscape. The landscape ends with the walls of the Opéra Bastille and not at the edge of the stage. This depth was very difficult to achieve, of course, because

stage sets were stored on the other nine stages. That's why I still have to work on it, so that absolutely everything extends into the distance. The Shekinah should come from the back, from the workrooms and the studios. She shouldn't come in through a set door. She should really come from the back, from the studio spaces, otherwise I wouldn't have wanted to do this project. I'm not making a proscenium. The audience should have the sense that it extends another 1,000 metres. And on the sides, too. Everywhere. Without boundaries.

Tadeusz Kantor proposed that humans are connected to an object. In his play, Let the Artists Die (1985), *the hanged man forms an object with the gallows, the cleaning lady forms one with the tin bucket and rags. Kantor called these objects 'bio-objects'. In your rehearsals, I also got that impression: that the rubble women themselves were stones.*

Yes, that's right. They merge into the stone. I painted their dresses to blend in with the landscape. It might sound cynical, but it's not. Adalbert Stifter describes objects as if they were people—he describes roses very minutely, for example—and he describes people as if they were things. This interchangeability between objects and people in Stifter's work is marvellous, in Kantor's as well. The rubble women actually become stones. And the stones come to life, they become animate as if the stones had been breathed on by the rubble

women. Things come alive. When I was talking with Beuys about man being the centre, I said to him: Well, why do you believe this? Maybe the mountains or stones are living beings and we just can't see that they're alive? Maybe stone has a higher consciousness than we do.

In Zen Buddhism there's the saying: I see the mountain and the mountain sees me.

I always had the feeling, I always believed that a forest, a stone, a tree were speaking to me. Sometimes the rubble women pause in their work and are still, that is, they actually become sculptures. It wasn't completely clear yet in the rehearsals you saw, but it will be.

You worked very closely with the composer Jörg Widmann. In your production, there are everyday sounds, like the sound of hammers on brick.

When I first made that sound in the 1980s for a BBC film, it struck me immediately that the sound of hammering makes incredibly beautiful music. When it's very soft, the hammering is like a drip, a wonderful music. Widmann agreed. Right away he said he would compose his music so that the orchestra takes up the hammering, so it transitions from life into art—that's important—and then that sound returns to the women. The sounds travels across various strata. It crosses the border between life and art and returns from art to the rubble women.

The sound moves through the landscape like fog.

No, not like fog, like a current of air, like wind. Did you hear how Widmann played the clarinet with the accordionist in one rehearsal? The accordionist only made the sound of wind. That's extremely interesting. There was wind without any tone. Air is present before the tone and only then does it crystallize or form itself into a tone. I like that very much, because that's its status before it becomes a tone, or art or music. What Widmann and the accordion player did was very good. That's probably how our production will start, with improvisation. I've known Jörg Widmann for a long time now. I was captivated by the way he played with his clarinet, so that it wasn't a clarinet any more. He turned it into a completely different instrument.

You subject your work to a process of drying out, of desiccation. When describing your method to Jörg Widmann you said you begin by painting with lots of colour.

Then I overlay the colour with grey, with water, so the colour doesn't disappear but does sink beneath a veil.

A shrouding of the colour?

Yes. The painting is veiled.

And it's unveiled at the same time?

Yes. In Ingeborg Bachmann's poem *An die Sonne* (To the Sun), there's the beautiful line: 'Without the sun, even art takes the veil again.'

Do you recognize your work in that image?

Yes, it's being veiled and at the same time made secretive again. It's a constant balancing act between art and life. When I put a painting out in the rain, it's naturalized again and it also gains a secret I must rediscover. Ideally, in rediscovering that secret—by working on the painting some more—I create something still more concentrated.

One of your paintings, which I saw in your Croissy-Beaubourg studio, is inscribed 'For Ingeborg Bachmann Remains of the Sun.' In the painting there's an enormous brick wall. Time has passed the bricks by, they were left to ruin. There are no people to be seen. They have all fled.

I wouldn't say they've fled. If the people have left, they will return. When I think of my paintings with the brick structures, I see countless people.

The opera, At the Beginning, *ends with verses from the* Psalms. *The last verse you selected reads*: 'Their eyes grow dim.' *Is* At the Beginning *a journey to the end of the night for you?*

Céline's novel describes downfall through war. While reading it, you always think you've reached the utmost stage of horror, but then things get worse. Worse and worse until the individual sections in the novel become a ritual. There's no meaning left. Emptiness appears in an alarming dimension. *Voyage au bout de la nuit* is a wonderful novel that inspired several of my paintings.

In Céline's novel, this emptiness and loss of meaning doesn't only spread in wartime—the narrator is also deeply shocked when he sees how life goes on in peacetime. A ghastly emptiness spreads through the scientific institutions. There can be no talk of research in the service of humanity. What do you think is the source of the violence that erupts with such force and causes the deaths of millions and millions of people?

Man is badly designed—he is a faulty construction. Civilization is only a thin veneer that can crack at any time. When violence is legitimized, then this veneer is very quickly broken.

In his 1954 novel Lord of the Flies, *William Golding described what happens among children when a community's structure collapses.*

Children can be cruel.

You've also addressed destruction that cut a swath through many countries in your painting Heereszüge Alexanders

des Grossen [Alexander the Great's Military Campaigns, 1987/88].

Alexander spread Hellenistic culture through all the countries of his military campaigns. There's a story that a snake led Alexander to the oracle. Alexander was not only a great military leader but, as the story of being guided by the snake shows, he also had access to the chthonic, to the earth.

The history of mankind is a series of wars, one after the other. After the systematic murder of European Jews, there was talk of a collapse of civilization unique in its bestiality and horror.

There can always be new collapses of civilization. Just think of the Khmer Rouge. Civilization collapses again and again around the world.

The question 'Where is God?' was asked in the concentration camps. One prisoner pointed to another hanging from the gallows and said: There He is.

Job is also in conflict with God. Heine, too.

Paris and Croissy-Beaubourg, 7 and 8 May 2009

OEDIPUS IS TRANSFORMED
FROM A GUILT-RIDDEN FIGURE
INTO A FIGURE OF LIGHT

How did your collaboration with Klaus Michael Grüber on Oedipus at Colonus (2003) *come about?*

At the start of my collaboration with Grüber, we had the following perspective on Oedipus in mind: Oedipus is a sadhu, an Indian itinerant monk, a figure of light. In the holy grove a transformation takes place. Oedipus' movement switches from horizontal to vertical. I've always deeply appreciated Grüber's work because it's very concentrated and devoid of modernist effects. When Grüber told me which play he wanted to stage, I agreed. I especially like *Oedipus at Colonus*. When Grüber and I talked about this play, the idea of the Indian monk, clad only in ashes, immediately occurred to me. In Sophocles, this guilt-ridden figure becomes a figure of light. This transformation in the play interested me deeply. For me, Oedipus is a sadhu, an Indian monk who wanders around naked, covered only with ash. We also have ash on Ash Wednesday and with it the reminder that everything is transitory. Ash runs

through the entire play. Ash is an end product on the one hand, on the other it's the beginning of something new. In our staging, ash falls from above, is illuminated with the lights and gains a transparent dimension. So ash not only covers, it also glows.

How was the work on Sophocles' play?

Working on *Oedipus at Colonus* wasn't so difficult because the stage is set up like my studio. The stairs are from my studio. There's a lot of ashes there, too. The plastic hanging on the walls of the stage set is the plastic I use to cover the floor of my studio so the paint won't eat into the flooring. For protection. I flipped the horizontal level to the vertical level—which is always an interesting process. That way, above and below are suspended. The spectator doesn't know this. Much of what you feel, you don't know, but you still feel it. I already knew the play. When Grüber told me that he wanted to stage it, I read the play again in the old translation of the Reclam edition that we used in school. In my studio I also do theatre plays or, rather, actions. The difference in this case is that the text is fixed. I don't see the theatre as a different art form. Long before rehearsals began, I discussed the play with Klaus and we worked everything out together. It wasn't the case that he told me: This is the play, now you do the stage set and I'll direct. It was a collaboration, not a fusion of different art forms. Before the rehearsals, we met in my studio and worked

it out over two days. We dropped the stairs down in my studio and I scattered ashes. It was a very slow process. Out of the many ideas we had, we concentrated on a very few. The problem is always making the choice, deciding what to leave out. I wasn't surprised that Klaus asked me to collaborate. I knew his work, especially what he'd done for the Festival d'Automne in Paris. I felt a kinship. I admired Grüber for going off to Italy and doing street theatre for a long time. That's a way of life or a way of being that I never tried. It always seemed like something special to me. There's not much theatre where I live. When I'm in Paris, I often go to productions. I haven't followed the theatre closely. I've seen a lot of beautiful pictures that Klaus evoked, which I'm proud to have created here. The space is for me a work of art you can enter and walk through. Oedipus arrives in Athens as an asylum-seeker, destitute, a beggar who has been cast out. He is transformed from a guilt-ridden figure to a figure of light. It's a wonderful process.

Your stage space and costumes also reflect destruction in our time.

I don't give any instructions for present situations but my art is involved with the present because I follow the times. Art is never morally or politically correct. If you take the moral point of view from the time of Sophocles, the time of Aristotle, it was a society of slave-holders. And not one of the philosophers would have objected,

not one of the democrats of the time would have cast doubt on that. Back then it was moral to own slaves. Today we have different moral principles that won't exist tomorrow. That's why art is never moralistic and, as such, is ahead of its time. Art doesn't pay attention to what the times demand. Art is not correct. Theatre isn't new terrain for me—I've done theatre in my studio many times. I've never yet worked with actors. Though I did have an old brickyard in Germany. I once had rubble women portrayed in it—I hired eighteen models who swept out the factory.

Does the transformation in Oedipus at Colonus *have a theological dimension?*

The play has an existential, a very strong human dimension, more than human, you could even call it a gnostic dimension.

Light and dark?

Yes, especially with the transformation, but it has nothing eschatological about it.

When you talk about a figure of light, it sounds like Oedipus has an eschatological dimension.

Yes, but I don't want to see it in a systematic sense—like Catholic theology in which the Saviour comes at some point and redeems the world. Oedipus doesn't redeem the world either, just a particular place: Colonus.

Whoever lives there, where his grave is, his unknown grave, nothing can happen within that radius. It still functions as a sign.

What kind of sign?

The sign that I can turn guilt into salvation.

How?

That's the play's secret. We don't know exactly how. Maybe through Oedipus' path, his long journey, his ordeal. Oedipus doesn't say anything about the goal. He doesn't say: I now want to become a saint. He suffers. And in the end he's the one who brings the city salvation.

In the Christian tradition, we'd say ecce homo.

In the Christian tradition it would be about emulation, *ecce homo*, emulating the life of Jesus Christ. You take up the same cross and are saved. Oedipus doesn't know that he will be saved. He doesn't know how things will go. A Christ knows, when he takes up the cross, that he will be redeemed. He has earned his salvation, so to speak. It's different with Oedipus.

In Christian thought, we'd speak of the grace of redemption.

Yes, of the grace that comes from God, of the grace that is granted. We've been speaking about it for a rather long time, because it's not clear. But that's what I find interesting about it.

Oedipus brings salvation for the city, not for the people?

People live in the city. The salvation is tied to the location. It's still thought of territorially. The constellation is the crown and is, I believe, the sign of Athens. Athens stands for a type of humanity, democracy, overcoming conflict. The king of Athens takes Oedipus in before he knows that it's in his interest. He takes Oedipus in simply because he's a refugee. Theseus doesn't do it out of calculation.

When the thunder sounded and the dust began to fall, I thought of the passage in the New Testament in which the Temple veil is rent when Jesus dies.

Do you know the photographs of solar wind?—There's something of that, too. Or it could be a comet that is disintegrating. An hourglass is also implied, as well as time trickling away—but not overtly. The space is very high. It's a connection upwards. I eliminated theatrical means. I don't create a script or illusions. I use lighting only sparingly. I avoided using everything that makes theatre theatrical. I wanted to activate the high flies with the stream light up there.

One of Tadeusz Kantor's fundamental ideas was the 'reality of the lowest rank'. Your work gave me the same impression. The reality of the lowest rank switches to the vertical.

Ash is that element. The monks in India cover themselves with ashes. I briefly use the floor as a wall because it accords with my cosmic sense. It's not clear where the floor is and where the walls are, which is above and which below.

This suspension of above and below is very poetic. At the same time, the illusion shatters on the clamps and wooden slats to which the plastic sheeting is attached.

I constructed it the way it is in my studio. When I want to set up a wall of plastic, I use the clamps and pull it up. Actually, I wanted to switch off the theatre with its illusionistic tricks.

With the tarpaulins, I had the impression of layers of slate with grasses and bushes.

There's everything possible on them, because the tarpaulins are lying on the ground. I also put trees behind them that show through.

That's why it appears translucent. As if the grasses and bushes were in this layer.

That idea didn't occur to me, but it's true. Slate is interesting. Slate is made from very small particles that are carried down from the mountains and, because of the way it gets sorted in rivers, the finest material is deposited farthest out in the sea. Slate is made of clay subjected to pressure, weight and temperature. Slate always breaks

into layers. That's also the case with the stage set. Before there was much more on it. With each production there will be less and less.

Do you see a relation between Jesus and Oedipus?

To the extent that both descend to the lowest point of human existence.

Oedipus also has a swollen foot.

Yes, everything that is disgusting. But it varies. Jesus comes from God and he knows his father is in Heaven. In the end, though, he's disappointed. He calls: My God, my God, why have you forsaken me? Jesus always sees himself in relation to something else altogether whereas Oedipus doesn't see himself in relation to anything else. That's why it's much more modern. Because Oedipus can't actually relate to anything else—he is forsaken by everything.

But not by his daughters.

No, they stayed with him, above all Antigone. But Oedipus is driven out of his country. He has no god to help him. Even later, when the gods accept him as one of their own, he is still forsaken by all. It takes a certain amount of time. He is an asylum-seeker, completely without rights. Whereas Christ never lost his rights. He was God's son, after all, and aware that he was a god.

In the end, Oedipus leaves, as if returning to dust, dissolving into matter and disintegrating. I think that's beautiful.

Yes and he says something important, which no one knows. At the end of the play, it remains open. He says it to the king but his daughters aren't allowed to accompany him. Again and again there are stories and scenes in mythology in which something is alluded to but not expressed. With Oedipus, the question that can't be answered is about his grave. First, its location is not known, and second, no one sees him die—except the king. Even Antigone isn't allowed to go with him. She must stay away. The place isn't known. We search for it. That's the black hole around which our thoughts circle in Zen Buddhism. A void.

Have you seen Tadeusz Kantor plays?

Yes, many of them. I always travelled to Paris to see his plays. Unfortunately, it couldn't go on without out him. It didn't work without him. His theatre was borderline kitsch—in a positive way, and so exaggerated that only Kantor could pull it off. Kantor was fantastic. We're underground artists. Where we're active, in theatre and the visual arts, there's no massive audience like there is for Madonna.

Vienna, 8 May 2003

I CALL ON NATURE FOR ASSISTANCE

In discussing the question of the relationship between art and life or, rather, the difference between nature and art, Martin Heidegger wrote in his essay from the mid-1930s, 'The Origin of the Work of Art': '*Albrecht Dürer, who surely knew what he talking about, made the well-known remark, "For in truth, art resides in nature, he who can extract it from her, has it."*' *Do you, like Dürer, see your work as extracting art from nature?*

I don't see it as Dürer did. Dürer was the first to take nature—a grassy meadow, for example, something completely mundane— and portray it. That kind of depiction hadn't been done before. Until then, plants were always symbolic, like the lilies in a picture of the Virgin Mary. Earlier, each plant had a specific meaning. Dürer portrayed the meadow simply as a meadow—and that was completely revolutionary, like his hare, in whose fur you can almost count the individual hairs. Dürer was a hyperrealist, if you will. If you're focused on the extraction, then I'd agree with Dürer, but not in principle. Art doesn't reside in nature as pure reality that you can depict directly. That doesn't work any more. Nature is

no longer the innocent nature it once was. Today nature is destroyed, rutted, Werner Herzog would say an offended nature. Although in another sense, I would agree with Dürer's remark because nature also has something unredeemed about it. There's something in nature that has not yet appeared. Ernst Bloch once put it very well. I don't remember the passage exactly any more, but it was along the lines of—In nature one can see the as-yet-unredeemed. To the extent that nature has anything to do with man, it is, to that extent, a part of man—but not in the way Dürer meant.

This brings to mind one of your watercolours, which I saw this summer in the Rotterdam Kunsthalle in the exhibition Von Dürer bis Kiefer [From Dürer to Kiefer]. *In it you see a night-time landscape with a mountain mirrored in a lake. It is titled* Noch nicht [Not Yet, 1977], *evoking the dialectical tension between 'no longer' and 'not yet'.*

Nature, like mankind, is not at all redeemed. Together with equally unredeemed nature, men can move towards what does not yet exist.

For Heidegger, art is the locus of friction between revelation and concealment. Is your art also a place of friction?

Yes, certainly. Novalis coined the wonderful word *verge-heimnissen* [to make secretive]. To make secretive is also to create a clearing in which something becomes visible,

in which room for a new perception is created, but not in the scientific sense, in the mythological one.

According to Heidegger, art is more philosophical than science. It's closer to the essence of things.

That is absolutely clear. Art brings all the disparate kinds of knowledge into a new system. It brings this knowledge together and creates a unified view that must constantly be reinterpreted. It cannot be defined for all time.

In his essay of cultural criticism, 'The Work of Art in the Age of Mechanical Reproduction', written almost at the same time as Heidegger's essay, 'The Origin of the Work of Art', Benjamin presents the view that the work of art was always essentially reproducible—a counter position to Heidegger's theory of art. Do you, like Heidegger, believe that truth is first revealed in art?

Yes. Art is the unconcealed. It is unconcealed, but also concealed. It is concealed to the extent that you can't reach it with clear discourse. It is also disclosed because it expresses more than any science. Heidegger understood truth as clearing and disclosure of the existent.

Now the difficult concept of truth is on the table. In Friedrich Schiller's poem 'The Veiled Image at Sais', a young man is forbidden from taking the veil off a painting because truth is behind the veil. The young man does it anyway. He goes

into the temple at midnight, lifts the veil and comes into contact with truth. He falls sick and dies.

The young man leaves the temple insane. The priests find him the next day 'pale and senseless' at the foot of the statue of Isis, as it says at the end of the poem.

What do you think the young man saw behind the veil in the temple?

He saw something he could not comprehend. He saw something so unfathomable that it broke him.

In connection with the veil, there's the remark of Immanuel Kant: 'Perhaps nothing more sublime was said, nor any thought expressed more sublimely than the inscription on the temple of Isis (Mother Nature): "I am all that is, all that was and all that will be, and no mortal has lifted my veil." '

That remark covers the entire field of time and space. Kant says there is something that embodies everything: past, present and future. No mortal has uncovered this field, but it exists. There is an invisible field that knows at all times what is happening everywhere—a suprapersonal intelligence.

When I was in your studio in Croissy-Beaubourg and saw your paintings with the brickyards for The Fertile Crescent *exhibition in London in autumn 2009, I had the impression that the temporal dimension inherent in the paintings works like a veil that reveals new horizons of meaning.*

Yes. As a painter, one always hopes that under the surface, underneath what is visible, whether bricks or whatever, there's something that will later mean more than what people see today. That is the veil. In important works of art, those of Fra Angelico, Michelangelo, there is something new to discover in each century, the reciprocal of the inscription on the temple of Isis. The reciprocal of the fact that Isis knows what used to be, what is and what will be—that the painting already knows what will be in two centuries, what those looking at the painting will see in it in two hundred years. The veil of Isis can be a brick or a forest or whatever is painted and what is hidden beneath it is fed by the preceding centuries but will also work in the centuries to come.

Do you think that the truth the young man came into contact with is complete grace?

I don't know, but it was too much for the young man.

Could the young man not comprehend what he saw behind the veil or did it burst his powers of comprehension, that is to say the comprehension of any mortal?

I would say that those are almost the same. He was suddenly confronted with the quintessence, the theory of everything and that completely destroyed him. It's like the *Shevirat Ha-kelim*, the breaking of the vessels. If you interpret it religiously, the young man in Sais experienced God's grace and that was too much.

God's grace is understood theologically to be a gift or a bounty that gives life, but, according to your interpretation, grace destroyed the young man's life and extinguished it in a short period of time.

In theology and mythology, grace can be too much for the mystics. Insanity was seen by the Jews, was seen in the Old Testament as a sign of divinity. Crazy women danced before the Ark of the Covenant, and some prophets were insane. In his poem, Schiller wants to say that man cannot get to the bottom of knowledge, he cannot grasp truth in its entirety, truth as such. It's not possible, and, if it were, we could not bear it. This idea runs through all of art and literature. The beginning of Rilke's first *Duino Elegy* is: 'Who, if I cried out, would hear me / among the angelic orders? and even if one were suddenly to hold me / to his heart, I would expire in / his fuller existence. For beauty is nothing / but the beginning of terror, which we just barely endure / and revere it so because it serenely disdains / to destroy us. Every angel is terrifying. // And so I restrain myself and swallow the siren call / of my dark sobs. Ah, whom dare we / allow ourselves to need? Neither angels, nor humans, / and the discerning animals are aware / that we are not completely at home / in our interpreted world.'

There is, indeed, an awareness that a complete truth exists. You describe the approach to it as a spiralling path.

It's like the path into a crater you can enter, but if you do enter it, you will die. I recently found a recording for a radio broadcast made by Antonin Artaud in 1947. This recording was edited out of the broadcast the day before it was aired and only aired later. Artaud just yelled for the entire recording. He was out of his mind. He said nothing in the radio show. The recording is so insane, you don't know what to do with the scream.

Artaud's scream was the expression of enormous suffering. He had recently been discharged from the asylum in Rodez. His scream devolved into a form without logic or grammar.

Definitely. A poem isn't always grammatical either. The recording of Artaud is actually an insane scream. You don't see any alienation or the distortion of an object any more. You don't see anything—you just hear screaming. That's precisely the edge: if you go that far, there's nothing left. It is so insane that you can't do anything with it; the thing that goes insane is no longer visible. Insanity itself is still something positive, something that can be experienced. If you've got an object that's gone insane, it's no longer the right object, but with Artaud's scream you can't even see the object, now insane, any longer. Insanity leads to a complete dissolution of the thing. It's almost nothing.

If you take this nothing to a cosmic dimension, it has an enormous effect on surrounding matter. Like neutron stars,

the pulsars that suck astronomical objects near them into a black hole and annihilate them completely.

Sucking them in is exactly the right way to put it—it's like a suction. One is always drawn into the void. When you're swimming in the sea, you want to swim farther and farther out. You don't want to return to land. It's a very strong pull, the desire to keep swimming out to the open water and to go under. Or when you're standing on a tower, there's a very strong pull downwards. Like with Empedocles, who flew into the volcano's crater.

There are two contrary energies connected to the crater: the rising energy, you want to climb up to the crater, and the sinking energy towards the hole into which you want to leap, the void, the nothing you're sucked into.

It's a climb that's brutally interrupted. You don't rise high in the celestial palaces—at some point you go back down.

The alternation between rising and falling reminds me of 'The Ruin', an essay Georg Simmel wrote in 1919 and in which he describes these contrary energies using the example of a mountain: 'The charm of alpine forms, which are, for the most part, coarse, accidental and artistically unappealing, rests on a sense of opposition between two cosmic tendencies: volcanic eruptions or gradual stratification have built up the mountain; rain and snow, erosion and

landslides, chemical dissolution and the gradual effect of invasive vegetation have sawn away and hollowed out the upper edge, have sent parts of what had been built up tumbling down, and have shaped its contours.' Nature obviously follows this alternating play of building up and wearing down.

The balance in the Alps is very interesting. The Alps are constantly being pushed up because of drift and plate tectonics, exactly as much as they are being worn away. Erosion makes the Alps smaller, reduces their mass and then more force can be unleashed to raise them up. On the geological scale, there's always a balance between elevation and erosion.

For a long time I didn't understand why Mount Fuji in Japan was so deeply revered. Only after I read Simmel's essay on ruins did I begin to understand what could draw the Japanese so deeply into their reverence for Mount Fuji. The movement upwards is visible in the contour of the mountain, and the eroded matter offers a very clear image, created by nature itself, for melancholy.

It also offers an image of this strange equilibrium. You could also say it's a compensation like you get in the psyche. There are times of deep despair and times of a renewed upswing. You can apply this geological phenomenon to the psyche.

In a BBC profile of your London exhibition Aperiatur terra
*(2007), you say that you're neither a pessimist nor an opti-
mist but are in despair over not knowing why you are on
this earth. Do you have a kind of energy within that mani-
fests itself in despair and one that is expressed in artistic
creation, in multifaceted production?*

There's joy each time you succeed in creating an illusion.
Of course, there's a repeated sense of deflation because
what you've devoted yourself to is just an illusion. It's a
similar phenomenon to the mountain that is rising and
being worn away again.

*How do you manage this constant swinging between elation
and deflation?*

At some point, it's all over. You can only take these
swings for a certain amount of time (*laughs*).

*If a society loses its shaping force, it lapses into decadence.
In that condition, society can only receive impressions.*

When the psyche is open only to having impressions
made on it, whether an impression of a great disaster
or an impression of great beauty, there's no possibility
of giving expression to experience. When people cannot
put their experiences in words or share them with
others in another way, they go insane.

*You have talked about the starting point of your work as a
feeling of shock.*

I said that in a different context. I said that I haven't invented a new form of art. I didn't want to rewrite the history of art or attach some appendix to it. I've always seen my work very personally as a means of survival, the possibility of giving some kind of visible shape to what happens to me.

Does a sensation of the truth revealed to you in the moment of shock linger in your works?

That shock opens your eyes to an abyss. The shock can be a poem you experience or a particular piece of music, whatever. It makes you feel very small, you almost want to hide from it. The possibility of survival is found in the effort to portray what was experienced in that shock in any way whatsoever, even if only in stammering. Even if it's only an instance of natural beauty, even if you're just taking a photograph of it, something very imperfect for just that moment, even that is a relief.

And a distancing?

A photograph is a distancing because you look through a lens—you're already looking through something else.

When I think of your large installation, The Seven Heavenly Palaces, *in the HangarBicocca in Milan in 2004 and your production* At the Beginning *at the Opéra Bastille in 2009, I'm reminded of another of Simmel's observations: That a ruin only has aesthetic appeal when it is*

built to a certain height and then is destroyed. The stumps of the columns in the Roman Forum have no aesthetic charm for us.

Fallen columns, rather. You can't call stumps of columns ruins. The stumps are rediscovered parts, they're archaeology. In archaeology, things are dug up. Ruins are not dug up, they're present: a pile of debris. The vertical is flipped to the horizontal. It's always interesting when dimensions shift. I see parallels to this phenomenon in my way of working. When I create a painting, it's laid on the floor twenty or thirty times as I work on it, then it's hung up again, then laid back on the floor. In this way, the painting becomes a ruin-event. When I lay the painting I'm working on onto the floor, it's like a ruin. I walk on it. I pour water over it. I put it out on the grass and so on. Those are ruinous processes. Afterwards, the painting is hung up again and I work on it some more.

Simmel describes nature's intervention in civilization as a positive passivity. You become what Simmel calls an 'accomplice of nature' when you expose your paintings to the effects of nature and surrender them to transformation.

A painting is left out in the sun and rain and frost. I call on nature for assistance. That's my 'Naturphilosophie': I see in nature what is not yet disintegrated or redeemed. I consider nature a collegial assistant.

You don't always extract art from nature, you also give art back to nature in order to receive this collegial assistance.

For Dürer that extraction was a revolutionary act. We no longer need this revolution. We're no longer dependent on predetermined symbolism. Today we no longer have the clear, dogmatic explanations of mythology. I bring a grassy meadow back to the grass and see what happens or what had just happened. Dürer extracted the grassy meadow from nature, as he puts it, when he painted the watercolour. As history went on, many things happened to the grassy meadow that Dürer could not have known about.

Returning a work of art to the effects of nature, exposing it to the process of weathering, to rain, snow and wind, is a stage in a process that goes on and on and actually has no end.

The paintings are always brought back into the studio after having been subjected to the processes of nature. The question I'm weighing right now is to what extent Dürer's method is phenomenological because, for example, Stifter described things that are initially without symbolic content. Stifter described things the way Alain Robbe-Grillet later described a table or dust on the table. Does that have a phenomenological aspect? Is Dürer's method a kind of phenomenology or not? I don't think so, but there's a certain similarity. For one

thing, it's striking that the point of view is similar. Phenomenology came after Idealism, after Kant. The Idealists believed they were explaining the world, that they were able to shape it with thought. And Husserl simply said that we want to look and see what's there. To that extent, it's a similar process as well as a revolution in the way of seeing. Stifter is also subject to the 'gentle law' in which milk boiling over is as significant as a volcanic eruption. Dürer said: This patch of grass is interesting, it's worth being depicted as it is or that it's worth showing a hare as it is. You could draw a line from Dürer, through Stifter to Husserl's phenomenology.

And this line leads to you.

That goes without saying (*laughs*). I also say that objects and matter are interesting: spirit is inherent in matter. Stifter doesn't stretch an idea over everything but describes very simple things: children crossing a mountain or a storm. Stifter says, these simple things are significant. He singles them out. In Stifter's work, the form of relationship is contained in the description. The phenomenological method lets simple things shine.

A ruin feeds itself through an extensive root system and spreads its ramifications in many directions, so that in a ruin we have the image of a tree with many branches. Can one say that for you a ruin is a rhizome of stone?

On the one hand a ruin creates many connections, on the other it's also significant in the Heideggerian sense of revealing and concealing. With a ruin, something collapses and you suddenly see a structure. You suddenly see what is underground, the cellar, the plumbing, everything that was hidden.

A city loses its face when it becomes a ruin. The actual, not just metaphorical, loss of face is a recurring theme in literature.

The city gains another face. When you see a ruin or a house split by a bomb, you see walls that have been cut open like in a doll house. On the other hand, streets and squares are buried in rubble. In a ruined landscape there are no more streets, just paths that wind through the rubble however they can.

Does the concealment occur through the wound or later through the scar?

No, through the traces of the wound, through the piles of debris everywhere. The city's structure is no longer evident everywhere. The returning German soldiers didn't recognize their cities, the first time they saw them after the air-raids. They couldn't find the streets where their houses stood. The soldiers found another world when they returned home.

In the 2007 monograph edited by Andreas Böhn and Christine Mielke, Die zerstörte Stadt: Mediale Repräsentationen urbaner Räume von Troja bis SimCity [The City in Ruins: Representations of Urban Spaces from Troy to SimCity], *there's a very informative essay by Kay Kirchmann, titled 'Blicke auf Trümmer: Anmerkungen zur filmischen Wahrnehmungsorganisation der Ruinenlandschaften nach 1945'* [Views of Rubble: A Commentary on Cinematic Perceptual Organization of Ruined Landscapes after 1945]. *Kirchmann analyses the destruction of cities by bombs, using the concepts of 'delocalization' and 'dedifferentiation'. By virtue of the 're-establishment of the horizontal gaze' and the crisis the protagonists face when they try to move through the bombed-out cities, there is a 'valorization of what Deleuze calls the "purely optical and sound situation": we are now faced with a cinema of observation and no longer with a cinema of action.'*

That's a lovely conclusion. In bombed-out cities, all traffic has disappeared, the usual noise is gone, you hear other sounds, maybe just birds or the wind, especially the wind that blows through the ruins, wonderful—a completely new music.

For Kirchmann, the characters in films of destroyed cities are exposed to 'optical sensations of ruined cities'. What was appealing about the staging of At the Beginning *is that it came down to—in Deleuze's words—a valorization of the*

purely optical and sound situation. In this sense, At the Beginning *is a post-dramatic work of art, in which man appears on the sidelines and leads an unremarkable and marginal existence there.*

The prior context, in its entirety—certain streets, certain intersections—are erased and suddenly mixed up in a strange way. It's fascinating, as is the fact that, all at once, new lines, new paths through the rubble appear. I find it an immense shame that one or two cities weren't left as they were after the air-raids. Forests would have grown over them and you'd be able to walk through them—like the ruins in Mexico.

In Mexico, nature has successively overrun the ruins. As nature grows stronger, the ruins decay even more.

I was in Mexico in the late 1980s, when the country was not as geared to tourism as it is now. At the time you could see ruins that weren't yet over-restored. You could only reach Bonampak by boat or airplane. Now there are bicycle tours to the ruins and events held all around them. The ruins made a deep impression on me then. Roots take hold in the walls and break them open: explosions are not only caused by bombs but also by nature. Entire walls were broken apart. Of course, the walls don't last long in that condition. In 50 or 100 years, even less of them will be visible. The destruction of civilization by nature is fascinating. You can often see the process

in action: when a sidewalk is badly made, a root will break the asphalt open again. That's wonderful.

Aperiatur terra, a breaking up and an opening.

It doesn't happen with concrete, but perhaps it could as well.

Can you recall what impression you had, what emotions you felt when you saw the ruins in Mexico?

The impression of a marvellous battle between a building—a human construction—and nature. It actually wasn't a battle any longer, the building had already surrendered. The impression I had of traces of a civilization was particularly fine. The Aztec structures didn't have any rounded arches— they had those corbelled vaults, a rather rigid, clunky architecture. Nature, the roots that reached into the walls, actually made that architecture spiritual or elegant.

Simmel finds that ruins convey a sense of peace. Did you have a similar perception at the sight of the Bonampak ruins?

Of peace? A ruin reveals traces of a battle. The building was either destroyed in a war or was abandoned to nature's attack. It's a battle against the building. The battle is over, you see that in a ruin. Peace is always an intermediate state. It's not a state that arises next to war. Peace is an interim solution. War is the existing condition.

Peace is the interregnum of war. During the Pax Augustana, everyone thought eternal peace had been achieved. There is no eternal peace. A ruin evokes a sense of peace to the extent that the force that had been deployed against a building is spent. Is it a battle when nature, when trees attack civilization? Who is fighting whom? It's not a battle because nothing fights back against nature. In a ruin there is still something there, but nothing that resists nature.

Ruins reverse the order between nature and mind. This reversal is experienced as a return to the 'good mother,' as Goethe calls nature.

Simmel applies geology to cities. He says that instead of the intellect that built these buildings, a natural organization steps in—like the force that wears away the Alps or in a river that seeks a way through a landscape and gradually creates a channel.

The roots, the brush overrun the structures, as it were, albeit in this context 'overrun' becomes too intentional a concept.

I now see what Simmel meant when he said that we feel a sense of peace at the sight of ruins. Peace also means: you've come back. Maybe that was the impression I got in Mexico, what you realize in your will to create something, to establish something, to bring a certain order: Whatever you do, nature is always there, will always be

there, it will always intervene and will always bend every-thing to its will. We experience that as peaceful. That's probably what Goethe meant when he called nature the 'good mother.' When I think of the ruins in Mexico, especially those in Bonampak, I recall a very meditative, peaceful sensation.

Another thing that speaks for a sense of peacefulness is the phenomenon in which a ruin takes on the colouring or atmosphere of its surroundings. When I saw your Seven Heavenly Palaces *in Barjac last year, surrounded by the various plants and shrubbery native to the area, I felt I could see how the towers had taken on the colour of the nature around it.*

I do that with my pictures, too. What develops in my paintings is like a building that is returned to Mother Nature.

Do you see nature as a good mother?

She is a mother whom I would like to join, but who knows nothing of me. She doesn't notice me.

Nature not only fails to notice you when you devote yourself to her, she comes at you with an ultimate threat. Or, to express it in line with the image of the sea you brought up earlier: Nature pulls you into nothingness.

Nature is utterly indifferent. Nature is an indifferent mother. There's a wonderful poem by an American

poet. In it, a young man leaves his house and goes into the forest. He hears a bird chirping and knows that the bird doesn't mean him. But he still finds it lovely to hear the bird.

That would be the indifference of nature, who goes her own way and releases her powers onto human structures—like those in Bonampak.

Nature couldn't care less about pyramids. Nature doesn't attack pyramids—nature is simply there.

Could one say that roots have their own intelligence? That roots 'decide', let's destroy this structure à la longue?

No, roots are not at all conscious. The most you could say is that the roots are part of a general intelligence that drives evolution, an intelligence that knows what is occurring everywhere. The roots are part of an intelligence, but I don't believe that the roots themselves are intelligent. The way the structure of DNA represents a grand intelligence that is omnipresent.

Did the sight of the ruins in Bonampak give you a feeling of joy?

Yes, above all joy in discovering something I hadn't seen before. A sense of peace, of joy and of attraction. It really was like the desire to keep swimming farther and farther out in the sea. I felt that kind of pull looking at the ruins.

You were surprised at the expansion of time. Alberto Savinio quoted this entry written in his diary on 27 August 1943 in the book, Ascolto il tuo cuore, città [I Listen to Your Heart, City], *published the following year: 'I walk through the ruins of Milan. Why am I so excited? I should be sad but I'm bubbling over with joy. I should be thinking thoughts of death, but instead thoughts of life caress my forehead like the breeze of the purest, brightest morning. Why? I feel that new life will arise from this death. I feel that a stronger, richer, more beautiful city will rise from these ruins. Back then, Milan, I silently offered you my words, audible only to you and to my own heart.'*

Interesting, that's exactly what I'm saying. How funny. Who is this author?

Alberto Savinio, the pseudonym of Andrea de Chirico—Giorgio de Chirico's brother—a writer, musician and painter. Destruction is very present in your work. I wondered how you withstand the 'processing' of destruction, the atrocities of war and the unspeakable extent of human misery. As you create representations of destruction, do 'thoughts of life' caress your forehead, giving you energy for your work?

Ruins are for me the most beautiful things of all. I knew this before, but when I visited the German Historical Museum in Berlin recently, I saw photographs of bombed-out cities. These are the most beautiful pictures I can imagine, they're wonderful. Naturally, I asked

myself why. Why do I find these pictures so beautiful? I expressed my answer in *At the Beginning* in the Opéra Bastille: because something new always arises, because the old connections are disrupted, because something is in an intermediate state. It makes everything secretive again.

For Savinio, ruins evoke thoughts of a city that will be stronger, richer, more beautiful.

I'd say the city is already more beautiful. Savinio is saying the same thing, he means that something doesn't yet exist. The bad movies you see on television are bad because they tell you absolutely everything, they always give the audience everything. The more something is left indefinite, imprecise, the more beautiful it is. We can work on it ourselves, we can come up with our own ideas. That's why it's wonderful, because a ruined city offers an extremely high number of possibilities. There's material galore and nothing is predetermined. A city in ruins is a city brought back to the state of an idea, the expansion of a city to an idea.

In his movie, Germany, Year Zero, *Roberto Rossellini shows the terrible nadir of Berlin.*

But it's not a complete nadir. There's already something there. There's great richness, a wealth of material, a wealth of possibilities, so full and so profligate. Ruins are profligate like nature. Ruins are themselves real

luxury. When you consider how many seeds nature produces, how much fruit it bears, and only a very small portion is used. That also what's fantastic about nature: very little hits the mark. It's the same with sperm—only one in a million hit the target, the rest is sheer extravagance.

The unborn.

That is extravagance. These cities, these ruins: there's also the openness. Openness on the one hand and things buried on the other. Open, so you can enter bombed-out cities. There are no fences, there's no longer a structure of ownership. All of a sudden, it's all one.

Entering and mobility, both gain a new meaning after the disaster of utter destruction.

You don't need to knock, you don't need to ring. You can enter houses the way you enter the streets of a city. That's what's fantastic. You can walk around as you'd walk around a brain. In a ruined landscape, it's not just that you see what's happening in the moment, roots spreading among stones, say, you also see a time spread out before you. You almost have the quintessence of time in front of you. You know that the buildings looked like this or like that before, that there was an open square on which the Aztecs played ball games and performed their rites. Now everything is overgrown. You see a time from more than five centuries ago. It exerts

a strong pull, putting yourself back so far in time. An immense fascination that overcame Schliemann and other discoverers. People wonder why they do this—to know for certain if you were, in fact, in Troy or not is a foolish answer. They do it because they like to be set back into that time. Consciousness extends very far back and suddenly you feel stretched very far. It's an expansion of the self, not just of the mind but also of the entire person. The hunt for ruins is just a pretext to experience this expansion. At the same time, it's the means to experience it. The result of the hunt is not so important. The place where Muhammad ascended to heaven is the most extreme example of time and trace. People say: Ah, he was there, that's where he ascended. In Jericho there's a tree in which the tax collector sat, whom Jesus told to come down. Apparently this old tree still exists in Jericho today. These are all ideas about the expansion of the self and the dissolution of the self. When your self expands so far, when it extends to such distant times, your self dissolves in a very fascinating way.

Peace comes through expansion and imminent dissolution, so that the self is no longer able to commit an intentional act. In the act of looking, the self almost becomes one with the structure overrun by nature.

Most of all with the time you're entering. You go back in time, you go back to the point in time when the building

was constructed. At the same to you go forward, to the point when nothing will be left of the building at all, when there will only be vegetation, to the point when leaves fall again and turn to humus. In the end, all you see is a hill that rises a little and falls. That's it. You move in both directions, you expand in both directions. It's also a kind of solace because you know that you're contained in everything and will always be contained in everything.

Another expansion that is significant in your work is the expansion into mythology. To name one recent example: on a photograph of rubble women from your theatre production At the Beginning, *you wrote the names of the three Norns: Skuld, Urðr and Verðandi. The rubble women's fate is extended to join the three Norns who spin the threads of fate at the foot of the tree of the world. In an analogy to Dürer's remark, you could also say: He who can extract art from mythology, has it.*

People connect with concepts of fate that have existed for a long time, with the idea that someone knots up one's fate and they integrate this concept in their thinking as another possibility of explaining existence. I don't believe that the Norns or the Fates determine fate, but they offer another possibility of understanding existence in this fashion. In this case, it's an extension of the interpretation, an extension of an explanation of the world and our place in the world. The Norns and the

Old Testament prophets are two possible ways to explain the world. People relate to explanations of the world that men have thought since the beginning. Or take libraries: people strive for heaven's sake to know everything that has ever been thought.

Another form of expansion is music. I read somewhere that you know Wagner's operas so well, you can sing along.

Really, did I say that? I'm exceptionally unmusical. I don't know if I could sing along with Wagner's operas. Music, for me, is the highest art form. The best, the most profound musicians died very early, Schubert, Mozart.

Do you have a strong affinity for Wagner's operas?

Obviously. The dissolution of chronological or ultimate time in *Tristan und Isolde*, that endless melody—it starts somewhere, the music could also start earlier, then goes on and on. A wonderful kind of expansion. *Tristan und Isolde* is dramatic, but that's not so important in this context. With *Tristan und Isolde* you could say that the music has no beginning or end. I also get that sense with the prelude to *Lohengrin*. *Lohengrin* is the opera that made an enormous impression on me as a child. I have the feeling I grew up in that opera, although I only heard *Lohengrin* in a broadcast from the Bayreuth Festival Theatre on a cheap radio. I don't know how old I was at the time. I was still little. *Lohengrin*, of course,

also has to do with clearing, with concealing and revealing. As soon as Lohengrin reveals himself, he has to leave. It's like with the veil in Sais. As soon as Elsa von Brabant asks her question, it's over. As soon as the young man in Sais looks behind the veil, it's over. The impression the music of *Lohengrin* made on me in my childhood has remained so strong because on the one hand it refers to a place we can't access, but, on the other, something comes from there that we find strangely fascinating. However, we can't reach this place, we can't even ask about it. The music is wonderful. There's a fortress called Monsalvat: that feeling of longing and unsatisfied desire suits us deeply. The mere word satisfaction doesn't fit our desire, it's not an answer. Elsa is an example of not getting what you wish for.

She does get it, but she can't bear it.

She doesn't get what she wants. She not only wants someone who comes from somewhere, she also wants to appear with him as something real.

She does, in fact, get that: Lohengrin and Elsa marry. Elsa's betrayal, her flouting of the prohibition against asking him about his origins is motivated by her desire to know where he comes from.

She wants something different than what she gets. She wants a man whose genealogy she knows along with everything else about him. She wants something

257

complete according to her bourgeois expectations but she doesn't get it. She doesn't realize that what she wants can't be put into words and that's why it doesn't work. Lohengrin is taken away from her. The question about his origins is also a question of society. Back then everyone always wanted to know and, in fact, always had to know where someone comes from, who their father is, what sex they are. The question of one's origins was important so that they could be situated in the social order. To Elsa, Lohengrin is an upstart. Elsa gets someone she saves but can't define. She really would like to know whom she has. Maybe one could say that she is too inartistic.

The German literary scholar, Hans Mayer, sees Lohengrin *as a drama of the artist, for him,* Lohengrin *is a 'Utopia in A major'.*

Elsa is inartistic. She refuses to accept that she is getting something that transcends her desires, her views, her ideas.

For Mayer, the grail is the utopia that cannot be made mundane: 'That is why the conflict in Lohengrin *must necessarily end tragically, all the more so since Wagner is fundamentally inclined to see the mundane reality and surroundings as unnatural and to see the miracle of the artist as on a higher plane of nature.'*

You could also say that it was not due to any kind of guilt but simply to what defines a miracle or another world. This other world can't be permanently sustained, that won't work at all. Tristan and Isolde do not die for naught. It wouldn't have gone well for long.

There's a particular tragedy in Lohengrin *for Mayer. On the one hand Elsa becomes guilty because she tried to 'constrain the wonder of sensuous existence,' but Lohengrin is also guilty because his mission cannot be reconciled with marriage and the daily life of the nobility. When Lohengrin takes up the mission nevertheless, 'he also establishes his guilt and lays the foundation for the sense of sorrow that the swan "wistfully" reveals to him at the moment of farewell and makes him speak to Elsa, "wracked with grief".' There are also a few fragments of texts that are not set to music in Lohengrin's concluding words that starkly highlight his internal division.*

Well, then. I always saw Lohengrin as a spiritual being, in a more abstract way. That Lohengrin is also guilty is an interesting point of view. Elsa, a noble—today we'd call her bourgeois—firmly placed in her particular societal context, and Lohengrin meet on another level at times. Elsa believed in Lohengrin. She trusted that he would come. She called him. That is an achievement in itself.

She needs him because she is being accused of Gottfried's murder.

What I find important is that Elsa is not like the others who live in the banality of the court. She called on him to come. If she hadn't believed, Lohengrin wouldn't have come to her. That presumes a profundity of mind and spirit.

It's a miracle that Lohengrin appears. Elsa calls in great distress. She calls for help from someone who stands above earthly orders.

She didn't call anyone in particular. Did she simply call for help? It's an interesting question—whether Elsa already had a different level of consciousness than the others. If you call on someone for help and believe that person will save you, then you're already relating to a different world.

In Tristan and Isolde, *silence causes a tragic ending. Tristan and Isolde don't express their deepest feelings. It's a tragedy of speech that doesn't reach another but passes by like an 'empty sound'. In a letter to Mathilde Wesendonck on 12 October 1858, Wagner wrote that he has* Tristan and Isolde *speak in the 'profound art of resonant silence'.*

In the beginning, on the boat, silence reigns. At that point Tristan still wants to speak to Isolde. It doesn't last. Then, when it is possible for them to talk to each other, Isolde can't reach Tristan any more. They're always missing each other, they're essentially trapped in themselves. Does Tristan keep his self hidden?

Yes. Tristan's inability to express his being is probably due to being traumatized through the wound.

Do you know if the Festival Theatre in Bayreuth was destroyed?

No, it was intentionally spared from the English bombs. The English didn't want to bomb the Festival Theatre—they didn't want to look like a country without culture. During the war, the Germans opposed Bayreuth to Moscow— Bayreuth as a city of culture, Moscow as an uncultured place. As a fourteen-year-old, Adolf Hitler identified with the Knight of the Grail, Lohengrin.

Along with *Lohengrin*, there was another drama that profoundly affected me as a child: Schiller's *The Maid of Orleans*. I saw a production of this play in a theatre in Ötigheim. One passage influenced my entire life: when Jeanne d'Arc falls in love with the Englishman. That's impossible—she's not allowed to fall in love with the Englishman. The French and the English are at war. I don't remember the exact scene, but I can remember the feeling I had exactly: a very deep sense of longing, Jeanne d'Arc's powerful desire which is by definition not possible. Jeanne d'Arc is made much weaker by this human desire, by this longing. She can no longer fulfil her utopian mission.

When dreams, the imaginary, are realized, having one's wish granted becomes a nightmare.

Yes, a weakening. I'm not sure it becomes a nightmare but, at that point, the dream, the utopian mission doesn't work any more. Jeanne d'Arc walks a very fine line with complete confidence, like a sleepwalker. That completely fascinated me. It's like she's not really there, but in an entirely different reality that has nothing to do with that of the kings and bishops, all the people running around there. She gives answers that are completely certain in her system. And all the courtiers are impressed at first, as is the weak king. She has powerful resources, she is in league with something greater than she is, but mostly greater than the courtiers.

The way Lohengrin is in league with the world of the grail?

Except: Jeanne d'Arc cannot go back. Lohengrin can return to the world of the grail, his place is there. He actually just makes an excursion. Jeanne d'Arc, however, does not make an excursion—she falls. All of a sudden, she wants something that suits her desire. At first she doesn't long to have her wish granted. She has her utopian mission, her vision, and as long as she sticks to that, everything goes well.

Does Jeanne d'Arc possess an indomitable strength?

She is almost not herself. You could say she's a prophet. She goes out into the world and upsets everything. She says: Englishmen, get out! (*laughs*) She's not of this

world. *The Maid of Orleans* and *Lohengrin* are the two works that touched me most profoundly when I was little.

Were you later influenced by other Wagner operas? Were you also touched by Götterdämmerung?

Götterdämmerung is also very impressive, but as a child I only experienced *Lohengrin* and *The Maid of Orleans* on that existential level. The story of Wotan, the ruler who destroys himself, the anarchist on the throne, interests me more on an intellectual level.

Are there works of art or visual artists who touched you as deeply when you were a child as Lohengrin *and* The Maid of Orleans *did?*

The pictures on the walls in our house were rather trivial. A view of the Rhine (*laughs*), a reproduction of a Frans Masereel woodcut, and so on. These works weren't remarkable for their quality, they were pictures that said to the uninfluenced and impartial child: This is what a picture can do. Naturally, I eventually associated a lot of things with the Rhine painting, the relation to nature. Actually, nature was behind this painting. The painting itself wasn't worth anything. It was effective as a symbol of nature, not because of its quality as a picture. I didn't see a single important, exceptional or meaningful painting in my childhood. Wait, no, I did:

there was a reproduction of Brueghel's winter landscape *The Hunters in the Snow*. It was a copy made by my father and it made a deep impression on me in various ways. Can you picture it? A snow-covered landscape, fire coming through a door on the left. Women cleaning something. I don't remember now exactly what they're doing. But I do still remember there was fire and snow. This combination was very interesting as were the separate planes. The foreground with the bare trees where the hunters are walking, below them the landscape with people ice-skating, and in the background a mountainous scenery with sharp peaks invented by Breughel. This painting had a profound impact on me for several reasons: because of the relation between the foreground and background, the enormous distance that must be bridged, and above all because of the overhead view. It is, in part, an overview of the landscape, you're looking down at the landscape where the people are skating. An overview is something special, a combination of contrivance and reality. This painting continued to have an effect on me for a long time.

What effect has it had in your work over the long run?

I've painted many snow landscapes and trees. One after-effect has to do with the depth you can give a painting. I've worked a lot with perspective. In Breughel's painting there's also a perspective but it's more of an aerial perspective.

There's the perspective of immense depth in your painting Siegfried vergißt Brünhilde [Siegfried Forgets Brünhilde, 1975], *to name one example, with lines of the snow-covered furrows that extend to the horizon.*

Snow as a veil. The snow is like a veil because it changes the structure of the landscape. When the snow's very thick, the landscape is changed, of course. But when the snow melts or is thinner, it starkly emphasizes certain features in the landscape, furrows in fields or roads. The structures become much clearer, they become an abstraction of the landscape. I remember another painting from my childhood, a still life with apples and pears painted as round. I've always been fascinated by still lifes. I've got lots of books about still lifes in my library. The *Pronkstilleven* (sumptuous Dutch still lifes) that are so beautifully drawn, like those mugs, those still lifes in which you see where the light is coming from, water drops like pearls on a flower petal, and so on. Still lifes have also always irritated me deeply because they bored me to death on the one hand and deeply intrigued me on the other. As did the concept of Vanitas. On one hand there was immense expertise, and on the other meaning packed into banal objects. There are two kinds of still lifes: phenomenological and non-phenomenological. When I take an especially beautiful still life of Chardin, it has something phenomenological about it: an object is selected and depicted. The *Pronkstilleven* with

the Vanitas idea, possibly even with a skull, are the opposite of phenomenology because they're so laden with symbols. The disparity between the different kinds of still lifes has always interested me. You have the actual or presumed reflection on death, the Vanitas, the still life with traces of decay, in which worms can already been seen in the fruits, or Chardin's still lifes, which merely portray objects.

Since you just mentioned skulls, would you say that skeletons are the ruins of human beings?

No, not at all. I wouldn't call a cadaver that already has worms in it a ruin. Perhaps one reason why not is that you can't do anything with bones. You can rebuild ruins, reassemble bricks, but there's nothing you can do with bones.

Imagine that instead of the ruins you saw in Mexico, there was a corpse in the forest of Bonampak, overgrown with plants, shrubbery and trees that had broken down its bodily structure. Imagine that, in the middle of nature, you came upon a corpse in a clearing, a corpse overrun by nature. What do you think you would feel at the sight of it? A sense of peace? Because here, too, the human struggle would be over.

On no account would I describe a human cadaver as human ruins. I would never associate a corpse with the idea of ruins. Rather with petrification. I remember that

when I saw my grandfather, with whom I grew up, on his deathbed, I noticed a petrifaction in him. A cessation of movement, but nothing ruin-like. The death of a person is something brutally final. Life really is over. The life of a collapsed building is nowhere near over. It continues to live. It's much more beautiful when a building has collapsed. To return to my grandfather and the sight of his dead body: he was present, more present than in life, shockingly present, as if he were still observing everything or could still speak, as if he might still say a word. Present in a very frightening way, a terrifying way. But only for an instant. I knew he would begin to decay at some point. If he weren't buried, his body would decay. Even if I saw 20,000 bodies lying before me, I would never refer to them as ruins. There are such graves, the mass graves of Katyn. Human bodies are consumed by worms or bacteria and then suddenly it's all over. There's no trace left. Bones, for me, are not a trace. What are bones?

Relics of an extinguished life?

If I had a bone or the skull of a relative, I wouldn't associate it with that person. But if I had a letter from him, it would touch me much more deeply than his skull. That's strange.

So one could think a person's substance is in his spirit, in the act of fixing his thoughts into words or in what he has accomplished over the course of his life.

267

In the traces. He wrote the letter himself, we know that. Not in the skeleton, not in the bodily remains.

In Landschaft mit Kopf [Landscape with Head, 1973] *we see your grandmother in profile. Two red rays shine out from her into a gloomy, almost dark landscape.*

She's looking out into an endless landscape, that's why it's black. On the right, the painting doesn't end—the canvas simply frays.

This arrangement makes the shock and the associated presence tangible: the grandmother already stands outside human society but is still looking at the landscape.

The people you've known who have died are still present inside you. You've got memories of them, they're present in your thoughts, but, strangely enough, not in the bones. Bones are the clearest sign of an absence of sprit, the absence of any trace. Bones are *remnants*. I once saw a church in Naples that was appointed in the Baroque style. Bones had been used in an almost cynical way to make rondels— monstrous. The bones were denatured and desacralized. In this case, you can clearly see that bones are not ruins because they were used for the décor of this church.

Bones have no significance of their own?

For me, bones have no significance. I also don't understand the significance of a skull. Carthusian monks keep

a skull in their cells as a reminder that they, too, will die one day.

An ever-present momento mori.

I see the *momento mori* in a figure like Jeanne d'Arc, not in bones. The fact that we are only on this world for a short time and do not get what we desire: that is a *momento mori*. To me, the human presence is much stronger in an empty theatre. When you see all the seats, empty seats, especially in an old theatre where you know that plays were staged in it. In that case, I feel an uncanny presence of people who are no longer there. Or in an old factory, where you can see all the kinds of work that had been done there, a factory in which 20,000 people had worked every day. That, for me, has far more presence than bones.

How are children shaped by influences?

A child is shaped by the pictures in his parents' house even though some of the paintings themselves may be utterly trivial.

Do pictures remain in a child's mind only due to formative energy?

The pictures remain in a child's mind simply because they're there. American painters saw Mickey Mouse when they were children and later they painted him.

In his Scientific Autobiography, *the Italian architect Aldo Rossi speaks of the abandoned houses on the banks of the Po River, 'abandoned for years in the wake of the great floods. In these houses, one can still find broken cups, iron beds, shattered glass, yellowed photos, along with the dampness and other signs of the river's devastation.'*[1] *You once told me that the house you lived in as a child was flooded by the Rhine. Were you shaped by the destruction from the flooding, by a broken cup, perhaps, a shattered pane of glass?*

The water was much more mysterious—it flowed into the cellar. The groundwater rose. It's fantastic when water comes into the cellar: suddenly the house is standing in water. I remember very well when there was a flood, how all of a sudden, where the street used to be, there would be water. And the water flowed rather fast over the street. The street that led to the ferry dipped slightly and you could see the Rhine in a place where you couldn't before.

Do you have a connection to water that dates from your childhood?

Water is very important to me. Especially the border: the Rhine overflowed its banks, grew much wider and came into our cellar. Where was the border with France then?

1 Rossi, Aldo, *A Scientific Autobiography* (Lawrence Venuti trans.) (Cambridge, MA: MIT Press, 1981), p. 15.

Otherwise the Rhine was a very distinct border. There were dams, the embankment, the Rhine, the ferry and on the other side was France—a completely different country.

You once told me about film directors who were very open. Which films were you thinking of in particular?

Michelangelo Antonioni's *L'eclisse* is the most beautiful film, with Alain Delon and Monica Vitti—the actress to whom Antonioni was married, a fantastic actress. Those almost static pictures of new construction in Rome.

Both La notte *and* L'eclisse, *which Antonioni filmed in 1962, two years after* La notte, *show the agony of love. The devastating scene at the end of the movie, in which Jeanne Moreau reads a love letter out loud and Marcello Mastroianni asks her who wrote her that letter. And she says:* You.

L'eclisse opens with a couple breaking up in a room, then you see the stock exchange where everyone is running around like crazy and large amounts of money are being lost. In *L'eclisse* there are quasi-geometric settings in the new district of Rome. Completely banal. Antonioni shows the facades of the buildings, where so little is happening that you get a lot going on in your head. Although Stifter describes things minutely, there's still

a huge degree of freedom for the imagination, precisely because it's apparently so boring.

Did you have the same reaction when watching films by Andrei Tarkovsky?

With *Solaris*, yes. I like all of Tarkovsky's films, *Solaris* most of all. In *Andrei Rublev* there are images that are wonderful. But otherwise, Tarkovsky is too obsessive for me. His films have a weight that is never lightened by the absurd or the comic.

You have a strong connection to names. You once said that you find names on a map of places in the desert very stimulating. Where do you think your connection to names of people, cities and places comes from? Maybe these names radiate the openness that you just mentioned.

When I look at the map of a city in which I've never been, I'm struck with vague but very strong ideas. When I look at the map of a desert with a few oases, a few names, I find it utterly fascinating. That's the freedom of imagination I spoke about just now, but there has to be something that goes beyond one's own memories for there to be an immediate reaction to names. I once read in Henry Miller, if I recall correctly, that when he was still living in America and wanted to go to France, he looked at a map of Paris and got an unbelievable sensation just from looking at the name on the map. But it

was probably something else. For Miller, it was probably because he had once read about one of the streets, the Boulevard Haussmann, for example, and then reading the name evoked the sensation. For me, it works with names I definitely have not read about before. When I merely look at a map of a city or a country, the place is already present for me, I can already imagine myself flying over it. Taking a helicopter and flying over an area I've often walked through is always a powerful experience for me. I find flying over an area is so fascinating because suddenly the landscape becomes abstract, among other reasons. The landscape not only becomes abstract but also incredibly present. I know exactly where I was, where I've been and what I've done. But if I see it on a map, it's as if I were dreaming. The different perspectives are interesting.

The horizontal plane when you're walking around a city and the vertical plane when you're in a helicopter, the bird's-eye perspective.

It's a cycle. Initially you're down below, you go here and there and, of course, you have a certain perspective, always a horizontal one. After that you rise and everything looks completely strange. At the same time it's a new beginning. It's a new start. It's as if you were seeing an area, a place, a city for the first time. This cycle is interesting, from below where you know everything,

you rise up and experience the area, the city afresh as a map, as a new beginning.

Do names evoke images for you based on their sound alone?

Yes, through their sound. It has to reach very far back. Take Africa, for example: I find certain names of places in the desert, certain station stops very enticing. First the sound, the musical sound of the name and also the contour, the map.

For Marcel Proust, as he writes in the beginning of The Guermantes Way, *a fairy hides in names and gives them their power: 'Yet, the fairy perishes if we come into contact with the real person who bears her name, for the name begins to reflect that person and it contains nothing of the fairy; the fairy may reappear if we distance ourselves from that person, but the fairy will die in the end and with her, the name . . .'*

In *The Guermantes Way*, the narrator falls in love with the Duchess de Guermantes. But when he arrives, it's over. Naturally this is exactly what we've been talking about: the wish and the outcome—it doesn't work. The entire book is built on names, on names that are used satirically. The way aristocratic genealogy continues to branch out, one princess is more elevated than another and so on—the satire is all there. The sound of names is very important for Proust.

Does the sound of a name or of the lines in a poem elicit an image for you?

I experienced that very immediately when I read Theodor Fontane's *Wanderungen durch die Mark Brandenburg* [Ramblings Through the March of Brandenburg]. In those five volumes there are many names, all the aristocratic estates. I know for certain that I'd never heard these names before because some of them are tiny places, but the names always attracted me—in a genetic way, you could say.

What would the connection to names of places in Fontane's fiction have been?

In Fontane, it would have been the sense of belonging to the Germans. The east was always a myth for the Germans: the March of Brandenburg and Pomerania farther east and so on. Since the Bamberg Horseman, theirs was always an eastward gaze. A child picks up on that in a very odd way. I can still remember when, after the War, in 1949 or 50—I grew up with my grandmother in Donaueschingen—her son, my uncle that is, came home after being a prisoner of war. His return had been announced, that is, we were told he would arrive at the train station at such-and-such a time. We had to go to the station two or three times because the train didn't arrive. It's a truly mythological image, a very powerful one: there was a bridge or a tunnel, I don't

quite remember, over or through which the train had to come from the east, from Russia. For a small child, it made a huge impression that someone was coming from so far away. We waited for him for hours on the platform, back then the trains were not as punctual, and this coloured my idea of Russia: somewhere immensely far away, with someone returning after having disappeared for a long time and so on. And so my gaze was turned eastwards for the rest of my life. I still remember the first time I went to Poland. I rented a car in Warsaw and drove through the villages. I thought I was somewhere back in my childhood, when I was four. The sensation was so strong, I could hardly keep driving.

My father was also in a Russian POW camp. He was sent to the eastern front very young, at 17, in 1942. He was captured in Poland and taken by train to a Russian prisoner-of-war camp near Minsk. He would always say that he saw Warsaw twice: once on the forward march and once on the retreat. My father never told us what he saw in Warsaw when they were retreating, but I always knew what he meant. Although he never said it explicitly, always implicit in his words was the total destruction of Warsaw, which I learnt about much later. The verbal expression of this shock is contained in memory.

It was a condensed language, reduced to the essential: forward march and retreat. These words contained

everything. It's also a transmission from one person to another, from your father to you. With me, it was my grandmother. My grandmother never told me that her son was 1,000 kilometres away, that's not how it was. As I child I sensed that it was very important to her that her son was coming home from captivity. I felt the distance, the long journey, the hole out of which the train emerged and so on. That's a transmission, a transfusion, without words.

How did things go, when your uncle returned?

I don't remember exactly. I rode bicycles with him. He also took care of me. But the wait was important. The wait stayed in my mind, the repeated waiting. That period of waiting was the most important. Almost the entire Trans-Siberian railway was contained in our waiting.

Can that waiting be transferred to your work as well: the wait for a painting to come to you?

Certainly, yes. I have many paintings here in my studio that are unfinished and are constantly changing their spatial relation to me. Sometimes they're farther away, sometimes they're close, but they fundamentally distance themselves more and more and when they're far enough away, I get another idea. When they come to me from far enough away, there's a spark. When they're

forgotten in a superficial sense, when I discover a painting that I don't recognize but that still speaks to me, because it seems to have been forgotten but is essentially still very actively present: the dialectic of forgetting and remembering.

Until the forgotten painting forces its way to you.

The dialectic in which the forgotten picture is closer to me than the one I remember because it is comes along as at-once something strange to me and something that had been detached from me. If it's something detached, I can work on it again because the painting becomes an object. The painting becomes a counterpart—then I can begin to work on it again. When the painting is forgotten, it becomes a counterpart.

Croissy-Beaubourg, 17 September 2009

ART JUST BARELY SURVIVES

As a starting point for our conversation, I'd like to ask about an observation you've made: For you, 'Art just barely survives.' How did you come to this conclusion that sees art as under constant threat?

A while ago, I painted a watercolour while travelling in Norway. I'd spent some time that summer on North Cape and there you have that phenomenon in which the sun barely sets. It grazes the horizon and then rises again. This made a deep impression on me, the way the sun at first appears to set but then doesn't. On the water-colour *Nordkap* [North Cape, 1975], I wrote 'die Kunst geht knapp nicht unter' [art just barely avoids going under or just barely survives]. It's very difficult to define art, impossible, in fact. It can't really be grasped. Art is like a fish you pull out of the water that then slips away from you. Art is always very endangered, constantly under threat. First, art presents a threat to itself. It's always taking subjects and topics from outside and transforming them. These are unartistic, uninteresting, banal and very unaesthetic subjects that become art. Over the course of history this, in turn, has an effect on

these very subjects. They ennoble and crown themselves by becoming art. You can observe this process, for example, in design or in the art movement that developed out of Abstract Expressionism in the late 1950s in reaction to the *School of Paris*, in which very simple geometric patterns suddenly became art. Today it's clear that some of these works of art have become design. Donald Judd's boxes have actually lost the qualities that make them art and are now design.

Is the transformation of art into design primarily a result of changing times?

That too, but above all this transformation is a result of art's own strategy: art takes objects from the worlds of fashion and design as subjects. Design then declares itself art in a counter-reaction. With this you have the decline of art into design, because art can no longer be distinguished from design.

How can this levelling process be held back?

There's no longer any question of holding it back, because the process is already complete. The only possible thing to do is to find a different subject and simply leave aside all those objects that have become design.

To look for an object that is free of this usurpation?

To choose an object that has not yet been ennobled by art. This phenomenon is comparable to Olbers' paradox

about stars: in principle, no stars should be visible in the sky. There are so many stars, the sheer quantity should illuminate the sky to such an extent that individual stars are no longer discernable. And that's what happens with art or, rather, that's what could happen with art: because there are so many objects in the world that have become art, art has almost perished. Nevertheless, I claim that art just barely survives because it is still discernable to those who have a practiced eye. You have to seek it out like a prospector looking for gold or like someone who works in a quarry, searching for those pieces of stone that gleam.

It's easier to establish what's gold and what isn't. But in art, the possibilities for making clear-cut determinations diminish.

There's a consensus about gold. The Aztecs didn't consider it a precious metal. For them, it was simply a useful material. Gold became valuable for us through the circulation of money.

It's the same process with art: art obtains value through the circulation of money.

When it's a question of economic value, it's not hard to make determinations. Economic value is very perishable, thank God, some things don't keep their value. At some point, speculations collapse. Economic value is, in itself, not an indicator of art.

And aesthetic value?

Art differs from mundane objects, above all it differs from normal life. Art does not equal life. In the Fluxus movement, objects from daily life were taken and made into art. This process rejuvenated art, made it interesting. But it also brought on a kind of autoimmune reaction. Art suddenly became full of life. Art has irradiated life and thus runs the risk of becoming mute after a certain half-life period.

This muteness probably has to do with the fact that art took on so much life through the Fluxus movement just as the theatre did through Happenings, so much that there was an evaporation of contents. Susan Sontag once said that in Happenings, the audience is the fool.

It reached a state of extreme expansion and dilution we can still observe today since there are still offshoots of Happenings and Fluxus. What used to be avant-garde and transformed art is now standard. If someone employed yesterday's radicalisms, the result would naturally be very stale. Certain manifestations of the avant-garde cannot be repeated. You can put a urinal in a museum once, maybe even twice, but it won't work a third time.

In this respect, would the artist's role be to submit to continuous transformation, perhaps even to bring it about?

The artist is always transforming himself in any case. He is constantly looking and seeking out what can be transformed. Something that has already been crowned as art can no longer be transformed.

What are the implications of this for your own work?

To avoid the autoimmune reaction, I always try to find a point outside of art. The circuits within the art world always produce the same thing: the avant-garde and so on. You have to find an independent standpoint, an Archimedean point, so to speak. You could put it this way: the Archimedean point is found in one's own confrontation with the world.

Is the sense of shock inherent in this confrontation for you?

Yes.

Does this sense of shock cause a trembling in your soul?

There are such moments: when a breeze rises and branches and leaves begin to move. There are such moments, as the lovely expression has it, when there's something in the air. I don't look for what is still possible in art. I look for a standpoint outside art. One day, I discovered a lead pipe in the house in Germany I used to work in. There was still lead plumbing at the time. This lead fascinated me and it has never lost its grip on me. Through this physical experience of lead, I accessed

a spiritual level. I was able to determine that my fascination with lead is not an aesthetic fascination but a mythological, historical one. Over time, I've learnt a great deal through lead. In the beginning, it was an immediate confrontation—it spoke to me directly. Lead wasn't associated with any artistic context. There was no leaden bas-relief that called to me, since there's never been such thing in the history of art. It was the fact of a lead pipe that released a spiritual movement within me. Another instance was the sandbox I had as a child. My sandbox was small, 1 metre by 1 metre. Later, in my work, sand was a provocation. That's what led me to the idea of *Märkischer Sand* [March Sand, 1980–82]. I took two experiences—the little sandbox and the sand fields of the Brandenburg March—and overlaid one on the other. The result was that I threw sand directly onto the painting and the sand stuck because of the glue. Because of my encounter with sand, not an encounter with a work of art, I was able to charge the sand in such a way that it could become a picture, a work of art. The charge comes from the superimposition in my consciousness of an historical dimension onto the sand of my childhood.

In an interview for your two exhibitions in London, The Fertile Crescent (2009) *and* Karfunkelfee (2009), *you said that history is your mother and that it feeds you.*

That's one way of putting it. History makes overlaying possible. Roland Barthes once wrote of the French historian Jules Michelet that he grazed through history as through a field. This lovely image corresponds to the idea that history has fed me.

In earlier conversations we spoke about the various elements: fire, earth and air or wind. Water is also a central element in your work. Was water—like lead—an element that you first apprehended outside the realm of art?

Definitely. I grew up on the Rhine, on a large river. The Rhine was straightened in the nineteenth century by the engineer Johann Gottfried Tulla, but there was the Old Rhine arm into which high water flowed. The water reached all the way to the villages. The river and the spreading of the floodwater sparked many things inside me: water both establishing and eliminating limits.

As, no doubt, did seeing how the spreading water flows: quickly and easily over the earth that lay just below the water.

The way water always keeps flowing: water as a means of thinning, of diluting. The concept of alkahest is of a solution capable of dissolving everything, a universal solvent. That's the alchemists' idea. Naturally, dilution is very important for me. I often lay paintings on the ground and pour water on them or I sprinkle them with

diluted paint. And so I expose the paintings to a dilution. The last lines of Rilke's *Sonnets to Orpheus* are: 'And if the earthly has forgotten you, / To the silent earth say: I flow. / To the rushing water say: I am.' These are wonderful verses. Water is involved with erosion. Entire mountains and sediment collected over millions of years are carried to sea by water. Water contributes to the cycle of nature: seemingly permanent stone is worn away, crushed into sand and mud.

In Barjac, you have an underground room in which water 'stands' and lead 'flows'.

What was special about the so-called lead-room was that you couldn't hear a sound. The lead-room was a space without a single sound from outside. Of course, lead and water have their own particular connection. There's also a depth to the lead-room: the space is reflected in the water, in which the lead is reflected in turn, and so on.

An association with the lead-room that occurs to me right now is Moses striking the rock with his staff.

Moses brought forth water from the rock by striking it, a wonderful image. He was probably a dowser. He had seen where the water was. Moses managed to strike it out of the rock.

You see something solid, like a mountain, for example, which begins to flow in your work.

I once painted a mountain and water with lots of grey poured over it and all of a sudden it was clear that the mountain was alive. The mountain ended up as a river.

Sheer relentless flowing is very present in your sea paintings. In one room here in Croissy-Beaubourg, there are three paintings of the sea bounded by the beach. The waves break with a force that seems not to let up. A leaden boat lies washed up on the shore.

The boat isn't in the water but on the beach. The stranded boat is connected to time, it's waiting for the water, waiting to be lifted again so that it can sail onwards.

Is your observation that 'art just barely survives' connected to the image of Noah's ark? Could one say that in art, too, 'cargo' is being carried on the sea, through the Flood?

Mount Ararat is a beautiful image. The ship stranded on a mountain—the ark is actually no longer a ship. The ship cannot sail any farther. I always think the ark is waiting for the next flood.

What does this image signify for art? That art will emerge from the 'ark' after it is newly stranded?

Everything will be covered up again (*laughs*), and art will continue on its solitary way. We could perhaps say that we're caught in a Flood. That would be a highly paradoxical situation: art almost sinks beneath the abundance

of its manifestations, the abundance of revived avant-gardes, and so on, and yet, at the same time, this Flood could make the ark flow again. It's a kind of hope, however, I don't know if that works pictorially. It's the hope that something will rise again from what's left behind. The ark is the concentration, the remnant. You could also put it this way: when the Flood, today's flood of images, becomes too much, it could be that the Flood will lift the ark, that it will be afloat again, in a counter-reaction, so to speak.

Because through the flood, as Roland Barthes presented it in relation to photography in his study, Camera Lucida, *the so-called advanced societies became consumers of images. In the past, they were consumers of beliefs.*

We hope that the flood will grow stronger and the ark will rise again. The ark is in danger of drying out. If it lies on dry ground too long, cracks will form in the hull and it will no longer float. The ark awaits the next Flood and also barely survives. Indeed, in this case you'd have to say, the ark barely avoids drying out.

The experience of shock opens channels through which the water can flood into you and what you perceived in that state of shock can penetrate you.

It will flood, yes, and launch what was perceived, so to speak. Now you're talking about my method of working.

I'm constantly liquefying paintings, covering them with water so that they will float again. You can also say that the paintings are arks that dry out from time to time which I then have to water. It's a process of drying out and irrigating. In the past, priests entered the church at the beginning of Mass and sprinkled holy water in all directions. Blessings were done with water. The priest had a staff topped by a sphere with little holes. Water sprayed in all directions through these holes and the faithful were besprinkled by the aspergillum. Besprinkle is a nice word.

Is an encounter with an object necessary to launch the 'ship' in artistic creation? Francis Ponge wrote in his Proêmes, *published in Paris in 1948: 'Even the humblest of objects is so expressive that I am unable to report on anything but the simplest objects: a stone, a blade of grass, a piece of wood, a piece of meat.'*

For Ponge it's a matter of looking at objects as objects. That's an approach similar to Hegel's phenomenology. Ponge's Archimedean point: the object as object, independent of anything else. Not discovering what has been imposed on the objects but what reaches one from the objects themselves. Through this, something begins to flow.

Flowing is not only associated with water. In the mysticism of Isaac Luria, it's light that flows, that is poured out and

recedes again. How did you come across Isaac Luria's conceptual world?

Through Gershom Scholem. In the early 1980s, I was in Israel and visited Jerusalem several times. I was very engaged with Scholem's writing and Luria is prominent in his work. Luria had a completely different conception of cosmogony. For Luria, unlike all the other philosophers and theologians, there was no God, no Gaia, or any other being who created the world. The world created itself and God allowed it to happen, He withdraws so the world can create itself.

So that primordial space can come into being and light will flow into it. The lower vessels could not contain the light.

Five vessels were shattered by the emanation of the light: *Shevirat Ha-kelim.*

That was the Breaking of the Vessels. The light not only flows into primordial space but also flows out and back in again.

There is a kind of exchange, a circulation, but something shatters in the process.

Do the vessels have to break?

Yes, there's a discrepancy between the magnitude of divine grace and their ability to hold it.

Elements are formed because of this discrepancy?

When physicists picture the creation of the world, they say that matter emerged from a certain mass of energy. Still, compared to the energy present at the big bang, there is relatively little matter. This space, this world that was formed, can only hold a small portion of the grace, otherwise it would be too much. You can say that it contains an original flaw.

Which leads to the cosmic catastrophe.

Matter, thus the elements, emerged from this flaw. Everything that is present is also incomplete. Perfect light cannot be comprehended—it's energy. As soon as something forms, there are holes in the system. Alexander Kluge would say it's the hole left by the devil (*laughs*).

The explanation of evil in Luria's system is a very difficult one. One wonders where evil comes from if light is pure divine energy.

It was easier for Luria to frame a theodicy because according to him, God didn't create the world, he only allowed it to come into being.

But wouldn't evil then also be contained within God?

Evil is there where God has withdrawn from. Luria's system is ingenious because it allows for evil. Evil is not in God but outside God. Evil comes into being only when He withdraws, it was not there before. Luria's cosmogony

becomes a dualistic concept but originally it was the void. Luria's system begins with a void, with empty space.

There's also the idea that in this void, in this empty space, there was the golem.

There is that idea (*laughs*), but if a golem is sitting in an empty space, it's no longer a void.

When I saw your painting Shevirat Ha-kelim (2009) *in London, I had the feeling that the concentration of energy was so high, the clay shards on the floor had burst out of the painting.*

As if it had exploded. That fits Luria's concept: there's too much grace, it overflows and therefore bursts through the whole. The shards were strewn around the room.

I had the impression I could see eyes in the top left of the painting.

I didn't see any eyes, but they could be there. I didn't paint any eyes.

In Merkabah mysticism, the throne-chariot is covered with eyes. I'm reminded of this.

It's good if you see eyes, I have nothing against that. It makes no difference. I'm always happy when someone notices something that I didn't see.

According to Luria's mysticism, it's man's duty to find his way back to his original spiritual form.

That would be a release—one should become spirit.

If you turn these reflections onto your own life, what might they represent?

That at some point it will no longer be necessary to work with matter. Or, applied to my own life: over the course of my life, I notice more and more that I'm not the so-called creator but that my work takes on an overall intelligence or comes from a general intelligence. You notice more and more often that ideas are not limited to particular places. Ideas spread independently over the globe. Discoveries and inventions also occur simultaneously on opposites sides of the globe. There's a network, an invisible field, that spans the whole and in which the individual is no longer important. I also notice these thoughts evermore often in relation to my life and my creative work.

Kantor once said that in art, the artist is God. So I've tried to apply this to your studio complex in Barjac. You've left Barjac. Does this withdrawal create an opportunity for something new to arise in Barjac?

It's the same process as when a painting leaves the studio—something new comes into being. A number of people look at the painting with different eyes. In

each person's head something new emerges that I didn't see in the picture. Like the eyes you saw in the *Shevirat Ha-kelim* painting.

Does the departure create a new space as well?

There is a kind of liquefaction or expansion of the space. The more people see a painting and have ideas about it, the more its meaning will spread. This creates more mental space.

Because more ideas and interpretations can enter that space?

I wouldn't say interpretation, that concept is too professional. It's another kind of activation. A lot of things are released. It's as if a shot were fired, as if something were triggered.

The bullet follows its trajectory and hits a particular spot.

Or it bounces back or ricochets off in another direction, becomes a stray bullet. Something results that couldn't have been predicted. That's really the reason I work at all—because something unexpected is constantly occurring. That keeps me entertained.

Franz Kafka once said that his stories were a kind of closing of eyes.

Did Kafka mean by that that a standstill is reached?

I assume that Kafka was referring to the physical sensation of closing one's eyes that his stories elicit. When you get to the end of a story, the movement is one of eyes shutting. The sensation moves inward. If you consider Kafka's novel, The Trial, *it ends in a way that evokes the closing of eyes.*

It's a pivot, you could say, a flip. What's external becomes internal, you see your own skin from the inside, suddenly you see your own skin. The eyelid is also a membrane through which something penetrates and then goes back out again. When I close my eyes, space expands vastly. When I look, my gaze is like an arrow, aimed at something specific: the car driving past just now, the tree outside the studio, or the airplane approaching the runway. I aim, I aim. When I close my eyes, I'm no longer aiming at anything but I have endless space inside me.

Is your work a creation-outward of what was seen in your inner space?

My method is as follows: first I make something specific, I paint a mountain or a river. Then I try to close my eyes, metaphorically as well, and, as Novalis says, to make it secretive. With that expression, to make secretive, I mean both to create a vast space with it and to see the extremely vast space inside me. The targeted object, initially very detailed and concentrated, becomes a wide-open space with time and with sustained work.

In your painting Karfunkelfee (2009), *the forest becomes an extremely vast space.*

Initially I painted forests. The forests were forests, nothing more. They were depictions of forests like those painted by field-forest-and-meadow landscape painters. You know the term. The forests were a bit kitschy, nothing but trees. Through the thorns I put in front of it and through the glass shards, in which you partly see yourself—so that you see yourself in the forest—the space was opened up to something else and extended in depth. When I close my eyes on hearing the word 'forest', I apprehend an infinite expansion of space. You can't see the end of the forest when you're in it, you don't know where it stops. As a child, I often went into the forest. I always had the idea that I'd like to keep going until I no longer knew where I was—to lose myself in the forest, without any sense of direction.

Even at the risk of not finding your way out of the forest and back home?

I never actually did, but it was always an idea I had. When you swim in the sea, as I mentioned before, you also get the notion of swimming out so far that you lose sight of land.

In that notion are you swimming towards something?

Towards a state of being.

And towards a person?

No, not towards a person. You swim out towards a dissolution. You swim until there's nothing left to hold onto, until land and shore have disappeared. That desire you have while swimming: you'd like to swim out so far that you can't see the shore.

A friend once told me that after his girlfriend's death he wanted to swim out into the open sea. One summer night he sat on a sail-boat and said to himself: Now I'm going to swim out until I sink. Swimming out, for him, was bound up with the hope of seeing his girlfriend again when he went under.

That, too, of course is a conception of space in which you meet again after death. The various religions configure this space differently. In one religion it's reincarnation, in another nirvana, and so on. My desire while swimming out was not connected at all to a person. On the contrary: it was a distancing, the desire to be farther away from others.

The wish to distance yourself from those close to you is also present when you walk into the forest.

By means of the thorns behind the glass shards, the forest is moved into the distance. It's difficult to make your way through the thorns.

At the same time, there are swaths of light that expand the space.

Light shines through, it's the dispersal of light. I painted this after motifs of a snow-covered landscape. Snow makes the light particularly distinct.

Snow and light are the intrusion of another reality into the forest.

Yes, light is reflected above all by the snow in the forest, up to 80 per cent. Snow is highly reflective. People aren't aware of it, but because the snow immediately reflects the light back, a cosmic context is produced. The sunbeams that bounce off the snow are sent back into the cosmos, they're no longer curbed by anything.

I was moved not only by the light reflected on the snow covering the ground, I also responded to the snow drifts between the trees. Maybe as an image of transcendence breaking into a forest: something from another world drifts through the forest, something from another world blows into oneself.

Those are rays. The light is split into rays and these rays shine between the tree trunks and through the branches.

In an interview with Kerstin Decker about his film Antichrist, *the Danish film director Lars von Trier said that the forest is the maximum of pain. I also had that feeling in London when I stood in front of your forest paintings.*

Yes, with forests one also has the idea there's something hidden in them. The forest is a refuge, too. The tall trees are like a church, like the columns in a Gothic church.

Destruction is very present in your forests: on a ribbon strung through the thorns, there are photographs of buildings.

The towers in Barjac are visible on film loops. The loops showing the towers repeat and bring verticality into the painting in a different way, but in a dilapidated state.

You can also see an erect snake.

The snake is the chthonic element, the earthy, the light. There are a great number of references, of course.

In the Old Testament there's the image of the raised bronze snake. For the Israelites wandering through the desert, snakes were a threat.

The snake was tilted vertically, snakes can't do that on their own. They can only hold a third of their body length upright. A snake can't do anything if you hold it by its tail. The Israelites set snakes on poles in the desert for healing because snakebites were toxic. They complained about God and so were bitten by a snake. Whoever looked on the bronze snake was healed of snakebite.

On the lower right side of your picture, there is an upright snake.

It's like a menetekel, like an incantation. You take a snake that's crawling on the ground and simply hang it up, just make it vertical. You make it visible, raise it up. When it's set up like that, it loses its destructive effect.

There's another vertical line in your Karfunkelfee. *It's as if gold had fallen from above onto the karfunkelfaerie's grey dress that is visible in the treetops.*

The karfunkelfaerie is a very equivocal apparition. On the one hand she connotes the glowing red ruby and gold, on the other she signifies black and darkness. In addition, the carbuncle could also be coal or it could be ergot. Ergot is a disease that used to attack wheat. Today these diseases have all been eradicated. When wheat was afflicted with ergot, it turned completely black. When women were in labour, they were given this fungus to speed up the birth. The terms carbuncle and karfunkelfaerie contain vividly glowing and bright elements as well as an element of absolute darkness.

Gold falls from the sky onto the grey dress of the karfunkelfaerie similarly to the way it falls in your staging of Am Anfang *in the Paris Opera.*

It recalls *The Star Talers.*

In that fairy tale of the brothers Grimm, a girl goes into a dark forest, and, because she has nothing but her own body, naked and exposed, stars fall from the sky. In exchange for

the chemise she had given away, the girl receives one of finest linen in which she gathers the stars that have turned to taler coins. The words 'star talers' certainly evoke a twee atmosphere because of the fairy tale's reception.

That's why I didn't call the painting that, but I do have in mind the child who receives gifts from heaven and is saved.

In your painting, the dress is an empty shell and the fairy is absent. The grey dress could be the chemise the poor girl gave away. The movement through the trees is not only from the ground upwards, but for me, gold is always falling from above onto the dress.

Manna falls from above.

An airplane appears to have gotten caught in the branches.

Or airplanes want to take off in the forest but get trapped in the trees. The painting with the airplane in the trees is called *Aus dunklen fichten flog ins blau der aar* [From Brooding Pines, an Eagle Upward Swept into the Blue, 2009]. It's the first line of Stefan George's poem 'Urlandschaft'.

When you get close to the forest paintings, you see a vibrant red as if the forest were set on a bloody subsoil.

Everything is initially painted with a layer of red. My pictures often begin with lots of colour. I wanted the

preliminary drawing to be done entirely in red, in cadmium red. A little of the red should remain—like the resin of a tree or like veins or arteries. Suffering, bleeding. Trees bleed when a branch is sawed off.

You've been intensively engaged with Ingeborg Bachmann's poetry. In London, you wrote the lines from her poem 'Das Spiel ist aus' (The Game is Over) in black on a white wall: 'Only he on the golden bridge who still remembers the secret word / for the karfunkelfaerie has won. / But I must tell you, it melted away with the last traces of snow / in the garden.' The painting Für Ingeborg Bachmann: der Sand aus den Urnen [For Ingeborg Bachmann: The Sand from the Urns, 1998–2009] *is dedicated to the poet. Has Ingeborg Bachmann's poetry changed your view of the world?*

No, but that's an interesting question. You might put it this way: Bachmann's poems turned my gaze away from the world—onto another reality. Her poems showed me that the world, as I see it, doesn't exist at all, that it's an illusion. The poems are more real. The world is shrouded in fog. When you ask me if Ingeborg Bachmann's poetry altered my view of the world, do you mean that I might have gained another view? I say no, but through her poems I recognized that there is no concentrated or correct view of the world. That's an illusion. The world is in the poems.

If I understand you properly, Bachmann's poems have completely changed your way of seeing. After your initial view of the world, you now say that the world is in the poems.

For me there is no other world. With the poems it's almost as if her flow—in Luria's sense—rends the veil of the world, burns the veil of the world. All at once it becomes clear that the world is not the way you assumed it was. The poems create a breach. Through the poems something also shatters, there's also a *Shevirat Ha-kelim*. The tearing of the thin veil of illusion runs through all of her poems. Or the breaking open of minds quickly pacified after the War. The poems lead to a rupture. Something is always bursting open—as with Luria's flow. Through the poems only rubble remains.

Paul Celan's view was that the consummate poem must 'scratch the world' the way 'an engraver etches the plate from which prints will be made.'

That's it. I didn't know Celan had said that. We've come to the same conclusion, thoughts are everywhere. His expression 'scratch the world' is good.

Celan wrote in a letter to Ilana Shmueli, a childhood friend who had emigrated to Israel: 'There is not a single line in my poems that isn't connected to my existence: I am, as you see, a realist in my own way.' Would you also say that you're a realist?

Yes, my reality is different from the world's, illusory as well, to be sure, but on another level.

For Celan, the consummate poem is legitimized only through its 'accuracy . . . its representation of our resistance.'

For me resistance means soldiering on in the face of meaninglessness. I resist dissolution. When I swim out in the sea, there's also a resistance. At some point I turn around, but that's the resistance of the survival instinct. Resistance is very complex: resistance against the usual, worn out, standardized use of words. That can be a kind of resistance, but also resistance against one's own complacency. Or resistance against settling for whatever reassurance one is offered. Resistance against the sufficient. Nothing is ever sufficient.

Is it about keeping alive the trembling mentioned in Victor Hugo's poem 'Expiation'? To keep from falling into a stable state, and instead to be reduced to a state of trembling by some defeat—as you depicted in your Waterloo *cycle* (1980–82)?

'Waterloo! Waterloo! Waterloo! morne plaine! . . . Quarante ans sont passés, et ce coin de la terre . . . Tremble encore d'avoir vu la fuite des géants! [Waterloo! Waterloo! Waterloo! mournful plain! . . . Forty years have passed and this patch of ground . . . Still trembles from having witnessed the giants' flight!]' For Victor Hugo

it's a connection of geological time and human history. Hugo associates these two different times to evoke pathos. That defeat was so terrible, the earth is still trembling today. In the fusion of two eras, the 'I' in its ephemerality is connected to geological or cosmic time. We're like a shooting star, it's over very quickly. This connection is also a means of consolation. Saul Bellow, I believe, once wrote: 'Hitch your agony to a star.' In the interest of survival, human beings have not been content with the border or their front gardens. The ability to endure constantly stepping over this border and looking into infinity—that's probably also what Celan meant by resistance. There are many opportunities to become complacent: through consumption, through comfort, and so on.

When you hitch your agony to a star, that agony takes on a cosmic dimension.

On the one hand the cosmic dimension is vertiginous, on the other it's also comforting because it leads away from the individual fate and into the universal.

This brings the question of perspective into play. For Blaise Pascal, as he says in his Pensées, *man is 'a mere reed, the weakest thing in nature, but he is a thinking reed. There is no need for the entire universe to take up arms to crush him: a vapor, a drop of water is enough to kill him.'*

Compared to the cosmos, one's own life, one's body, one's existence, all become—flipped onto a scale of smallness—just as infinite. These relationships are also found in Merkabah mysticism: as far as it extends in vastness, it simultaneously descends just as deeply into the self.

Does connecting one's own agony to a cosmic dimension really provide consolation? The feeling of being lost in the infinite space of the universe becomes a great deal stronger.

It is stronger. At the same time, it's consoling. In those places you feel most lonely, on a beach, for example, or in the mountains surrounded by permanent snow and ice, you feel most connected.

With nature?

With everything. You carry a longing for dissolution within. We talked earlier about swimming out into open water. When I fly over the Alps or the Himalayas and look down at the permanent ice and snow, I think: I'd like to be down there. The longing extends there, too. Where you're loneliest, you're most connected: Your relation to everything reaches into infinity.

When I flew to Japan in late November a few years ago, I gazed at the Siberian desert of ice and snow for a long time in the early morning hours.

A tremendous expanse. When you fly to Japan, you always see that desert of ice and snow. It's wonderful.

According to Walter Benjamin, the artist is blessed because in his work, he surpasses nature so to speak. In your painting Für Ingeborg Bachmann: der Sand aus den Urnen, *the brick structures are almost completely covered with sand, faster than could ever have occurred in real life.*

It's the point where there's still something that can barely be glimpsed. If I'd gone on with the sand, the structure would have disappeared into nothingness. Naturally, there's a feeling of being fortunate because a natural process is almost being re-enacted. Little painter that I am, I can re-enact the natural process of something being silted over. When buildings are covered with sand, that's something wonderful, of course. Maybe that's what Benjamin means with 'surpassing nature'.

An incredible acceleration.

Acceleration was very important for the alchemists. They didn't do anything other than speed nature up. I also look at painting and my artistic practice as a kind of acceleration.

Up to what point do you accelerate?

Up to the point when there's still something visible.

Up to extinguishment?

In the picture you mentioned: with a few more handfuls of sand, it really would have been nothing but sand.

To the point where no visible trace would have remained.

When the trace would have tipped from almost nothing to nothing. I work on that edge.

A few philosophers consider the camp as the epitome of the twentieth century. In his Carnets de captivité [Notebooks in captivity], *Emmanuel Levinas reflected on the experience of being held prisoner and its effect on the concept of the human.*

Camps like Auschwitz?

Yes. What do you see as the epitome of the last century?

Albert Einstein's theory of relativity and everything connected to it: scientific understanding that went beyond anything man could have imagined or can imagine. Einstein opened the world to quantum theory, which for us is almost inconceivable. The twentieth century is one of terrible catastrophes: more than 50 million dead in one world war. A raging century. A century of great intellectual advances and discoveries in physics and also terrible political frenzy in the Second World War.

And when you look into the future?

In the future I see, above all, expanding digitalization, a system of surveillance—it will change many things.

What man has always fought for—freedom—will gradually be eliminated through surveillance.

The digital camp?

The digital camp is something so horrifying we can't even yet imagine how far it will extend. The replacement of analogue images by digital ones is a twentieth-century development, but its full effect will take hold in the twenty-first: the possibilities of manipulation that go with it. Total surveillance, complete information storage, this is monstrous. We overtook Orwell long ago.

And when you think about the end of time: when the earth, the entire planet, everything that man has ever done is sucked into a black hole.

That will happen in any case (*laughs*), at some point the earth will cease to exist. The earth can't be eternal. At the very latest when the sun no longer shines, perhaps even before then.

When you envision the earth being sucked into a black hole at the end of time, the gravitational pull will be so strong even the elements will be smashed. What will happen with this destructive energy, will it explode again or will it end?

There are several theories about this. One posits the big bang will happen over and over, expansion, then contraction into a hole, then another explosion, and so on.

Art just barely survives. And the artist?

The artist is constantly foundering. He never achieves what he wants. He can only skirt the crater. And when he gets too close, he falls in like Empedocles.

In his Little Manifesto, *Tadeusz Kantor wrote:* 'It is not true that MODERN man has conquered fear. Do not believe it! Fear exists, fear of the external world, fear of the future, of death, of the unknown, of nothingness, of emptiness. It is not true that artists are heroes and fearless victors as old legends tell us. Believe me, they are poor, defenseless beings who have chosen to take their place opposite fear.' *What place have you chosen?*

I believe that I haven't chosen anything. I'm caught in a net, but not like poor Agamemnon. Rather, I'm in held in a network that stretches back to the beginning of the universe. You mentioned Kantor. He's the greatest. I saw all his productions. I flew from Odenwald to Paris for them every time. After one performance we gathered in a small hotel room, drank all night, and at sunrise I wandered the empty streets with one of the actors who spoke German, and Zbigniew Gostomski, the Pole, the victim, sang German songs from the 1930s, songs of the terrible oppressor: 'We will march on / when everything shatters / For today Germany hears us / and tomorrow, the entire world.' Imagine: those songs at dawn in an empty Paris, it sent shivers down my back

despite my drunkenness and I thought: soon all the window will be thrown open, we're not in the theatre any more, this is not art, this is life. It was confusing: the chronological as well as the definitive border between *occupation* and *libération*, between perpetrator and victim, seemed to have been erased. When you eliminate borders—and every border is an illusion necessary for survival—you get the defenselessness Kantor talks about.

If there is no such thing as eternal life in the Christian sense for you, what do you think of Pascal's wager?

How could we conceive of eternal life? Or even paradise? If there were such a thing as paradise, we wouldn't exist. Our life is life only because it's transitory, because it's the last chance and therefore so precious. It's paradoxical to speak of eternal life as a continuation of this life somewhere else, as a resurrection of the body. We exist only because life will end one day. Pascal's wager contains this paradox. All of his writing is filled with paradoxes and alienating exaggerations, very artistic. Pascal's wager is not proof of God's existence but more like extra insurance. He says that if God exists, it's foolish and dangerous not to believe in Him since nonbelievers will end up in hell. But if God does not exist and we are mounted on an illusion, then it's not bad since it makes no difference. So he cleverly links belief

with unbelief. It's nice that you've brought Pascal into the conversation because he has always fascinated me with his paradoxical style which transcends, in its artistic way, the particular subject, i.e. his defense of the Jansenists. Faith and art can move mountains, even if both are illusions.

Croissy-Beaubourg, 30 November 2009

BIOGRAPHY

'I think in pictures. Poems help me with this. They arc like buoys in the sea. I swim to them, from one to the other. In between, without them, I am lost. They are the handholds where something masses together in the infinite expanse.' *Anselm Kiefer*

'The artist is constantly foundering. He never achieves what he wants. He can only skirt the crater and when he gets too close he falls in like Empedocles.' *Anselm Kiefer*

The only visual artist to have won the Peace Prize of the German Book Trade, Anselm Kiefer is a profoundly literate and literary painter. In fact, more than half his output takes the form of artist books. His paintings, sculptures and installations have won him acclaim as one of the most prominent artists of his generation alongside Gerhard Richter and Georg Baselitz. Recently, Kiefer has also been active in the theatre, designing stage sets for productions of Sophocles' *Oedipus at Colonus* and Richard Strauss' *Elektra*, and creating an opera based on the Old Testament prophets Isaiah and Jeremiah for the Opéra Bastille. In these ten conversations with the writer and theologian, Klaus Dermutz, Kiefer returns to the

essential elements of his art, his aesthetics and his creative processes.

Kiefer describes how the central materials of his art—lead, sand, water, fire, ashes, plants, clothing, as well as oil paint, watercolour and ink—influence the act of creation. No less decisive are his intellectual and artistic touchstones: the sixteenth-century Jewish mystic Isaac Luria, the German Romantic poet Novalis, Ingeborg Bachmann, Paul Celan, Martin Heidegger, Marcel Proust, Adalbert Stifter, the operas of Richard Wagner, the Catholic liturgy and the innovative theater director and artist Tadeusz Kantor, along with many other writers and thinkers.

Born in 1945 in Donaueschingen, Anselm Kiefer studied law and literature before attending the School of Fine Arts in Freiburg and the Academy of Fine Arts in Karlsruhe. His regular discussions with Joseph Beuys at the time would prove as important as his formal studies. His work shown at the Venice Biennale in 1980 provoked a heated controversy for his treatment of German history. In 1993, Kiefer moved to Barjac in the south of France and spent the next decade and a half turning the abandoned silk factory at La Ribaute into a *Gesamtkunstwerk* of buildings, tunnels, studios, lead-lined rooms and pavilions to house single paintings. In 2007, he moved to Paris where he now lives, working in a 35,000-square-metre studio in the former Samaritaine department store warehouse in Croissy-Beaubourg. One of, if not *the* most important post-War German artists, Kiefer continues to be a major presence in the contemporary art world. His major retrospective in London's Royal Academy of the Arts was

booked solid and demand was so great they had to extend hours to accommodate the viewers. He has had solo exhibitions at the Hermitage Museum in St. Petersburg, the Museum of Modern Art in New York, the Guggenheim Museum in Bilbao, the Centre Pompidou in Paris, and other major international art museums. Kiefer is also the only living artist on permanent display in the Louvre.

Kiefer has been awarded numerous major international prizes including the Praemium Imperiale from the Japan Art Association, the title of Commandeur dans L'Ordre des Arts et des Lettres, and the Leo Baeck Medal.

For all the widespread recognition, Kiefer remains a controversial figure. His relentless examination of German history, the themes of guilt, suffering, communal memory and the seductions of destruction have earned him equal amounts of criticism and praise. Kiefer's work is visually stunning but also deeply and consistently provocative intellectually. He has profoundly influenced the course of modern European and American painting as well as the way critics, writers and art historians discuss the relationship between history, politics and the visual arts. The conversations in this volume offer a rare insight into the mind of a gifted creator, into a mind in the act of creating. This volume will appeal to a wide audience ranging from specialists—artists, critics, art historians and cultural journalists—to anyone interested in the visual arts and the literature and history of the twentieth century.

'While producing each painting, I often despair over the results. In the meantime, I've developed ways to wipe out everything except for a few remnants.

315

Either I use fire or ashes on the painting or I cover it with sand and so on. In the very process of making a picture there's a creation and a retraction, destruction, too. Something new can emerge from destruction. I've often worked on a painting with a hatchet, with an ax and such. With this rhythm I obviously feel at home in the Old Testament.' *Anselm Kiefer*

A NOTE ON SOURCES

Paint in Order to Understand, Understand in Order to Paint appeared in an abridged form as *Der Mensch ist böse* [Man is Evil] in the weekly newspaper *Die Zeit* (10/2005).

I Make Matter Secretive Again by Exposing It appeared in an abridged form as in the catalogue of the exhibition *Maria durch ein Dornwald ging* (2008) [Mary Walks Amid the Thorn] in the Thaddeus Ropac gallery in Salzburg.

Remnants Fascinated Me From Very Early On appeared in an abridged form in the programme book for the premiere of *Am Anfang* [At the Beginning] at the Opéra Bastille, Paris 2009.

Oedipus is Transformed from a Figure of Guilt into a Figure of Light appeared in the monograph by Klaus Dermutz: *Klaus Michael Grüber—Passagen, Transformationen* (2008) [Klaus Michael Grüber—Passages, Transformations] published by the LIT-Verlag.

All illustrations are reproduced from Anselm Kiefer's private archive.

REFERENCES CITED IN THE
GERMAN ORIGINAL

BACHMANN, Ingeborg. 'Das Spiel ist aus' in *Anrufung des Großen Bären*. Munich: Piper Verlag, 1972, p. 82f.

CELAN, Paul. 'Ich bin allein' in *Mohn und Gedächtnis*. Munich: Deutsche Verlags-Anstalt, 1952, p. 53.

KANTOR, Tadeusz. *Ein Reisender—seine Texte und Manifeste* (Institut für moderne Kunst ed.). Nürnberg: Verlag für moderne Kunst, 1988, p. 273.

MAYER, Hans. *Richard Wagner* (Wolfgang Hofer ed.). Frankfurt: Suhrkamp Verlag, 1998, p. 108.

NEHER, André. *Jüdische Identität, Einführung in den Judaismus* (Holger Fock trans.). Hamburg: Europäische Verlagsanstalt, 1995, p. 77.

PONGE, Francis, *Texte zur Kunst* (Werner Spies trans.). Frankfurt: Suhrkamp Verlag, 1989, p. 124

SAVINIO, Alberto. *Stadt, ich lausche deinem Herzen* (Karin Fleischanderl trans.). Frankfurt: Suhrkamp Verlag, 1989, p. 401.

SEBALD, W. G. *Luftkrieg und Literatur*. Munich: Hanser Verlag, 1999, p. 30 and p. 36f.

ACKNOWLEDGEMENTS | KLAUS DERMUTZ

I extend my heartfelt thanks to Anselm Kiefer for his confidence, for our conversations in Barjac and Paris and for permission to use the photographs from his private archives for this volume.

I would like to thank Renate Graf for our meeting and the cover photograph for the German edition of this book.

I am grateful to Thaddeus Ropac and Dr Arne Ehmann for their generous support; and to Waltraud Forelli and Eva König for their active engagement and manifold information.

I am thankful for Dr Hubert-Christian Ehalt's help and encouragement.

I also extend my thanks to Sophie Fiennes, Angelika Lantzberg, Muriel Lyonnet, Sylvie Pagès, Margot Wallard, Mag. Gerhard Dermutz and the 'Schwarzen Maske e. V.', Professor Dr Otto König, Dr Kurt Leodolter, Dr Walter Smerling, Professor Dr Hans de Vries, Jörg Widmann and Christoff Wiesinger for their encouragement during my work on this volume.